Dedicated to the _____
of the Beverly Hill_____
who have given the very b_____
themselves in serving and protecting
the citizens of Beverly Hills
for more than one hundred years,
and to the journalists of days gone by
who got the facts right.

BEVERLY HILLS CONFIDENTIAL

A Century of Stars, Scandals and Murders

FROM THE FILES
OF THE
BEVERLY HILLS
POLICE DEPARTMENT

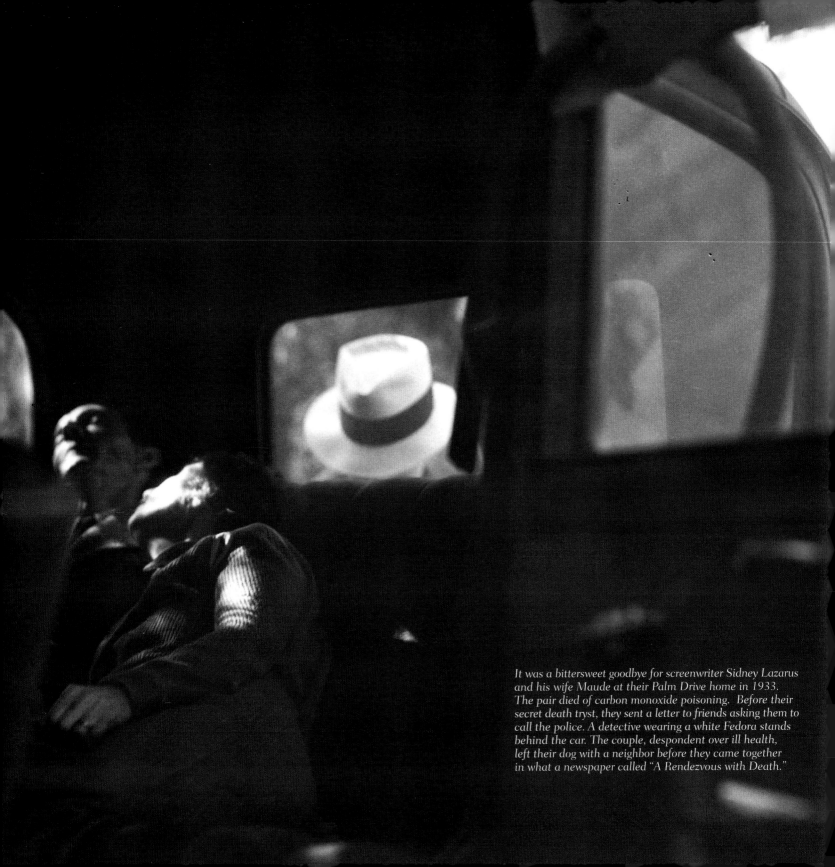

It was a bittersweet goodbye for screenwriter Sidney Lazarus and his wife Maude at their Palm Drive home in 1933. The pair died of carbon monoxide poisoning. Before their secret death tryst, they sent a letter to friends asking them to call the police. A detective wearing a white Fedora stands behind the car. The couple, despondent over ill health, left their dog with a neighbor before they came together in what a newspaper called "A Rendezvous with Death."

BEVERLY HILLS CONFIDENTIAL

A Century of Stars, Scandals and Murders

BARBARA SCHROEDER & CLARK FOGG
DESIGN BY LENTINI DESIGN

ANGEL CITY PRESS

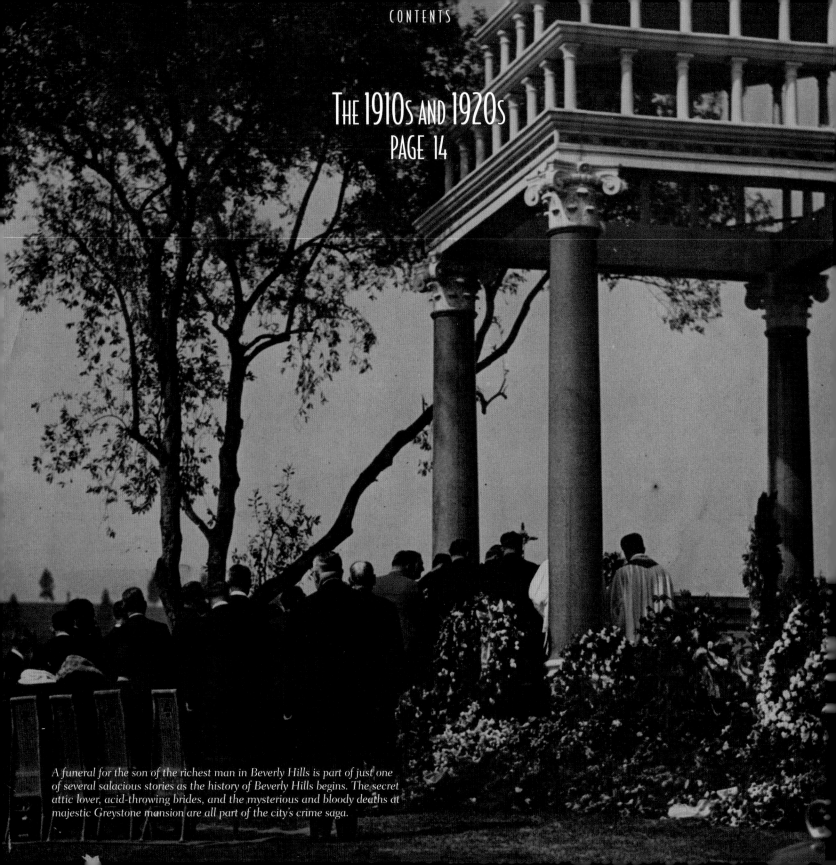

A funeral for the son of the richest man in Beverly Hills is part of just one of several salacious stories as the history of Beverly Hills begins. The secret attic lover, acid-throwing brides, and the mysterious and bloody deaths at majestic Greystone mansion are all part of the city's crime saga.

B. H. P. D.
No. 17465

Beverly Hills Department of Police
BEVERLY HILLS, CALIFORNIA

MALE

May 1st, 1939

WANTED FOR MURDER
$50.00 REWARD

NAME — RAMOS, Lazaro Aguiliar, alias Larry Ramos

Age — 25 years

Weight — 150 lbs.

Height — 5 ft., 9 in.

Nationality — Filipino

Occcupations — Houseman, busboy, prizefighter, vegetable worker, railroad worker.

Educated in the public schools in California. Speaks good English.

Lazaro Ramos
Sign proper name

Warrant No. A-6495, Beverly Hills City Court, charging Murder, has been issued for subject. Will extradite.

A Wanted for Murder poster is all that's left of a Beverly Hills mystery. Did this boxer ever do time for his crime? Plenty of other bad guys will get caught in this decade: sneaky butlers, cult leaders invading mansions, but the most tragic tale of all involves sexy silver-screen star Jean Harlow and her new husband's secret life...and death.

CHAS C. BLAIR, Chief of Police

Phone BRadshaw 22113

Detectives Anderson and McBain

As the city grows, so do the scandals. The Forties will see the most famous comedic actor in the world, Charlie Chaplin, ensnared in a tawdry courtroom drama. A tragic movie star suicide also takes the life of an unborn child. And mobster Bugsy Siegel is gunned down for good.

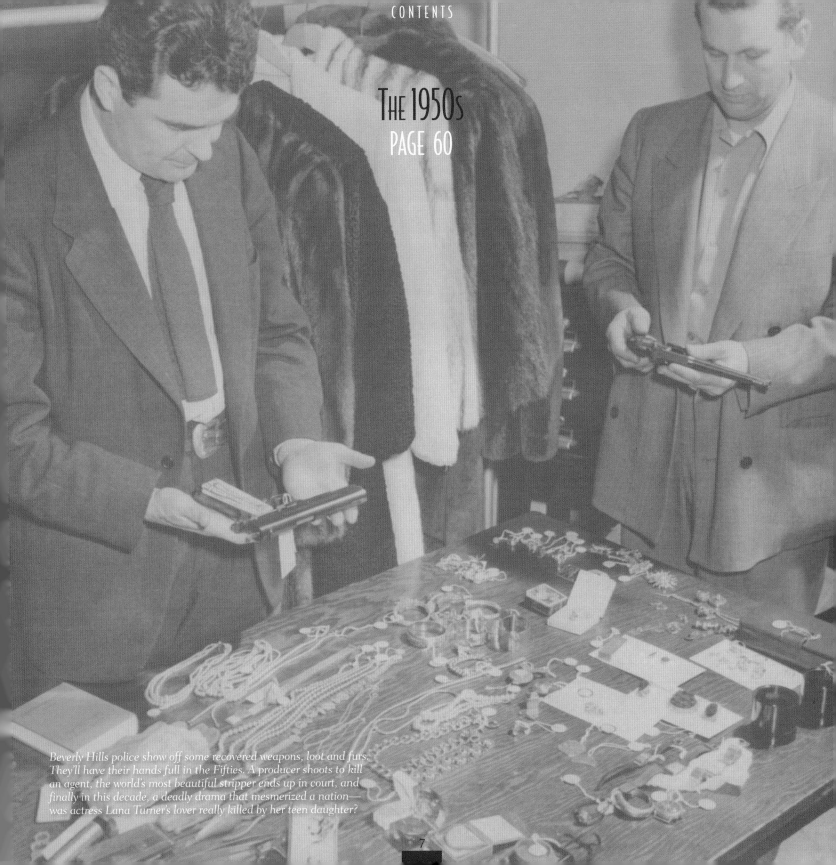

Beverly Hills police show off some recovered weapons, loot and furs. They'll have their hands full in the Fifties. A producer shoots to kill an agent, the world's most beautiful stripper ends up in court, and finally in this decade, a deadly drama that mesmerized a nation— was actress Lana Turner's lover really killed by her teen daughter?

The 1960s and 1970s
PAGE 72

*A modern mansion that belonged to the heir of the Firestone fortune
became the scene of a kidnapping gone haywire...and deadly.
Just more show-stopping drama as the Sixties and Seventies unfold.
A millionaire ends up in a coma after an ugly bar fight with Frank
Sinatra, a beautiful young widow is buried in a Ferrari, and the head
of a cosmetics conglomerate loses his family...to a vicious murderer.*

Lyle Menendez is taken into custody for killing his parents; he'll meet his equally guilty brother in court. These are Beverly Hills's most notorious years, as hostages in a high-end jewelry store heist die, rich kids start up a deadly Ponzi scheme, and high-class hookers are forced to close up shop.

The scene of a crime on Sunset Boulevard that mystified many is the setting of the profoundly sad Ronni Chasen killing. As a new millennium begins, a first century of mayhem ends in Beverly Hills with the tragic death of the mother of a famous radio personality, a much-loved brother loses his battle for life, and pretty girls are accused of ugly crimes.

Introduction

We met because of a murder—but not just any murder; it was the cold-blooded execution of a highly respected publicist gunned down on Sunset Boulevard in the heart of Beverly Hills. Our first meeting began with the classic reporter-investigator exchange:

"May I see that file?"

"No."

We were both familiar with this dance. Me, the nosy investigative reporter, and Clark Fogg, senior forensic specialist for the Beverly Hills Police Department, a gatekeeper of secrets at one of the most storied police departments in the world. Oh, the tales he could tell…

I was trying to find out what really happened the night Hollywood publicity agent Ronni Chasen was murdered. The police department said the classy blonde's execution was simply a random robbery gone bad; the killer was a transient on a bike looking to rob someone. Case closed. Legions of doubters, myself included, were suspicious. After all, it seemed odd that the gunman was on a bike. Plus, a report claimed bullets from the killer's gun didn't match those found in the dead woman's body. The white vinyl "Chasen Murder Book" was right on top of Fogg's file cabinet, just out of my reach.

I reminded him that our paths had crossed on numerous headline-grabbing cases, like the Menendez murders, the sex-capades of Madam Heidi Fleiss, and the Winona Ryder shoplifting saga. But no matter how I tried to establish a rapport, Fogg would not let me see that Chasen file. There would be no exclusives at this time.

I got up to leave when another "Murder Book" caught my eye: the Greystone Mansion killings from way back in 1929. This was the city's first blockbuster crime. A filthy-rich father builds his son the biggest mansion in Beverly Hills and, just a few months later, the son is found dead there, lying near his equally dead male secretary. Was it a case of a clandestine gay love affair gone bad or an anger-fueled bloodbath over a political scandal? The answer, a holy grail in Beverly Hills crime reporting, could be inside that file. "May I look at that?" I asked, my calm demeanor belying my pounding heart.

"Maybe," he said. "Depends on what you want it for. But first, take a look at this." I was intrigued; he unlocked a door marked "PRIVATE." Inside was a treasure trove: archives containing a century's worth of evidence and details of the dark underbelly of glamorous Beverly Hills. I pulled out some yellowed and brittle newspaper articles from a file marked "old." They were sensational stories, now long forgotten, like the one about the pretty twenty-five-year-old maid who hacked her boss to death after an argument over how to cut a roast. Or the story of the nymphomaniac wife who "Hides Teenage Lover in Attic." Or yet another story of a female police pilot who was sunbathing nude—midair—on her plane's wing, and crashed.

The stories became even more intriguing: a cult in the 1930s invades a Beverly Hills mansion; an actress known as the "Mexican Spitfire" kills herself and her unborn child; and, buried in the Bugsy Siegel mobster murder file, a new clue about the never-solved whodunit. Next, Clark showed me never-before-released evidence from the 1950s slaying of playboy Johnny Stompanato: did his lover, the famous actress Lana Turner, twist the knife into his gut, or was it her fourteen-year-old daughter? I saw heartbreaking photos of the mysterious death of the mother of radio talk-show host Dr. Laura—mom was mummified, dead for months, the details cringe-inducing. There were files bulging with never-published crime scene photos and police reports of recent cases that slipped by the media, like the one where a beautiful model murders her sugar-daddy husband while he's trying to crawl away from a relentless barrage of bullets.

But most chilling of all—we found a negative tucked inside an unmarked folder, no information attached. Holding it up to the bright lights in the CSI lab, we looked at the image—it was a show-stopper. A young blonde, clutching a Kleenex, was laying face down, nude on a gurney. Covers were pulled back to reveal the chilling words "Last Warning" scrawled backwards on her back. Did someone carve the letters into her skin? Who was she? It would take the combined efforts of Fogg's CSI expertise and our persistent research to find the answer.

Our partnership had begun—a collaboration that's turned into this chronicle of an unprecedented century of crazy crimes, salacious scandals, and gruesome murders in a city that has lured most of the richest, most eccentric, and famous residents the world has known.

I had one last question for Fogg: would he agree to tell all about the Ronni Chasen case? He nodded. Time to set the record straight. As the great quote from a gangster movie goes, "There is a line you cross, you don't never come back from. I'm going along for the ride, the whole ride."

We hope you enjoy the journey.

Barbara Schroeder and Clark Fogg
2012

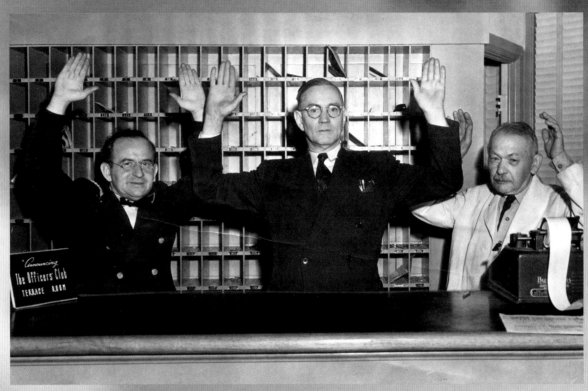

Hands up for the news photographer! Beverly Hills Hotel employees re-enact how they were held at gunpoint while robbers looted the safe on February 15, 1943. Suspects were caught, and the booty was recovered.

ening Herald Grows Just Like Los Angeles

WEDNESDAY, JULY 22, 1925

Hotels and Trains
Five Cents

THREE CENTS

LATEST NEWS

TRIAL

PLOT

AND SO IT BEGINS...
The 1910s and 1920s

804:—Private Swimming Pool and Home of "Doug. and Mary", Beverly Hills, California

Beverly Hills. Just the name alone conjures up images of glamour and glitz. But there was a time, long ago in the early 1900s, when this town was but a glimmer in real estate developers' eyes: no mansions, no fancy stores, no tourists. Just lima bean fields and a lonely, dusty train station stop. The only stars to see were the ones twinkling in the night sky.

In fact, you could say things didn't get exciting around here until the first traffic accident in 1910. A couple of those newfangled driving machines, Model T Fords, crash over on the newly paved Rodeo Drive. It is the first time a ticket is issued, written up by the first marshal in town, Augustus Niestrum.

Even a decade later, in 1919, it's still such a rural area that there isn't even a "pokey" (jail) near by. If someone commits a crime, the new marshal in town, Charlie Blair, takes the bad guy to his house and Mrs. Blair rustles up a meal and a blanket for an overnight stay. If the bad guy is really rotten, say, a bank robber, Blair promptly puts the perpetrator on a Pacific Electric train and ships him off to the downtown Los Angeles county jail.

Fast-forward a few more years and things are changing dramatically. No more bean fields; movie stars and moguls have started moving in. They love this rural and peaceful enclave just west of Hollywood, perfectly situated "Between the City and the Sea" as the brochures boast.

Over on Summit Drive, north of Sunset Boulevard, the first movie star mansion pops up—it's home to the world's original celebrity couple: Mary Pickford and Douglas Fairbanks. She is "America's Sweetheart," the most popular actress of the silent movie era. He is equally famous, a swashbuckling lover who performs his own stunts in movies like *Robin Hood* (1922). Gossip columnists, known as "sob sisters," breathlessly chronicle the couple's scandalous love affair (both are married to other people).

When the lovers finally get their respective divorces and move into their grand manor, they instantly bestow an aura of stardust on the city. The press quickly dubs the place "Pickfair," a magnificent home, with two separate wings, five guest bedrooms, a bowling alley, quarters for fourteen live-in servants, and the area's first indoor swimming pool. Pickfair becomes known as the "White House of the West," as the couple entertains dignitaries, kings and queens, and luminaries such as physicist Albert Einstein, aviator Charles Lindbergh, and baseball great Babe Ruth.

Suddenly, Beverly Hills is on everyone's most wanted list. From 1920 through 1925, the population explodes from seven hundred residents to seven thousand five hundred. Mansions spring up everywhere. A rambling bridle path is built, and the city gets its first movie house in 1925, the East Indian-themed Beverly Theatre. By the end of the 1920s, the population more than doubles to seventeen thousand.

The town's first honorary mayor is announced in 1927, Will Rogers. The cowboy humorist catapults Beverly Hills and its fabulous image onto the national stage. Rogers is the most widely read newspaper columnist of his time, and his dateline reads Beverly Hills.

Also in 1927, Marshal Charlie Blair gets a new title: he's now the first official Chief of Police of Beverly Hills. Blair is a great leader, initiating policies—like fingerprinting all solicitors and salesmen coming into town—that help launch the city's reputation as one of America's safest places to live. His officers are the first in the nation to train at pistol ranges, so they become expert marksmen.

Around the city, Frisbee-sized red and green lights appear on top of tall structures: water towers, utility poles, and even mansions. It's a

crime-fighting system. If the red lights are turned on, street patrol officers rush to the nearest callbox to check-in with headquarters. If the green lights start to glow, detectives respond immediately. Red and green lights both flashing? Emergency! Calling all cops.

Prohibition presents some of the first challenges for the department: it's hard to stop the flow of illegal liquor in a town like this, a town where people have enough money to buy anything, and their homes come complete with secret panels to hide the stuff. Secret doors around town often lead to clandestine, custom speakeasies. But police quickly shut down several shady and ingenious operations, like the one where a bold bootlegger fakes a funeral, using a hearse and a procession of cars to deliver bottles of illegal "hooch."

Sadly, it is also liquor that causes the first tragedy for the police force. On April 9, 1925, thirty-one-year-old motorcycle officer Jesse Farr is driving over a Pacific Electric railroad crossing on Wilshire Boulevard when a wrong-way driver in a Cadillac smashes into the officer's motorcycle and flees the scene. Bystanders pull the officer from the wreckage; one of his legs has been severed. Farr dies in the hospital the next day, about the same time fellow officers are arresting the driver of the car, who admits he was very drunk and speeding at about fifty miles per hour.

Shortly after this incident, the police department deals with the death of another thirty-one-year-old: 1920s actor and sex symbol Rudolph Valentino. The "Latin Lover" dies suddenly in New York due to complications from abdominal surgery. After a memorial service there, the body of "the celluloid aphrodisiac" is brought via train cross-country to Beverly Hills for a second funeral at the Church of the Good Shepherd on Santa Monica Boulevard at Rodeo Drive.

Valentino had come home (but as for most stars of the day, "home" was a loose term—he'd only lived in his beloved "Falcon Lair" Beverly Hills estate for about a year before his death). Grieving, weeping fans surround the cathedral, mourners overflowing into the streets as police arrive for their first crowd-control assignment—a sure sign that life, and police work, in this town will never be simple again.

The first traffic accident in Beverly Hills was near Olympic Boulevard. Los Angeles is off in the distance.

[left] Moonshine was discovered after a car wreck. [right] Charlie Blair, the first Beverly Hills chief of police, appeared with Honorary Mayor Will Rogers.

Rudolph Valentino was renowned as "The Sheik."

A first for the Beverly Hills Police Department: crowd control at Rudolph Valentino's second funeral.

1912

The Beverly Hills Hotel • Trouble At The Pink Palace

Investor Burton Green was in trouble. Green and his business partners had just made a really bad call. They had hoped to find oil under the bean fields in Beverly Hills—after all, there was plenty of black gold in nearby Los Angeles. But instead of oil, all the wannabe wildcatters dug up was water. The year was 1906.

Time for a new plan: sell the land as lots for exclusive homes. They chose the name Beverly Hills (after reading an article about President Taft vacationing in Beverly Farms, Massachusetts) and dressed up the area with lush, grassy parks, and magnificent palm trees. Only one problem: sales were slow (the average price of five hundred dollars per parcel was a few hundred more than most lots in Los Angeles). The company needed a draw, some sort of magnet to get the attention of wealthy homebuyers, so Green decided to build a big—a really big—hotel and paint it pink.

Green hired the best manager in the business, Margaret Anderson, a widow, to run the new hotel—she was the pioneering manager who turned the Hollywood Hotel in Los Angeles into a class act. Anderson performed the same magic at the Beverly Hills Hotel when it opened in May of 1912, creating a tourist destination as well as a community gathering spot for dances, parties, church services, and even movie screenings. At last, a buying and building boom began, and a village was born. On January 23, 1914, Beverly Hills became a real city, incorporation papers and all. Population: 550.

Unfortunately, along with attracting the rich and famous, the hotel attracted troublemakers, too. The first time law enforcement was called to the hotel, the complaint was noisy guests playing a too-lively game of poker. Marshal Greenwood arrived to conduct a thorough investigation. He determined that no laws had been broken and promptly sat down to play cards and have a few drinks. He lost his job shortly after, accused of being "stewed up" (drunk) on duty—and "laying down under a palm tree to recover," according to police reports.

A far more serious crime occurred years later when some unwelcome guests arrived at the hotel on March 31, 1926, around 3 a.m. Two young men in their twenties, dressed in dark suits, tweed overcoats, and stylish caps, quietly entered the lobby. They approached the night manager, Charlie Fitts.

Suddenly, there was a flash of metal as one of the bad guys pulled out a gun and commanded Fitts to open the safe. Charlie struggled to

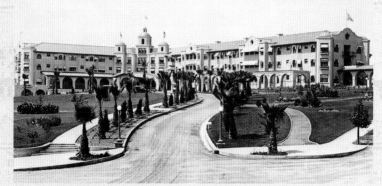

Newspapers described the Beverly Hills Hotel as a "monster hostelry" that cost three hundred thousand dollars to build.

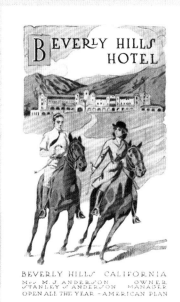

An original brochure featured the bridle path that stretched all the way to the Pacific Ocean.

make the dial do its job, when suddenly, whack! One of the punks slugged him, knocking him to the floor. The other brute yanked him back up to his knees. This time, despite a case of the shakes, Charlie opened the safe and out poured treasure: sparkling jewels and wads of cash, stashed there by safety-conscious hotel guests, and worth ten thousand dollars.

The thugs grabbed the loot and made a quick getaway. Newspaper headlines noted, "Police have slender clews" (that's how they spelled "clue" back then). But the brutes didn't get away with the dastardly deed. A few months later, the young men were caught robbing yet another hotel. Police used fingerprint technology for the first time in Beverly Hills to catch the thieves, lifting prints from Charlie's safe, and putting the youthful bandits behind bars.

1918

THE FIRST SENSATIONAL DIVORCE ◆ SCORNED WIFE'S JUDO JUSTICE

They call it "crazy time," that period couples go through during a divorce. Smart v. Smart was an epic custody battle that culminated in a showdown involving guns, judo experts, and a bizarre hostage: a house.

When the Smart marriage crumbled in the couple's Canadian homeland, Howard Smart, an accountant, was despondent. Not only would his temperamental wife, Marie, abandon the family and disappear for long periods of time, but when she was at home, she spoke constantly of how she intended to get her hands on "some of the millions" belonging to her sister-in-law who was married to one of the richest men in Canada.

After a series of court battles and a highly unusual ruling, the father was awarded custody of the couple's seven-year-old daughter and ten-year-old son. Howard Smart moved his fractured little family into a guesthouse at his sister's new estate in Beverly Hills. He was hoping to raise his children in peace, now that his wife had disappeared again.

But his tranquility was shattered one chilly November night in 1918, when, during the middle of dinner, Marie Smart reappeared, bursting through the door with two judo experts at her side. She'd come to take her kids. Smart leapt into action, took out his .45 Automatic, fired several shots into the air, grabbed the children, and quickly whisked them up to the main house where they all spent the night. His wife refused to leave the guesthouse. She settled in for the night with her two sidekicks as bodyguards. The house was her hostage until morning, when she was arrested for disturbing the peace.

Marie Smart's trial was the talk of Beverly Hills. Newspaper reports detailed how the jury and audience, made up of "men and women from the less-luxuriant walks of life" were riveted by the testimony. (The case was heard with just eleven jurors after one was excused by the judge, "owing to urgent housework.") When Smart took the stand, she testified that her rich sister-in-law had verbally poisoned her children against her, telling them their mom was crazy. She described how her kids wouldn't hug or kiss her anymore, and began to cry. The jury was moved to tears as well and deliberated just three minutes before coming back with an acquittal.

The Smarts worked things out between themselves eventually. Howard Smart took over primary care of the children, but not before another unusual legal twist. The judo duo (who were never arrested) decided to charge him with attempted murder. Smart hired the most

famous criminal attorney at the time, Earl Rogers,* to represent him in court. "A man's home is his castle," Rogers passionately proclaimed, explaining Smart wasn't aiming to kill, rather just to frighten intruders away to protect his children. Thanks to Rogers' eloquent arguments, the lawsuit was dismissed. It was a groundbreaking case, one that would go on to be cited in future incidents involving capital crimes and homeowners.

In later years, after the children were grown, Howard Smart became the first volunteer deputy probation officer for the courts in Beverly Hills, saying he wanted to give back to the city where he had been treated so fairly and had finally been able to raise his children in peace.

*Earl Rogers was an impressive legal superstar of the times, losing only three of seventy-seven murder trials. A popular 1960s television program, called Perry Mason, was based on his career. Rogers' daughter, Adela, was often his sidekick in court. She went on to become famous in her own right as Adela Rogers St. Johns, one of the era's best "girl reporters."

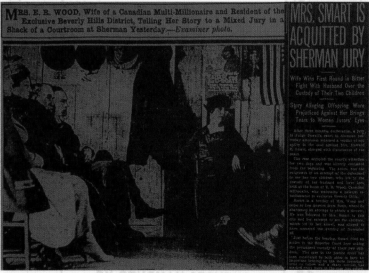

MRS. E. R. WOOD, Wife of a Canadian Multi-Millionaire and Resident of the Exclusive Beverly Hills District, Telling Her Story to a Mixed Jury in a Shack of a Courtroom at Sherman Yesterday—Examiner photo.

MRS. SMART IS ACQUITTED BY SHERMAN JURY

Wife Wins First Round in Bitter Fight With Husband Over the Custody of Their Two Children

Story Alleging Offspring Were Prejudiced Against Her Brings Tears to Women Jurors' Eyes

The only known photo of the Smart divorce case doesn't show the couple, just Mrs. Wood, on the right, who filed charges against "crazy Marie." Before Beverly Hills had a courtroom, cases were tried in an area of town named Sherman (now the city of West Hollywood).

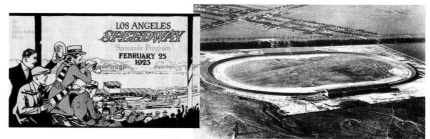

1920
The Beverly Hills Speedway Tragedy • Chevrolet Heir Dies

Beverly Hills ushered in the roaring 1920s with the sound of racecars. A group of fun-loving actors and investors, known as the Beverly Hills Speedway Syndicate, raised some five hundred thousand dollars to build a spectacular speedway and stadium that seated over seventy thousand people.

The "toothpick" track (it was made of wooden planks) was a mile and a quarter long with a thirty-five-degree bank. Second only in stature to the venerable Indianapolis speedway, the track was an instant sensation, and its Indy 500-style races were broadcast nationwide, adding to the city's newly glamorous appeal. The winning speed on opening day registered an eye-popping 103.2 miles per hour. "Californians Thrilled when Daring Riders Pace Fastest Track in the World with Terrific Speed," touted the headlines.

But tragedy struck on Thanksgiving Day of 1920, the last race of the inaugural season. Police were called to the scene after a terrible accident occurred involving Gaston Chevrolet, the younger brother of the founder of the Chevrolet car company. Investigators pieced together the story of what happened from eyewitnesses: Gaston and another driver appeared to be fighting to make up the half-dozen laps they were behind. Suddenly, three cars bunched up on a turn. Chevrolet tried to pass, but his heavy racing car struck and sideswiped a Duesenberg, sending autos careening out of control and over the top of the track. The impact tore out about twenty feet of fence; the vehicles rolled down an incline; and Chevrolet's car landed on top of another, pinning inside the driver and his ride-along mechanic. When the dust cleared, it was a heartbreaking sight; three men, including Chevrolet, were dead. One person, Chevrolet's mechanic, walked away from the smash-up, but suffered serious injuries.

Chevrolet, an up-and-coming driver who won the Indy 500 earlier in the year, was just twenty-eight years old when he died. Friends said he'd been sick for several days and almost bowed out of the race, deciding at the last minute to get into his car. His body was flown back for burial in Indianapolis where he lived. The next race, a few weeks later, began with a moment of silence as the engines then roared to life.

The track stayed open for only four years. It was razed because property values had skyrocketed and land-hungry business developers made an offer the city couldn't refuse. And with that, the brief era of NASCAR 90210 became history.

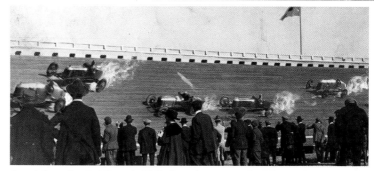

[top left and right] Beverly Hills Speedway stretched from where Beverly Hills High School and the Beverly Wilshire hotel would one day be located. [above] The flames behind the vehicles were added by artists to enhance the impact of news photos.

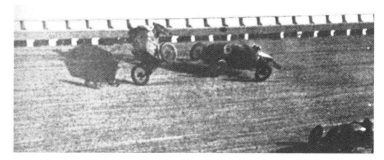

The deadly crash occurred on lap 146 of 200.

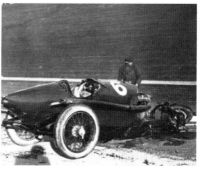

Gaston Chevrolet's green race car was a redesigned Monroe-Frontenac.

Gaston Chevrolet, twenty-eight when he died, was named the national "Speed King of the Year."

[left top] An early photo of Dolly and Fred Oesterreich. [left bottom] Dolly Walburga in court. [middle] Otto "The Attic Lover" Sanhuber shows officials the door to his secret hideaway. [right] Dolly Oesterreich appears in court with her attorney, Jerry Geisler, standing at right.

1922

The Secret Attic Lover • Crazy Love Triangle

One of the first grocery stores in Beverly Hills was owned by a very private widow who lived in near-seclusion above the store, but Beverly Hills police knew exactly who she was and were keeping an eye on her: Dolly Oesterreich, the woman behind the most fantastic murder story of the times, involving a secret teenage sex slave she had stashed in her attic for more than a decade, while her husband was totally unaware.

The salacious saga began in Milwaukee. Dolly, whose real first name was Walburga, was married to Fred, a wealthy apron manufacturer. She liked his money, but found him boring. So when this twenty-six-year-old housewife needed her sewing machine fixed, she used the opportunity to get her insatiable sex drive fixed, too—by Otto Sanhuber, the seventeen-year-old sewing machine repairman her husband sent over from the factory. Suddenly, Dolly's machine needed a lot of repairs.

The crazed lovers wanted more together time, so they came up with a novel plan for a love nest. Otto moved into the couple's 10-by-28-foot attic, and during the day, while husband Fred was at work, the couple carried on sexual trysts in between cooking and cleaning house together. Then, at night, before Fred would come home, Otto retreated to the tiny rooftop room where he wrote lusty romance stories and murder mysteries by candlelight, articles he occasionally sold to magazines. For ten years, in five different homes (the last one in Los Angeles), Otto lived secretly tucked away in the attics.

On August 22, 1922, Otto heard a violent argument erupt down below. Fred was threatening Dolly. Fearing for his ladylove's safety, the attic boy blew his cover and raced downstairs with a pistol. Husband Fred recognized Otto and was shell-shocked. The two men struggled and Otto fired, shooting his former boss twice in the heart, once in the back of the head. Fred was dead.

The secret lovers quickly concocted an alibi: Dolly would tell police that burglars killed her husband. They swore on their undying love they would never tell anyone what had really happened. Otto locked Dolly in a closet and ran to his attic haunt to hide. The police showed up, were suspicious, but didn't have any evidence to file charges.

It would be almost a year later before some of the truth came out. Dolly had amassed two more male "friends" by then (with Otto still living in the attic). The first new friend, Roy Klumb, turned her in to the cops after she broke off their relationship. He went straight to police and told them he'd thrown a gun into the La Brea Tar Pits for Dolly, and he realized now it was probably the murder weapon that she may have used to kill her husband.

Dolly was arrested, and on her first night in jail, she made an odd request to her other "friend" (her estate attorney, Howard Shapiro): please go to her house, tap on the attic door, and tell the man inside it's okay to come out. Shapiro obliged and was shocked to see someone pop out. Otto and Shapiro began talking, and once Otto learned Dolly was in jail, he spilled the beans about what really happened. Shapiro didn't believe him,

called him a liar and shoved Otto out the front door, telling him to get lost. (Otto moved to Portland, changed his name and got married, telling his new wife that his memory of events prior to 1923 had deserted him.)

Dolly's trial got underway. She never said a word about her secret attic lover/killer and the charges were dismissed; the jury didn't believe she killed her husband. Dolly returned to her empty home, Shapiro moved in, seven years elapsed, and Dolly lost interest in him, breaking off their relationship. Shapiro, finally out from under her spell, went straight to the police, told them the unbelievable tale of her attic lover/murderer. Both Otto and Dolly were arrested this time, she charged with conspiracy, he with murder.

Otto confessed all in front of the press. Peering from behind horn-rimmed glasses, he said memories of that fateful night tormented him. "I thought Mrs. Oesterreich was being killed. Suddenly I went mad with rage, seized my little automatic pistol, and ran downstairs. Oesterreich whirled on me, and I pulled the trigger. I ran back up to the little room and lay down. I was stiff with fright." Reporters had a field day with the sensational facts, calling Otto "Bat Man," "Garret Ghost," and "Attic Sex Slave."

The jury found Otto guilty, but he was set free because the statute of limitations had run out. When it was Dolly's turn to stand trial again, she retained a brilliant young attorney named Jerry Geisler* who did his job well. Geisler asked her on the stand why she never told the truth. Dolly replied, weeping, "I didn't believe that he meant to do it, and I didn't want to expose my life to the world—having him in the house." The jury was unable to reach a verdict and the charges against Dolly were dismissed.

After the trial, Otto faded from public view, never to be heard from again. But Dolly's love life was still getting her into trouble. She began an affair with her business manager, Ray Hedrick, who was twelve years younger—and married. Ray's wife filed a three-hundred-thousand-dollar lawsuit against Dolly for alienation of affections; the suit was dismissed, and Ray got a divorce. Dolly and Ray stayed together for more than thirty years, and just two weeks before she died of cancer at the age of seventy-five, Dolly and Ray got married. Dolly wrote in her will, "I give it all to my friend, Ray." Legend has it police checked her Beverly Hills home before her body was taken away; the attic was empty.

* Jerry Geisler was a famous go-to lawyer for troubled stars. He became a household name in the United States for his handling of legendary cases, such as the Charlie Chaplin paternity suit and theater mogul Alexander Pantages' acquittal on rape charges. *Time* magazine lauded him as a great performer who could stand proud among the actors he represented, noting his polished delivery should have earned him at least a half-dozen Oscars.

JURY TENTATIVELY PICKED

Despite the apparent disagreement between Judge Wood and Costello, trial of Sanhuber proceeded in Judge Hardy's court and last night found ten women and two men tentatively sitting as prospective jurors in the case. Each side, however, has twenty peremptory challenges to exercise, and indications are that the final selections of jurors will not be made before late today or tomorow. Those sitting in the jury box last night were Mrs. Margaret Dunn, Mrs. Gertrude Brown, Mrs. Florine Magenheimer, Waldo O'Kelley, Mrs. Anna Geck, Mrs. Grace P. Adams, Mrs. A. C. Drake, Mrs. Josephine Grossman, Mrs. Margueritta Kelley, Frederick Hunt, Mrs. Nolia Swinnington and Mrs. Nita Diebold.

[top] In the early 1900s, it was common practice to identify jurors, and newspapers were free to print their names. [middle] A detective shows the gun used to kill Fred Oesterreich. [bottom] Dolly Walburga in court.

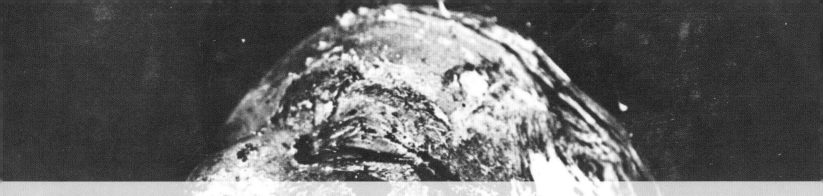

1925

The Acid-Throwing Bride • Husband Blinded

Mrs. Day knew from the start that the beautiful stranger on her doorstep, named Bernice, was trouble. The nineteen-year-old girl was standing next to Mrs. Day's only child and son, twenty-one-year-old Darby. He cleared his throat and said with a shaky smile, "Mom, I… I'd like you to meet the girl I just married."

Young Bernice was smiling confidently, like a Cheshire cat. Mrs. Day almost fainted. "Come in," she managed to squeak out, inviting the newlyweds to share all the details. Bernice confessed she had just recently been divorced, and that when she and Darby Day met at a social event, they fell so much in love they eloped. Oh, and one more thing, they had no place to live. Ever the doting mother, Mrs. Day quickly took charge. She arranged for "a real marriage" and then sent the newlyweds on a honeymoon. Three honeymoons, in fact, that took the couple all around the world, while Mrs. Day packed up the family's Chicago home and moved everything to their new estate on Alpine Drive in Beverly Hills.

And so it was that just a few months into their marriage, the young Days moved in with the old Days—but there would be no living happily ever after. Bernice wanted a home of her own. Unfortunately her new husband couldn't afford that yet since his daddy was bankrolling him. Bernice was not happy. Day told an acquaintance, "My wife has recently made unreasonable demands on me which I am not financially able to comply with."

The honeymoon was over. The couple began quarrelling constantly. Bernice was like a wildcat, slapping and punching her husband—who stayed calm and carried on. That only infuriated Bernice more. She threatened to kill him, staged a fake suicide attempt, and when she still didn't get her way, the tempestuous bride rushed out of the house to a nearby cliff and threatened to jump off. One of the family employees pulled her to safety and took her to his house for the night at Mrs. Day's request. When Bernice returned the next day,

expecting to move back in, Mrs. Day was cold and unforgiving, telling the girl to come back "when her nerves were quieter."

This was the final straw for Bernice. She returned later that night with a bottle of acid hidden in her coat pocket. Mrs. Day opened the door and told her to leave, Bernice saw Day standing behind his mother. "Please Darby," she cajoled, "I need you."

Despite his mother's warning, Day walked away with Bernice. Once they were alone, Bernice begged him, "Look at me, please!" The husband turned to face his bride just as she hurled a hot liquid at him. He was instantly blinded, flesh melting and dripping off his face. Bernice hopped into her car, leaving her husband stumbling in the dark to find his way home. She drove to a relative's house, drank some poison and wrote a suicide note, "Mothers-in-law shouldn't live with young married people. I guess it's quits. I love you from the bottom of my heart. They say love will make you go to extremes. You will never find a love as true or pure as mine. Love, Bernie."

The new bride recovered quickly from her alleged suicide attempt. Day underwent five grueling surgeries to regain his eyesight and repair

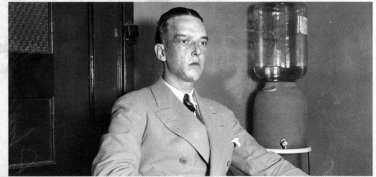

Darby Day Jr., who was "bathed in a flood of liquid fire," shocked observers when he requested leniency for his bride.

skin damage. Meanwhile, Mrs. Day filed assault charges against Bernice. The press went into overdrive covering the case that pitted mother-in-law against daughter-in-law. Reporters were incredulous when the mild-mannered Day took the stand, saying he had no desire for revenge, despite the ugly scars the acid attack had left behind.

When it was Bernice's turn to testify, she claimed she meant to throw the acid on herself. The jury didn't buy it, they found her guilty, and Bernice was on her way to San Quentin State Prison. When asked what caused her marital problems in the first place, Bernice snapped at reporters, "Too much mother-in-law!"

Darby Day moved back to Chicago with his family, where he eventually filed for a divorce. But just when his family thought he'd finally stopped being a human doormat, he petitioned a judge to take it easy on Bernice and let her out early, contending, "Bernice has been punished sufficiently for her act; this is the time to forgive and forget."

Bernice was released a few months early after spending one year in prison. When asked by reporters if there was any chance for a reconciliation, Bernice stomped her feet and retorted, "I'm glad he got a divorce, for I never want to see or hear of him again." She also said she wanted to forget her life behind bars. "Association with approximately a hundred women, white, black, brown, yellow, some good, mostly bad, all milling about like animals in damp and stuffy quarters, daily bickering, real fist fights, and a good deal of hair pulling—such a life is enough to take the heart out of anyone."

Darby never did get the chance to build a life of his own. He died

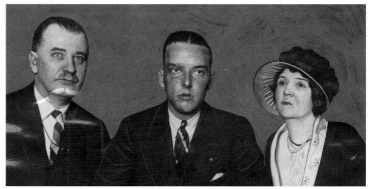

Wealthy banker Darby Day Sr., left, poses with his son and wife, who filed charges against her daughter-in-law.

suddenly at age twenty-four while undergoing an operation for a stomach ailment. He did make headlines one more time before he passed away. He'd been caught by the press bestowing a lingering kiss on a beautiful actress, Josephine Norman. A reporter asked him if he planned to marry the beauty, to which he replied, "Romance? Blah! I'm through with love and marriage."

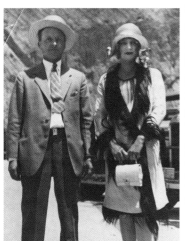

[left] Prior to the attack, acid-thrower Bernice Day had threatened to kill her new husband; she arrives for court accompanied by a deputy sheriff.

Bernice Day's younger sister, Carlyn (in the hat) was charged with conspiracy for driving the getaway car after the acid attack.

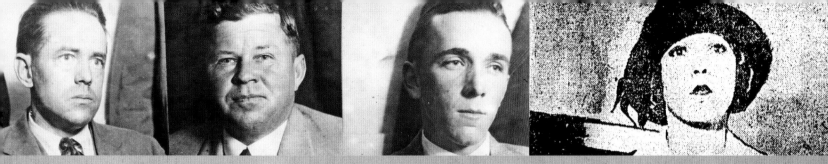

CALL MARY PICKFORD IN PLOT TRIAL

THREE CENTS CITY and COUNTY

LOS ANGELES
EVENING HERALD
AN INDEPENDENT NEWSPAPER
Reg. U. S. Patent Office. Copyright, 1925, by Evening Herald Publishing Company
The Evening Herald Grows Just Like Los Angeles

LATEST NEWS

VOL. L THREE CENTS Hotels and Trains Five Cents WEDNESDAY, JULY 22, 1925 Hotels and Trains Five Cents THREE CENTS NO. 22

1927

The kidnapping trio met Mary Pickford in person for the first time in court. The suspect on the left was acquitted, the others were found guilty.

"America's Sweetheart" Kidnap Plot • Pickford in Peril

Photographers' flashes were booming as the crowd outside the courtroom clamored and shouted, "There she is! Our Mary!" Rabid fans crawled out of windows to get a better view: Mary Pickford had just arrived for the trial of the trio who tried to kidnap her. The men, two truck drivers and a car salesman, had hatched the kidnapping-for-ransom plot one night after they had a few drinks. The plan was to ambush the star at a stoplight on Sunset Boulevard while she was driving home in her Rolls-Royce from the studio. Luckily, a police informant foiled the kidnapping attempt.

During the trial, the courtroom was packed with onlookers. One reporter noted, "The proverbial flapper was not much in evidence in this crowd, most of the women were of middle-age or older, and a large number of men made up the audience." Mary Pickford performed convincingly on the stand, helping bolster the case that she had been stalked. The jury began deliberations late in the afternoon (back in those days jurors were allowed to set their own hours). The verdict came in just four hours later, at 9:30: two were found guilty of conspiracy to kidnap the star, and one was acquitted.

Courtroom staff was on hand to control the overflow crowds, and one stern-faced bailiff broke into a smile as Mary's husband, the equally famous actor Douglas Fairbanks, walked out of the courtroom and shook the bailiff's hand; the "star" effect worked its magic once again to provide a Hollywood ending for this legal drama.

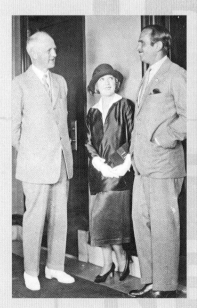

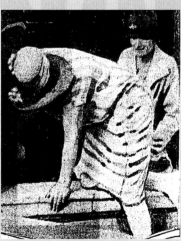

Jurors in a nearby courtroom crawl across a precipice eight stories high to catch a glimpse of Pickford and Fairbanks [left].

Other Stalker Targets

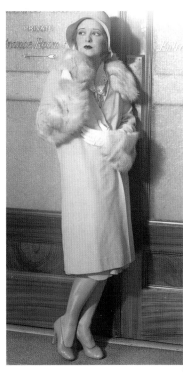

Clara Bow

When a big strange man rang "It Girl" silent-film star Clara Bow's doorbell, Bow's maid rang the cops. They arrived minutes later, but couldn't handcuff the lug; his wrists were too big. After sweet-talking him into the squad car, he was sent back home, where he did time in a mental hospital.

Gloria Vanderbilt

This wealthy seventeen-year-old heiress (newsman Anderson Cooper's mom) married self-described agent/bad boy Pat DiCicco in 1941. Police didn't get an invitation, but they showed up anyway to quietly arrest suspects who were planning to kidnap the bride at the reception.

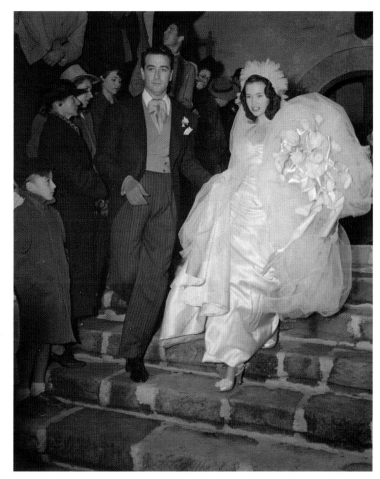

Sylvia Sidney

When a plumber from Chicago flew in to "marry" Sylvia (she was a popular actress in gangster films), he left love letters at her doorstep. Sylvia ratted him out to the cops who put the screws on the goon and took him straight to the hoosegow (jail—or "Gray Bar Hotel" as some liked to call it).

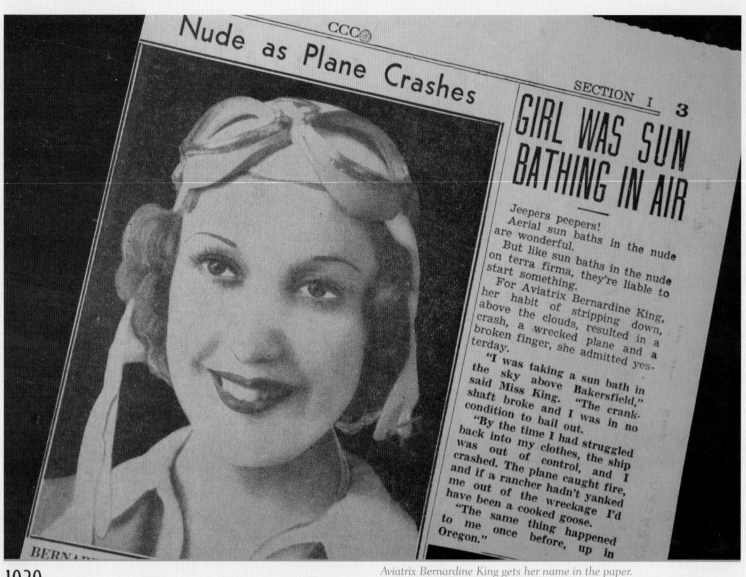

Inside the newspaper clipping:

Nude as Plane Crashes

CCC

SECTION I 3

GIRL WAS SUN BATHING IN AIR

Jeepers peepers! Aerial sun baths in the nude are wonderful.

But like sun baths in the nude on terra firma, they're liable to start something.

For Aviatrix Bernardine King, her habit of stripping down, above the clouds, resulted in a crash, a wrecked plane and a broken finger, she admitted yesterday.

"I was taking a sun bath in the sky above Bakersfield," said Miss King. "The crankshaft broke and I was in no condition to bail out.

"By the time I had struggled back into my clothes, the ship was out of control, and I crashed. The plane caught fire, and if a rancher hadn't yanked me out of the wreckage I'd have been a cooked goose.

"The same thing happened to me once before, up in Oregon."

BERNA[...]

Aviatrix Bernardine King gets her name in the paper.

1929

"FEMININE AIR COP" CRASHES—NUDE • LAST-MINUTE SAVE

Look! Up in the air! No, not a bird, but some fancy flyers, and one female pilot wing-walking in the nude. Seriously? Seriously. And now that we have your attention, here's the true story behind the attention-grabbing headlines.

Stunt flying was as big a craze in the 1920s as car racing. Out-of-work World War I pilots showed off their skills at air shows being held at the Beverly Hills Speedway. However, the aviators were also buzzing residential neighborhoods nearby, loop-de-looping and dipping perilously low to altitudes of about fifty feet. Residents were not amused. They also didn't like the "flower bombs" that had

recently fallen from a plane. An airplane crew hired to drop roses on the procession for screen actor Rudolph Valentino's funeral had not quite understood their mission. Instead of dropping the buds one-at-a-time, they dropped entire bunches of flowers, startling drivers below who were forced to swerve to dodge the falling bouquets.

Something had to be done about these aerial daredevils, so the Beverly Hills Police Department hired three pilots as part of a new "Sky Patrol." The aerial officers' duties were simple: intercept lawbreakers mid-air, escort them back to the ground, and write a three-hundred-dollar ticket. Elizabeth McQueen, deputized in 1929, became the world's first female police aviator, an amazing accomplishment since women weren't even considered fit to patrol the streets back then.

Bernardine King, an accomplished aviatrix who joined the force, held a number of records as a stunt flyer. She was flying from Bakersfield to her home in Beverly Hills when she made shocking headlines: "Nude as Plane Crashes." Apparently King liked laying out, in the buff, on the wings of her plane, "I was taking a sunbath in the sky above Bakersfield," she admitted. "The crankshaft broke and I was in no condition to bail out. By the time I had struggled back into my clothes, the ship was out of control, and I crashed."

King's plane plummeted into an alfalfa field, hit an irrigation ditch, and bounced 150 feet into the air, the craft landed upside down. "The plane caught fire and if a rancher hadn't yanked me out of the wreckage, I'd have been a cooked goose," said King, who spent the day in the hospital with serious injuries, bruises, and a broken finger. But she insisted on returning home the next day in a plane—with all her clothes on this time.

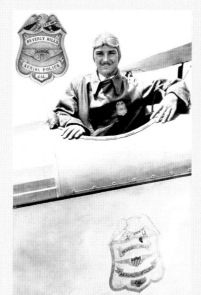

THE POLICEWOMAN'S REVIEW.

Office:
51, TOTHILL STREET,
WESTMINSTER, S.W.1.

Telephone:
Victoria 5827.

Vol. V. No. 3. JULY, 1931. PRICE 3d.

PRINCIPAL CONTENTS.

Women as Detectives. Jury Service for Women.

Provinces versus London. Thoughts on Training.

"THE FLYING POLICEWOMAN"

(By Permission of "The Gateway."

DEPUTIZED Jan. 1929

Mrs. Ulysses G. McQueen is the first air police-woman in the world and is a member of the police force of Beverley Hills, California, where she holds the title of "Aerial Police Investigator."

There is, no doubt, a great future for air police, and most countries are preparing for the time when qualified pilots will be a usual part of every police force. France claims to have had the first active Air Police Force in Europe which was formed in the department of Mosel for the protection of fortifications. Switzerland, Germany and the United States all have their air police, and in England at least one Chief Constable and several policemen in different forces hold their pilots'

certificates.

Policewomen will not be far behind in the matter of qualifying for flying appointments. Mrs. McQueen, who has already been appointed, worked under Field Marshall Allenby in Jerusalem, and there became enthusiastic over aviation. When she returned to America after the war she took up the organisation of aeronautics for women, and formed the Women's International Association of Aeronautics of which she is now Vice-President. She believes there is great scope for women in aeronautics, and she trains them to work in aerodromes, either as practical workers or as secretaries to air-pilots, and to do skilled work in the factories.

Officer Paul Whittier [left] and Officer Elizabeth McQueen [above], the first female police aviator in the world, were members of the Beverly Hills Air Patrol.

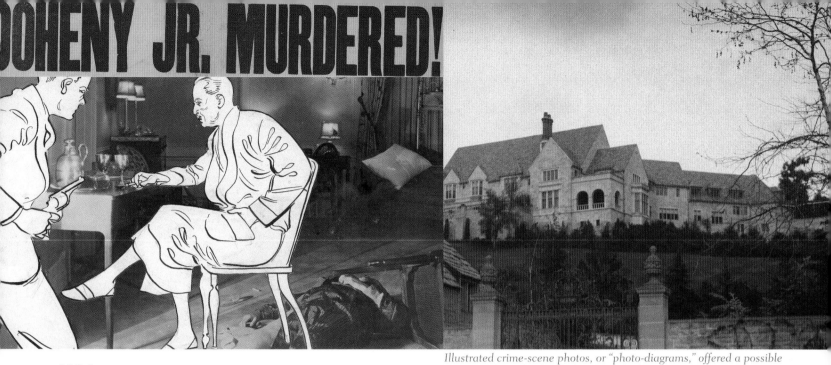

DOHENY JR. MURDERED!

Illustrated crime-scene photos, or "photo-diagrams," offered a possible scenario about the deadly drama at the huge estate.

1929

MURDER AT GREYSTONE MANSION ◆ WHO KILLED WHOM?

A light rain was falling on Saturday night, February 16, 1929. Hugh Plunkett drove his car up the winding road to the gates of his boss Ned Doheny's mansion. He had done this many times before. But this night would be different from all others at the recently completed Greystone Manor. This was the night employee and boss would die, their corpses lying in two bloody heaps just a few feet apart from each other.

"Something terrible has happened," announced the night watchman to the rest of the staff. "Mr. Plunkett and Mr. Doheny are both dead."

Rumors and whispers of what really happened that night have swirled ever since. Who shot whom? Was it a clandestine love affair gone bad or just an employee who suffered a spectacular crackup? Was a jealous wife to blame? Perhaps, as some have suggested, these deaths were related to a political scandal that involved the oil-rich Dohenys—maybe it was a professional hit to silence people who knew too much? The answers, like one of the bullets that pierced through a wall, then fell behind it, are just out of reach. But there are clues in the police file, a holy grail of Beverly Hills crime reporting.

First, some background: Greystone Mansion was built by one of the richest and most powerful oil barons in the nation, Edward Doheny Sr. The fifty-five-room mansion was a gift to his son Ned, his wife Lucy, and their five children. The forty-six thousand-square-foot estate, the largest in Southern California, featured a private bowling alley, a theater, a ten-car garage, exquisite landscaping with cascading waterfalls, a charming playhouse with child-sized appliances and furniture, and a live-in staff that included a riding master for the children. The deadly tragedy happened just five months after the Dohenys had moved in.

By all accounts, the relationship between Hugh and Ned, both in their mid-thirties, was more like a strong friendship than a business arrangement. Hugh Plunkett was a trusted and loyal employee who had worked for the family for fifteen years. He often traveled on business trips with Ned Doheny, like the time they personally delivered (at the request of the senior Doheny) a little black bag filled with a hundred thousand dollars to the U.S. Secretary of the Interior. Was this a gift or (as a Senate investigation implied) a bribe to lease oil-rich government-owned land in Teapot Dome, Wyoming?

Both Doheny and Plunkett were due to appear in court soon to testify about the scandal; Plunkett was upset that he'd been drawn into this drama, worried the family might make him the fall guy. It didn't help that his wife had just divorced him, and that he was in constant physical pain—headaches, toothaches, infections. Plunkett confessed to the family physician, Dr. Fishbaugh, that he was having trouble sleeping and was taking up to ten times the normal doses of the prescription sedatives Dial and Veronal.

The day of the deaths, Plunkett appeared to be particularly agitated and went to Greystone in the afternoon to talk with the doctor, Ned, and Lucy. They all urged Plunkett to take a vacation, or perhaps spend time at a sanatorium. "All these he refused to do, and, in the midst of our conversation, he got up and walked out of the room without saying goodbye," said the doctor.

Plunkett returned for a surprise visit to the mansion later that night. Did he have murder on his mind? These are excerpts from witness interviews conducted the night of the murder:

Joe Maurice, the live-in riding instructor, whose apartment was above the garage:
Q. Did you know Mr. Plunkett was on the estate last night?
A. Well…at…9:30 I heard his car come into the garage court…it made quite a lot of noise…shortly after…I heard someone…come upstairs to the closet where Mr. Plunkett

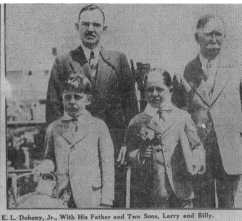

E. L. Doheny, Jr., With His Father and Two Sons, Larry and Billy.

[above left] A society newspaper features Ned Doheny and his wife Lucy attending a fancy party. [top right] Ned with his children and father. [above] Ned stands with his parents, who built Greystone for him.

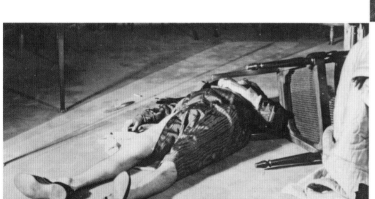

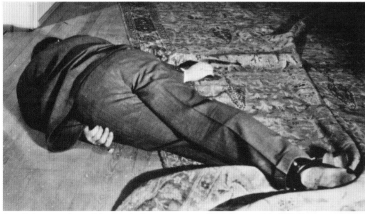

[top] A crystal tumbler and cigarette were found near Ned Doheny.
[bottom] A gun was found by Hugh Plunkett's body.

kept his fishing tackle and firearms and I heard a door open and someone walking very quietly.

The night watchman, Ed McCarthy, adds these details:
Q. Tell us in your own words what happened.
A. I was closing the back gate, I hear steps, look up, and it was Plunkett. He asked me if the folks had got in and I told him yes…Plunkett said I suppose they are asleep. I replied I don't think so, he then turned and left toward the entrance and I followed…as I came through the archway…I saw Plunkett going down the hall towards the guest room.

Q. Does Mr. Plunkett have access to the house?
A. Yes, indeed, he carried master keys to the house and was practically one of the family. It was not unusual for him to come and go at any time.

Dr. Fishbaugh continues the story (Doheny had called and asked him to come over after Plunkett showed up—he was worried about Plunkett's mental state):
Q. When you started to enter the hallway…met by Mr. Plunkett

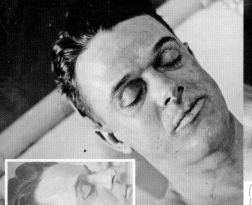
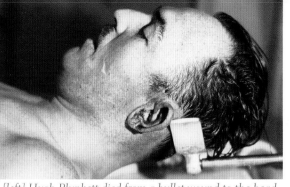

[left] Hugh Plunkett died from a bullet wound to the head.
[right] A bullet to the temple killed Ned Doheny.

was lodged underneath Plunkett. Also troubling him, powder burns usually indicative of suicide were found on Doheny's face, not Plunkett's.

As for the rumored love affair between the two men, few people in that era spoke of same-sex affairs, but Plunkett's apartment manager may have inadvertently revealed an intriguing clue to a reporter, who wrote, "On a few occasions the younger Doheny was seen to come to the apartment with Plunkett, but when they did come they were always alone and did not stay very long."

Newspaper headlines about the tragedy virtually disappeared after just a few days; the coroner quickly closed the case: it was a murder-suicide, end of story.

Oddly, Ned was not buried at the family burial site in a Catholic cemetery. (If you committed suicide, you couldn't be buried in a Catholic cemetery.) Rather, he was the lone Doheny family member buried at Forest Lawn in Glendale. That move fueled the theory that either the family knew of a clandestine love affair, and kept the two close by (Plunkett is buried just down the hill), or that Doheny was the one who shot first, killing Plunkett, then turning the gun on himself.

The widowed Lucy lived on in the mansion and married her second husband, financier Leigh Battson, a few years later. After raising her children, the couple built and moved into a home nearby. Lucy sold the bulk of the Greystone property in 1954 to Paul Trousdale who developed the area as Trousdale Estates. The mansion itself was sold in 1965 to a Chicago-based developer who never lived there. Instead, he

at the door, did you notice a gun in his hand?

A. I did not…Mr. Plunkett approached from the opposite direction and said, "Stay out of here!" (in very harsh words) and slammed the door. Almost immediately a shot was heard and a thud. I asked Mrs. Doheny to wait, and opened the door to find Plunkett sprawled out on the floor in the hallway, motionless. Blood was streaming from his head…When entering the guest room chamber, the body of Mr. Doheny Jr. was found lying sprawled out on the floor near the foot of the bed, still breathing, but blood flowing profusely from both sides of his head. Mr. Doheny's pulse was still faintly perceptible, he was lying on his back and froth and blood were gurgling from his mouth. In order to relieve the breathing, he was turned over on his right side by me until the blood and froth cleared out of his mouth and throat after which he was turned back into his original position where he remained. He stopped breathing in about 30 minutes. After coming out of the guest room, I met Mrs. Doheny, who had been waiting, and told her that both were shot, that Plunkett was dead and that Mr. Doheny was still breathing. She burst out in tears and said, "Oh, how horrible!" and rushed to the telephone to call…her sister… it was decided to call Mr. and Mrs. Doheny senior…they arrived in 20 to 30 minutes. Upon his arrival they notified the police.

The record shows police didn't arrive until several hours later, well after midnight. There is no record of an official interview with Ned's wife, Lucy. The police chief, in his notes, noted that Lucy told him she only heard what sounded like furniture toppling over, and then one gunshot.

So what really happened? Years after the deaths, an investigator who was on scene that night, Leslie White, wrote a book in which he questioned the police chief and district attorney's findings of a murder/suicide. White had no hard evidence to prove otherwise, just a gnawing suspicion that the witness's accounts sounded rehearsed to him, plus he wondered why there were no fingerprints found on the gun that

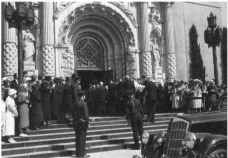
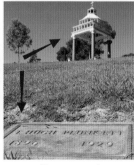

[top right] Photos of Lucy (Doheny) Battson occasionally appeared in local newspaper society pages. [above] Ned Doheny's funeral was held at St. Vincent's Cathedral in Los Angeles. [bottom right] Doheny's final resting spot was a marble monument at Forest Lawn in Glendale not far from Plunkett's simple headstone.

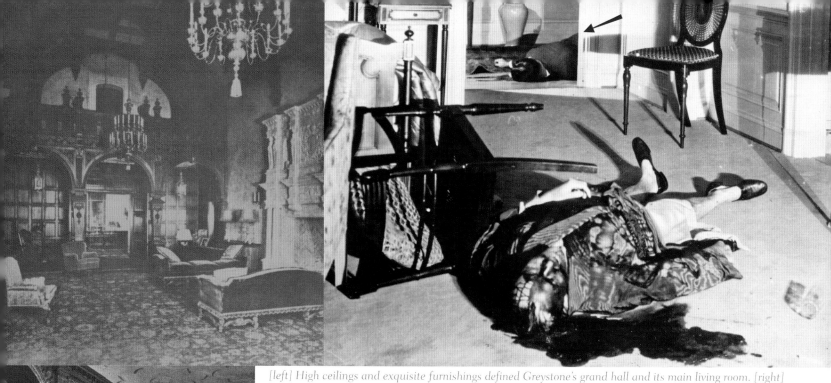

[left] High ceilings and exquisite furnishings defined Greystone's grand hall and its main living room. [right] Doheny's body was turned over by the family doctor, then placed back in its original position, thus the blood-drip lines across the face.

rented it to movie studios. (Later the City of Beverly Hills purchased Greystone, leasing it for a time to the American Film Institute, then turning it into a city park. The mansion now plays host to private parties and weddings and is often featured in movies, including the critically acclaimed film about the early oil industry, *There Will Be Blood* [2007]).

In the years that followed the double deaths, several other tragedies occurred with Greystone as the backdrop. In February of 1992, the body of seventeen-year-old Justin Zeitsoff, the son of a former Malibu city councilwoman, was found in the trunk of his BMW car that was left at the mansion's front gates. The young man had been killed by two gang members over a failed gun/drug deal. Then in the late 1990s, a local doctor, upset over his failing health, committed suicide in one of the gardens. Urban myths about a young child falling accidentally to her death from a balcony and a servant pushing another worker down the mansion stairs have never been substantiated.

Edward Doheny Sr. was seventy-nine when he died of natural causes, just a few years after Ned's death. There would be no father-son dynasty.

"In the evening of his life, Edward Doheny Sr., found himself but a plaything of destiny." Lucy (Doheny) Battson died in 1993 at the age of one hundred. Neither she nor her children ever spoke publicly about what happened that deadly night in the mansion. As one newspaper article put it in 1929, instead of a monument to the Doheny name, Greystone had become a "Palace of Grief."

CLARK FOGG'S ANALYSIS:

It's quite possible Hugh Plunkett didn't intend to kill his boss. The tragedy may have been an accidental murder/suicide. An examination of the crime scene images taken the night of the incident suggests that an emotionally charged conversation ensued between Plunkett and Doheny. A possible scenario: since the firearm was a Colt Bisley single-action revolver (single-action revolvers require less trigger-pull than double-action firearms), as Plunkett pointed the firearm at Doheny it could have accidentally discharged. With Doheny falling out of the chair and blood gushing from his head wound, Plunkett decided to end all outside pressures by ending his life as Mrs. Doheny and the doctor approached him in the hallway outside the guest bedroom.

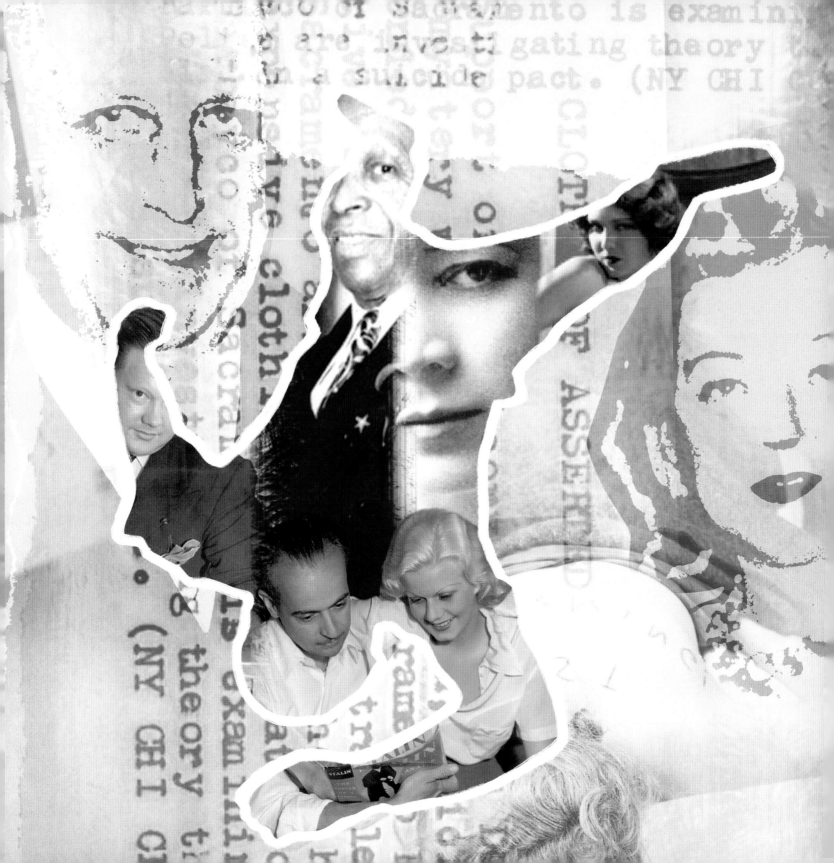

MANSIONS, MOGULS, MOVIE STARS
THE 1930s

As this decade begins, it's clear Beverly Hills has that "It" factor. Not only are there "more stars than there are in heaven"—an old M-G-M studio line—but it's also the fastest-growing city in the U.S., despite the Depression. Beverly Hills doesn't totally escape the ravages of the Great Depression, however; at least one bank closes its doors and several mansions on the desirable north side are foreclosed upon, shuttered, and sold for much less than they cost to build.

A commercial building boom is underway as new merchants come to town; the city is shedding its rural image. Horses are banned from city streets in 1930. A brand new city hall is built, housing both the new jail and police headquarters. The police department is now fully staffed with thirty-six officers. And in early January of 1938, the bronze-and-gold Beverly Hills city signs, soon to be recognized around the world, are placed along the city's six-mile perimeter.

The mass exodus of movie stars from Hollywood to Beverly Hills continues. Starline Tours launches the first sightseeing excursions of movie stars' homes; so many to see—like the imposing mansion belonging to Charlie Chaplin and the equally grand home of the beautiful actress Gloria Swanson. The stunning estates are featured in a short promotional film, a narrator announcing, "Look, the homes of the stars are shiny and different. Here's one right out of a fairytale book."

Also pouring into town: wealthy industrialists and entrepreneurs. Publishing giant William Randolph Hearst builds a mini mansion at 1700 Lexington Drive. It's smaller than his gargantuan castle at San Simeon in Central California, but still opulent. Neighbors gossip, but don't really seem to care that he "lives in sin" with his longtime mistress, actress Marion Davies. After all, the couple throws the best parties, overflowing with tycoons and box-office idols.

With all this new money in town, luxury merchants start popping up. No Gucci or Tiffany stores yet, but Ruser jewelry store sells diamond baubles for a hundred thousand dollars. Mr. Rex offers mink hats for five hundred dollars. And the city's most elegant dames frequent the exclusive Juel Park lingerie shop, perhaps picking up a custom-made, rose-point lace negligee for an astonishing fifteen hundred dollars.

Even the renowned Saks Fifth Avenue in New York can no longer ignore the enormous wealth and retail opportunity in this star-studded town. Saks opens its first West Coast store in 1938, firmly establishing Beverly Hills as an international shopping destination. Reporter and socialite Adela Rogers St. Johns writes in her book, *My Hollywood Story*, that there is simply no place like Beverly Hills, "Around us opulence rolled like lava from a volcano. Everywhere were foreign cars, gowns, and furs."

This town has the highest concentration of rich-and-famous people of any city in the world. No wonder it's also attracting the not so rich and famous. Crimes of attempted mayhem perpetrated by the devilment of wrongdoers start filling newspaper columns. Stories of criminals with real-life names like Frenchy Berry and Eddy LaRue enthrall the public, as do tales of the rich and famous getting robbed. "The servant problem is really something these days," blares a headline.

In 1936, the Beverly Hills Police Department installs two-way radios on police motorcycles, a first for law enforcement in the United States. A year later, the new technology will go into the squad cars, but the system is buggy. Seems the hilly terrain north of Sunset, where the biggest mansions are located, makes for spotty communications. The shiny copper dome on the beautiful new city hall interferes with reception, too. More remote towers are built, and the problem is solved.

In 1937, Police Chief Blair buys the department's first Thompson machine gun, Model 28, for three hundred dollars. Mobsters and

gangsters are coming to town and the department has a sparkling reputation it intends to keep. The conviction record is remarkable, almost one hundred percent. The Beverly Hills Police Department is hailed as being without equal in the country.

Beverly Hills is also a city without equal when it comes to the scandals and dramas that could only happen there, like the time international movie-queen Marlene Dietrich received a spine-chilling letter in the mail at her house on Bedford Drive. The author had cut out words from newspapers and pasted them onto the page, threatening, "Your daughter will be kidnapped," and demanding a one-hundred-thousand-dollar ransom. Officers set up surveillance outside the star's home. Dietrich's five-year-old girl never was abducted, and the author of the note was never heard from again. Dietrich announced she was thankful to Beverly Hills police, telling reporters in her distinctive German accent, "That message filled me with fear and horror." Meanwhile, the scandal sheets are delighted—Beverly Hills is a fertile new hotbed for headlines.

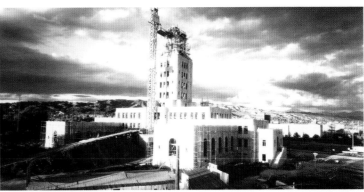
The new Italian Renaissance-style City Hall was under construction in 1932.

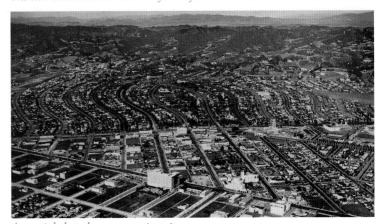
An aerial shot shows a growing city.

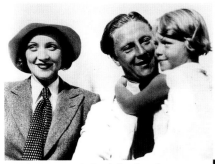
Marlene Dietrich (with husband Dr. Rudolph Sieber and daughter Maria) installed iron bars on all windows after the kidnap scare.

[top] Newspaper tycoon William Randolph Hearst was often photographed with his mistresses of thirty-five years, actress Marion Davies. [left] Gloria Swanson was one of only a few major movie stars who transitioned easily from silent films to "talkies."

[above] The new Saks Fifth Avenue store was a business competitor for the local high-end lingerie shop Juel Park. [right]

Cobina Wright, second from right, was a newspaper columnist turned hostess.

1930s

GIN RUMMY SCANDAL ROCKS MOVIE COLONY ♦ JOKERS NOT WELCOME

A gin rummy craze took hold in Beverly Hills in the 1930s. It's an easy card game to play and easy to win. But some newcomers were winning more than the locals: card sharks, swimming in big-money social circles and playing card tricks.

In fact, the police department switchboard was glutted with calls from irate residents who'd been fleeced. One, a humiliated movie producer, lost thirty thousand dollars in a single game. But there was really nothing the cops could do; it was not against the law to "play a friendly game of cards" with gullible guests.

So the community decided to take the law into its own hands and deal out some vigilante justice. The brain behind this perfectly legal plot: newspaper columnist and well-loved socialite Cobina Wright. She decided to bait the sharks with an irresistible lure. "We're having a party," Cobina announced to her famous friends, "a party like no other, with an unexpected twist. It will be the social event of the season!"

The night finally arrived and the evening was underway—it looked almost like a blockbuster premiere. There was heart-throb Clark Gable getting out of a Rolls-Royce and sexy sweater girl Lana Turner right behind him. Charlie Chaplin attended too. It was a glittering guest list of stars and studio executives. Two men walked in, looking just a tad bit out of place. They were undercover cops who were invited to watch what was about to happen. Also mingling with the overflow crowd were the incognito card sharks who wormed their way in.

The games were about to begin.

The conversation and liquor started to flow. Dinner was served; a

Baked Alaska dessert was quickly polished off, just as the hostess clinked her crystal glass with a silver spoon and rose to speak. "Ladies and gentlemen," she began with a sly smile, "I know you all came here to play cards, and we'll get to that. But first, I have a surprise. Let me introduce you to our very, very special guests this evening." And with that, a card trick magician named McDougall and an internationally famous private detective named Raymond Schindler were brought center stage. They proceeded to mesmerize the audience with a demonstration revealing how easy it is for experts to stack a gin rummy deck. "The naive player, the 'pigeon,' is you," explained the detective. "You don't stand a chance in a game with these con artists."

Friends described Cobina Wright to be "of undetermined age and very determined character."

The swindlers' tricks were exposed, and the con-men were rendered powerless. And while no one was arrested that night, it's clear the soiree was a huge success. No more calls came in to the police department about big money lost at friendly card games. Game over.

1932

Screen Siren Jean Harlow's New Husband Dead • Suicide Or Murder?

Here's a true story that sounds like it's meant for the silver screen: A successful studio executive with undersized, ahem, private parts, marries the hottest, sexiest, blondest star in town. She's twenty-one, madly in love, and grateful to this man who groomed her for stardom. He's forty-two, an average-looking, lifelong bachelor, who's thrilled he landed Hollywood's reigning sex siren. But just two months into their marriage, on September 5, 1932, he is found dead—a cryptic note on his desk, a single bullet wound to the head. His new wife is devastated—from bride to widow in eight weeks. And there's another twist: a mystery woman is pulled out of a river a few days later, a woman who claimed she was the executive's real wife:

There are two versions of what really happened the night Jean Harlow's new husband died:

1. He committed suicide because he was embarrassed that he couldn't sexually satisfy his bride.

2. That woman in the river, Dorothy Millette, killed him in a jealous rage. She was his common-law wife, one he'd hidden away in mental institutions.

The first version was the one M-G-M studio executives wanted the public to believe. They knew they had a scandal on their hands, and they wanted to minimize the bad publicity sure to follow. After all, Harlow was the studio's brightest star and biggest moneymaker. Far better to elicit sympathy for Harlow and cast her as a wronged wife than to reveal her new husband was a bigamist with sordid secrets.

The undisputed facts in either scenario are these: studio executives, alerted by the staff, arrived at the scene of the crime hours before police were called. M-G-M chief Louis B. Mayer, production chief Irving Thalberg, and chief of security Whitey Hendry left their family Labor Day celebrations and raced over to Bern's house where they found the small, nude body of their colleague lying upstairs near the master bedroom.

The execs found a cryptic note tucked in a green Moroccan leather address book on Bern's desk. It read:

> Dearest Dear,
> Unfortunately this is the only way to make good the
> frightful wrong I have done you and to wipe out my
> abject humiliation.
> I love you,
> Paul
> You understand that last night was only a comedy.

Was it a suicide note? It wasn't found near the body, but its contents reinforced the studio version of events: that Bern committed suicide because he was sexually inadequate. Adding more weight to that theory was the coroner's report. It stated that Paul Bern's genitals were "underdeveloped." Rumors were rampant that Bern's humiliation was the result of using a sexual device to please Harlow in ways he couldn't.

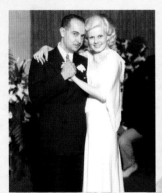

The happy couple poses on their wedding day, July 2, 1932.

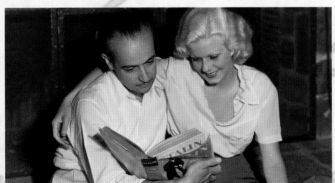

Bern, often called "the best-loved man in Hollywood," loved this photo.

Years later, Bern's home was bought by Jay Sebring, a victim of the Manson murders.

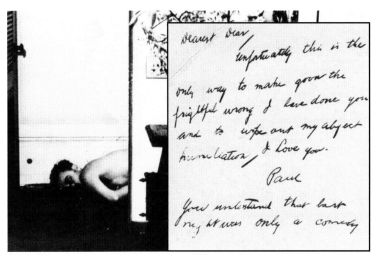

One of Bern's own guns was found in his hand.

"The note"—was it written just before he died?

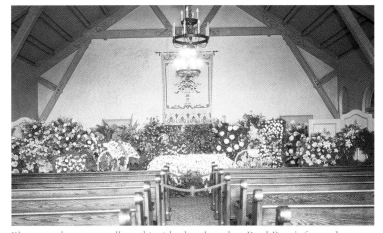

Photographers were allowed inside the chapel at Paul Bern's funeral.

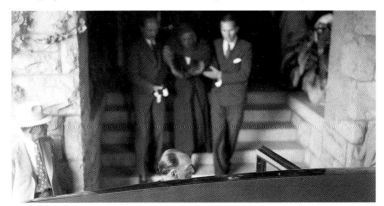

Friends support Jean Harlow as she leaves the church.

As for version number two—that Bern was killed by his crazed, common-law wife—there is evidence to support that theory as well. Apparently, the existence of Dorothy Millette was a secret Bern had been keeping quiet for years. He'd loved the beautiful redhead once upon a time; they lived together for several years and he often introduced Dorothy as Mrs. Paul Bern. But Dorothy had severe mental problems, most likely acute schizophrenia, and Bern was forced to institutionalize her. Their romance was over, but Bern still sent monthly checks to the Algonquin Hotel in New York where Dorothy lived after she was released from the sanatorium. She was an enigmatic figure, wandering halls and New York City streets as a well-dressed recluse.

According to Paul Bern's biographer E.J. Fleming, Dorothy had dreams of coming to Hollywood and becoming a star with Bern's help. But her obsession soon shifted from acting to the Bern-and-Harlow relationship. A hotel maid reported that Dorothy was constantly reading movie magazines, one in particular that she propped open to a feature article entitled "The Life of Beautiful Jean Harlow."

Fleming's research reveals that Dorothy Millette was indeed at Bern's house the night he died. She had arrived via limousine. Harlow was spending the night at her own Beverly Hills home. Fleming believes she knew Millette was arriving and wanted to give the two some time alone.

No one knows exactly what happened between Dorothy and Paul that night, but the staff reported hearing loud voices around midnight and someone screaming what sounded like "get out of my life." No gunshot was heard by the staff, but the housekeeper did see a strange woman in a pink dress and white hat run from the home and jump into the waiting limousine. She was in such a rush that one of her low-heeled, white shoes fell off.

Dorothy's limo driver reported that the only thing she said on the long ride back to the Plaza Hotel in San Francisco, where she'd been staying, was "Faster, faster!" She got up the next day, bought all the newspapers with articles about Bern's death, and boarded the *Delta King* ferry bound for Sacramento where some of her family lived. She never arrived. A few days later, two Japanese fishermen found her badly decomposed body floating in marshy waters near the shore. Witnesses who saw Dorothy on the boat said she had been nervously pacing the ship's deck before she simply disappeared. The coroner ruled the death suicide by drowning.

Interestingly, when police recovered thirty-eight-year-old Millette's belongings, they found a writing pad among her beaded slippers, expensive dresses, and perfumes. There was just one word on the page; it was backwards; and it looked like it might have been an imprint from another

page. When held up to a mirror, the note read "JUSTIFICATION."

So what really happened the night Paul Bern died? Many books and articles have been written supporting both theories. David Stenn, author of the Harlow book *Bombshell* (edited by Jacqueline Onassis) doesn't believe Bern was murdered. "No way, there's not a shred of evidence to suggest it…there's abundant evidence of suicide."

But the late co-author of *Deadly Illusions*, Samuel Marx, an M-G-M story editor who was actually at the scene of the crime (although not in the bedroom), wrote that it was indeed troubled Dorothy Millette who murdered Bern with a gun he was known to keep in plain view in his bedroom. Marx's basis: an interview with a pal of the M-G-M security chief. Reportedly the security chief, shortly before he died, confessed he'd planted the gun on Bern to make it look like a suicide.

Historian Darrell Rooney, who maintains one of the world's largest archives of Harlow memorabilia and is co-author of *Harlow in Hollywood*, says the true story of what happened will never be known, especially since key evidence was destroyed by M-G-M executives. But he does have his own theory—a third, credible explanation of what might have happened.

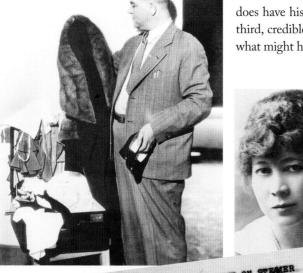

Rooney opines that Paul Bern killed himself, but not because he couldn't sexually satisfy his wife, rather, because secrets in his life had caught up with him and were about to explode. Clearly, Dorothy Millette was no longer willing to be ignored; she considered herself to be Bern's common-law wife. If word got out that Bern was a bigamist, the news could not only ruin him, but worse, it could ruin his beloved Harlow's career.

"There was no good solution to this mess he'd created for himself and his unwitting new bride," says Rooney. "This was the only 'gentlemanly' thing to do. That he might ruin the life of someone he loved so dearly, I think, was too much for him to resolve logically—hence, an irrational act."

Harlow never revealed what she knew about the night her husband died. A few days after Bern's death, she returned to the set of her movie, *Red Dust* (1932). The first and only time she spoke publicly about the incident she said, "I don't know what the note means…I simply cannot talk about the tragic event. It's inexplicable, unutterably sad. I am trying hard to concentrate on work. That is why I went back to the studio early; work has kept me from going mad."

The platinum bombshell went on to marry again, her career intact. But there was one final act to this story the public never saw. When Harlow found out that Millette's few belongings had been sold to pay for a funeral and there wasn't enough money left over for a grave marker, the actress quietly paid for a headstone, which reads simply: Dorothy Millette Bern.

Sadly, Harlow's own life story would end tragically, too. She died suddenly of renal failure at the age of twenty-six, just five years after Bern's death.

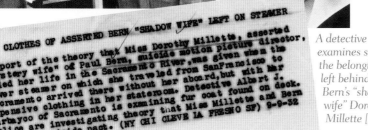

CLOTHES OF ASSERTED BERN "SHADOW WIFE" LEFT ON STEAMER
Support of the theory that Miss Dorothy Millette, asserted "mystery wife" of Paul Bern, suicide motion picture director, ended her life in the Sacramento River, was given when the river steamer on which she traveled from SanFrancisco to Sacramento arrived there without her aboard, but with her expensive clothing in her stateroom. Detective Albert J. Barbayco of Sacramento is examining fur coat found on deck. Police are investigating theory that Miss Millette and Bern died in a suicide pact. (NY CHI CLEVE LA FRESNO SF) 9-9-32

A detective examines some of the belongings left behind by Bern's "shadow wife" Dorothy Millette [above].

CLARK FOGG'S ANALYSIS:

I doubt it was a suicide. An examination of the images taken of the crime scene strongly suggests another scenario. First, it's unusual that an individual commits suicide in a hallway—usually it's in a bathroom, bedroom, living room. I have never, in all my years, investigated a suicide in a hallway. I do believe he clearly didn't want his personal life in the public eye. It could have destroyed Jean's career, and it would have ruined his "creation." No one wants to ruin their best work. My guess is he was the one who yelled, "Get out of my life." Hence, an argument and struggle for the firearm ensued, and Dorothy Millette shot him accidentally.

1933

The Sneaky Butler • Mysterious Burglary

Every two weeks like clockwork, Norman Philip, a wealthy, retired, dairy farm owner, opened a hidden wall safe to retrieve his checkbook so he could pay his staff. Imagine his surprise when he opened it up one night and saw a gaping space where his valuable bonds, worth almost one hundred thousand dollars used to be. The bonds were gone—poof, vanished, as if into thin air. It was a bona fide mystery and Philip immediately called police.

Officers were stymied; there was no sign of forced entry and no evidence that a crime had been committed. Clearly no one had tampered with the safe, and none of the other valuables in the home had been touched. Investigators questioned the two maids; they knew nothing. But they did mention that a butler, Steve Palinkas, used to work in the home. Police quickly dismissed him as a suspect. Not only was Palinkas an exemplary employee with squeaky-clean credentials, but he also hadn't worked in the home for months—he'd moved to a new job in Cleveland, Ohio. In fact, Palinkas had just recently sent a postcard to Philip.

All that Norman Philip could do was place a stop order on the bonds. The case was ice cold—until four months later, when Philip received a phone call on a Friday from an attorney in Cleveland. Seems the attorney had a client in his office who bought some of the missing bonds, but when he tried to sell them, learned they were stolen. Would Philip take the loss and buy the bonds back for less? The two men agreed to speak again on Monday.

Philip alerted police. Detective Clinton Anderson was most curious and, on a hunch, decided to head to Cleveland himself to see just who this "client" was. Commercial aviation was still in its infancy, so the detective spent all day Saturday and most of Sunday on a Ford Tri-Motor airplane. The officer arrived just in time to be at the lawyer's office Monday morning when the client walked in. Anderson got his handcuffs out. It was the former butler, Steve Palinkas.

After a few days in custody, the reluctant thief eventually caved and revealed the details of his ingenious caper: while vacuuming his boss's bedroom rug, Palinkas found a tiny piece of paper lying underneath. It had a series of numbers written on it: the secret combination to the big safe. He copied the numbers, made a duplicate house key, and then quit his job. Weeks later, he hopped on a plane and made a covert trip back to Beverly Hills on a night when he knew his former boss was on vacation, and the house would be empty. Palinkas snuck into the home under cover of darkness, used his key and the combo to pull off the heist, then left town in a hurry. Now he was on his way back to Beverly Hills to a new home: jail.

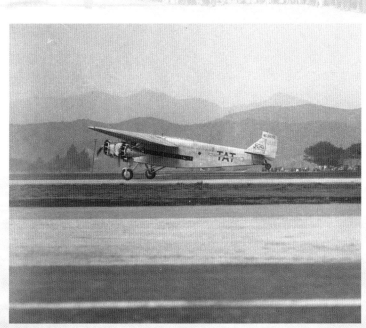

Detective Anderson flew in a Ford Tri-Motor to Cleveland.

1935
"Last Warning" Carved In Skin? • Chilling Photo

A mysterious photo found in a brittle, yellowing police file was simply marked with the name "Leonard." It was a mystery, this picture of a young blonde, clutching a handkerchief, lying face down and nude on a gurney. The covers were pulled down to reveal the words "Last Warning" scrawled in reverse on her back. Chilling. Were those bloody letters carved into her skin? Who was the demonic creep who'd left this cryptic message, making the case all the more terrifying? But most importantly, who was this woman?

An extensive search of 1935 police files and newspapers (there were several in competition back then, including the *Los Angeles Evening Herald & Express*, *Examiner*, *Record*, *Daily News*, and the *Times*) and finally, a few clues were found in the *Beverly Hills Citizen* about an alleged crime involving an actress by the name of Barbara Leonard. She wasn't a big star; she'd been cast in bit parts in some hardly memorable films. No doubt she was interested in a lead role.

She got one in real life, after claiming that two men had broken into her Canon Drive home to inform her she'd won first prize in a newspaper contest. When she let them in, she said the men pounced on her, tied her up and put a gag around her mouth. "I passed out and don't remember anything after that," she told reporters. Police issued Leonard and her husband a gun permit, and a photographer took a photo of the gun-wielding little lady. Newspapers across the country picked up the image. "Gun Warns Gangsters" announced the headlines. It was the most attention this bit-part actress ever had.

The following week, her husband, a piano teacher, reportedly came home to find her semiconscious in the bathtub, with those letters on her back. Leonard was taken to the hospital and treated for "hysteria," a common medical term used to describe out-of-control women in the Thirties. She claimed the men had come back into her home and attacked her, leaving the message on her back because they were angry she'd talked to police.

Police were suspicious of her story; not much had been stolen from the house, she was a chorus girl, hardly a lucrative target for robbers, and she had barely a messed-up Marcel wave. But most telling, those letters— what robber would take the time to write backwards, and why?

A careful examination of the evidence by CSI experts today revealed this juicy tidbit: Barbara Leonard most likely wrote the letters herself.

And while this stunt didn't give her career a boost (in her last known film, she had a small role as an inmate in *Women without Names* (1940)), it did get her the attention she so desperately craved—some seventy-five years later, on the cover of a book about real crimes.

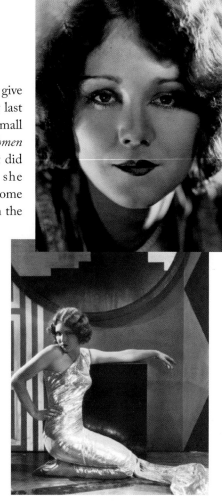

Barbara Leonard claimed she was bound and gagged by two men who stole five hundred dollars worth of jewelry and silver. The actress's career hit a slump in the 1930s.

CLARK FOGG'S ANALYSIS:

After we enlarged the photo to examine it, it was clear that the words weren't written in blood. And it was evident she had written the letters herself, perhaps taping an eyebrow pencil to a twelve-inch ruler, facing a mirror and spelling out the scary message that would be sure to attract attention. The lettering and words angle upward, indicating they were written with one hand extending over the shoulder. The starting points on each letter should be the ending points when written normally.

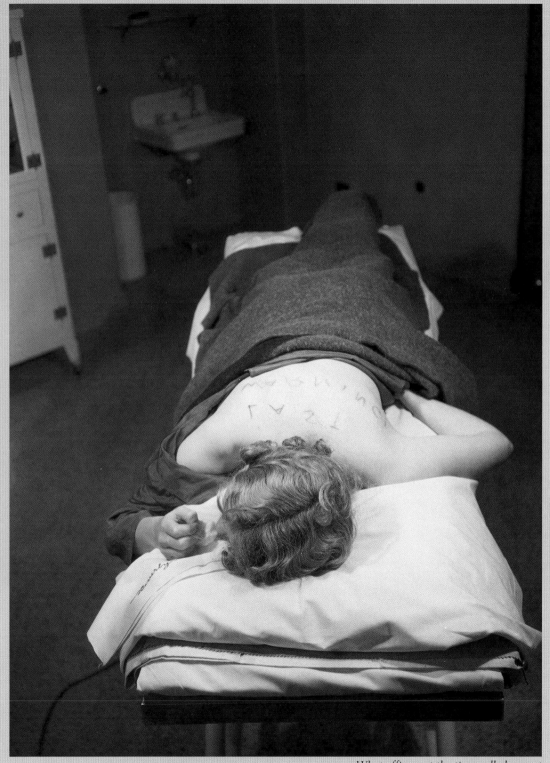

What officers at the time called a most unusual "threat note" is a mirror image of the words "LAST WARNING."

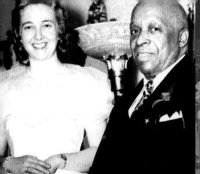

Father Divine was in his seventies when he married his twenty-one-year-old bride.

Throngs of followers board a plane to visit Father Divine in New York.

John Wuest Hunt takes the stand.

Hunt bought the "Throne Car" for Father Divine.

Newspapers said Delight Jewett "showed poise" as she testified how Hunt seduced her.

1936

The Father Divine Cult Invades Mansion • Teenager Raped

When a rich and rotund thirty-three-year-old misfit moved into a mansion in Beverly Hills, neighbors were curious. When he started throwing ten thousand dollars in cash from his balcony for "friends" to gather up, they were very curious. And when he hosted noisy prayer meetings filled with exuberant chanting that lasted well into the night, neighbors were, well, furious.

Who was this crazy new resident and why were dozens of zealots making daily pilgrimages to his house to pray and chant? Nearby homeowners were livid, including the esteemed and usually very private actor Lionel Barrymore, who complained so vociferously that he made headlines: "Sounds Like a Riot from Morning 'til Night!"

Police launched an investigation, and a local district attorney even went undercover to join "the church" to see what was going on. What they found was frustrating and fascinating. Frustrating because they couldn't stop the followers from "merely practicing our religion." Fascinating because a wild story was unfolding.

Turns out the new mansion owner at 807 North Roxbury Drive was John Wuest Hunt, a trust-fund baby with too much time on his hands and no direction in life. The high school drop-out (expelled four times) had inherited a fortune from his father's Cleveland, Ohio, lollipop-manufacturing empire. Married three times, Hunt finally found his real purpose in life after experiencing "vibrations" and meeting Father Divine, a colorful and controversial religious leader from Harlem who preached pacifism between blacks and whites—and who also claimed he was God.

Father Divine's sermons mesmerized Hunt, especially the one called "You got to accentuate the positive and eliminate the negative." (That phrase was used as the title for a hit song written by Johnny

Mercer after he attended a Father Divine sermon in New York.) Hunt was so inspired he became one of his new guru's "angels" and opened a West Coast branch of the church, or a "heaven" as Father Divine liked to call his outposts. Hunt took over his widowed mother's mansion (who also fell under the Divine spell) and invited followers to visit. At first, the chubby-cheeked Hunt was the perfect proselyte. Not only did he donate lots of money to help spread the word of the good Father, but he also built Divine an expensive ten-passenger "throne car" for an upcoming trip to Beverly Hills.

But before that trip would happen, Hunt got himself into serious legal trouble that caused the church great shame and embarrassment. He decided he was "Jesus the Christ" and he wanted to have his own twisted version of an Immaculate Conception, obviously blasphemizing the term. He talked a naive seventeen-year-old named Delight Jewett into coming to his mansion, aka The Temple, and he proceeded to rape her. When she ran away and called her parents, they immediately filed charges against "John the Revelator," the new name he used in court.

The two-week trial was sensational; Hunt decided to tell all in an effort to cleanse his soul. "Details of his confession are unprintable," wrote one newspaper reporter, also detailing lighter moments of the trial, like the time the jury had to contain their laughter when Hunt testified in all seriousness about how he had renamed his mother "Mary Bird Tree" and had "shaken" thousands of dollars from her. He also explained how spiritual vibrations struck him, turning him into "a soaring blimp."

Hunt was sentenced to three years in prison, the judge stating for the record, "Your claim is to have had a vision. I do not think that a vision which encourages a mature man to degrade and debauch a girl in her teens is a true religious vision."

1939

The Case of the "Come Up And See Me" Scam • Works Every Time

Seamed stockings and garter belts were all the rage in the mid-1930s, especially for ladies of the night.

Clever criminals were a dime a dozen in Beverly Hills, especially during the Depression years. But a sexy, leggy lawbreaker? Here's the story of how one gorgeous gal—we'll call her Lola—and dozens of others like her, found a clever way to pay their bills. Lola was not nearly as innocent as she looked. Her game plan was simple: hit up a handsome patsy at a local watering hole and catch his eye. She entered the bar, target in range. She shot the gentleman a sultry come-hither look, "Me?" he replied, incredulous that such a looker would be talking to him.

She nodded, letting her Veronica Lake, peek-a-boo hairdo fall seductively. He crossed the crowded barroom floor. They chatted. They drank. She cut to the chase, "How about we take this party to my place?"

He was happy to oblige the little lady, and he put his arm around the small of her waist, nuzzling her on the romantic moonlit walk to her apartment. When they got inside, the chitchat was over. Wild lovemaking ensued. "Care for a shower?" asked Lola. While he lathered up, Lola hopped into her clothes, grabbed Mr. Easy's keys, wallet, and clothes, and disappeared into the night, never to be heard from again.

A nearly naked, towel-draped gentleman ran down the streets of Beverly Hills, hailing a patrol car as it drove by, and the officers exchanged knowing glances. They'd seen this scene before and pulled over to explain to Mr. What-just-happened how he'd just been duped. "But can't we get her name from the rental agreement?" he cried.

"No," the officers told the poor guy. Depression-era rental rates were so low that Lola (and all the other Lolas in town) paid a mere ten-dollar deposit on a furnished apartment she secured with a fake name. Case closed.

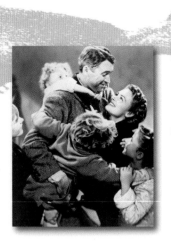

GAMBLERS AND GANGSTERS

The 1940s

What a transformation. The quiet little hamlet of early Beverly Hills is barely recognizable now that it has blossomed into a real city. Commercial buildings are popping up like rabbits out of a magician's hat. It's hard to tell where Beverly Hills ends and Los Angeles begins.

World War II gets underway and the city's star power proves to be surprisingly useful as a secret weapon: Actress Hedy Lamarr raises millions for war bonds by selling kisses on a nationwide tour. While she's away, burglars hit up her home but are quickly arrested. Mary Pickford holds fundraisers at the Pickfair mansion, but without Douglas Fairbanks. (He doesn't live there anymore; the couple's storybook marriage collapsed after just a few years.) And funnyman Charlie Chaplin, motivated by his disdain for the Nazis, makes his first all-talking picture, *The Great Dictator* (1940), a classic spoof of the rise of Adolf Hitler.

The police department is activated as a civil defense center and staffed with a "Police Auxiliary Force" to help protect citizens. Clinton Anderson, a new chief of police who rose through the ranks, takes over for the retiring Charlie Blair in 1942. Chief Anderson is a solid six-foot-tall, two-hundred-pound wall of trouble for criminals. His mission: keep Beverly Hills as crime-free as possible. Anderson quickly gains a reputation as a no-nonsense law enforcer, shutting down gambling joints that are so prolific in this era, and generally making life difficult for mobsters trying to infiltrate this rich little city. When three members of a New York City vice ring move in, the chief unwelcomes them with a personal visit. "I told them there wasn't any action for them in this town." Two hours later, the trio is off to Vegas. "Anderson's Law" is in effect.

The department adds its first female officers, called "matrons." (They wouldn't be known as "officers" until the 1970s.) More movie stars are moving into Beverly Hills, like actor Jimmy Stewart and comedian Groucho Marx. No doubt they feel extra safe in a town whose police chief is known for being a great keeper of secrets (what speeding ticket?). It's a good thing the chief insists on discretion, since his staff deals with lots of only-in-Beverly-Hills cases. Like the time they find the "I vant to be alone" movie star Greta Garbo standing alone in her front yard in just a flimsy nightgown. She's just shimmied down a drainpipe after crawling out of her bedroom window. The strange noises she heard were, indeed, an intruder, who dropped his loot as soon he saw police.

Not only do Beverly Hills movie stars get lots of news attention, so do some odd stories happening here. For example, the one about a stinky good-bye. Chief Anderson and another officer are attending the funeral of a small-time hoodlum, Pauly Gibbons. They want to get a good look at some of the dead man's acquaintances. The eulogy is underway when suddenly a ragged bum teeters in, hands the mortician a long-stemmed roses box and staggers away. The box looks heavy. Curious, the mortuary owner removes the attached card and reads the note, "To my Pal." He unties the ribbon, opens the lid and gags. Instead of roses, the box is filled with horse manure. The chief said they never did find out who sent the "condolences."

Then there's the time officers are called to a Beverly Hills home because a producer has dropped in. Literally. Eccentric millionaire and maverick film producer Howard Hughes has been trying to land his crippled XF-11 plane at the Los Angeles Country

Police Chief Clinton Anderson's 1960 memoir Beverly Hills Is My Beat *detailed highlights of a long career.*

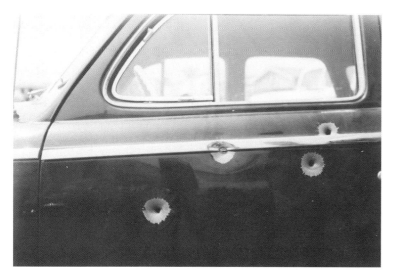

Investigators inspect the shiny black Chrysler in which gangster Pauly Gibbons was killed.

Club, but the aircraft is losing power, falling fast. The wings shear through two homes before the plane crashes into a third house on North Whittier Drive, bursting into flames. Miraculously, Hughes survives after a neighbor pulls him from the wreckage; his injuries are severe and he sustains third-degree burns. A patrolman, going through the rubble at the crash site the next day, finds Mr. Hughes's good-luck charm, his hat, and returns it to the tycoon at the hospital. Mr. Hughes thanks him with a five-thousand-dollar check.

Chief Anderson delights in nothing more than when his department looks good. Years after Anderson's death, an officer who worked for him revealed how they used to fudge crime statistics to keep their boss happy. "If ten offices in a building were burglarized, we'd file only one report. If

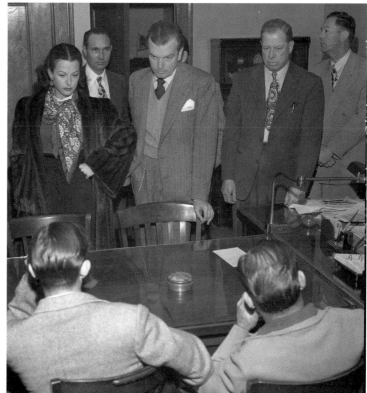

Charlie Chaplin starred in The Great Dictator (1940).

Actress Hedy Lamarr confronts robbers who invaded her home.

Once the toast of Broadway, Helen Lee Worthing died drunk and alone.

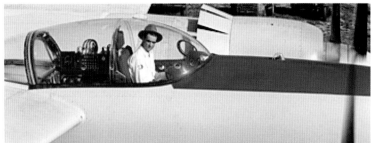

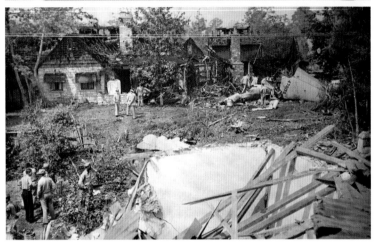

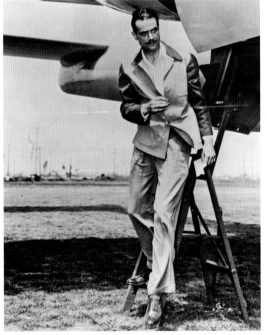

[above] An oil leak may have caused one of the propellers to reverse pitch, resulting in the crash of Howard Hughes' plane. Hughes reimbursed homeowners for property damage caused by the crash.

the thief was apprehended, we filed reports of ten cases closed."

Funny thing about image, so often it's not what it seems. The world sees 1940s Beverly Hills as glitzy and glamorous, a place where you live when your dreams have come true. Not so for everyone. A pitiable skid row drunk roaming Beverly Hills and Hollywood is an eyesore and a nuisance, talking to herself and begging for money. Little does anyone realize who she is—Helen Lee Worthing, the beautiful Ziegfeld Girl and 1920s international dance sensation, whose subsequent acting career fizzled. After she dies in a shack in the Forties, officers find a thick scrapbook by her side, full of old yellowed clippings extolling her long-gone beauty. "Fame is cruel," Anderson wrote in his memoir. "In their race to fame and fortune, people forget the most important thing about living, which is to live right."

[top right] Gambling gangster Elmer Perry profited handsomely from covert gaming operations on land and sea. [top left] Patrons gambled aboard the Rex [above] which was anchored off the coast of Santa Monica.

Elmer Perry, a professional ga[...] bler with a police record, [...] considered a public benefactor [...] some citizens, but his social cl[...] frequented by civic and frater[...] groups, was a front for big-t[...] gambling. He died in a gangl[...]

1940
Beverly Hills Athletic Club Scandal • Trump Card–Murder

Jovial businessman Elmer Perry had a great reputation in Beverly Hills. If you needed a room for a big event, he'd give you a great deal at his place, the Beverly Hills Athletic Club on South Roxbury Drive. But what many upstanding citizens and customers didn't know was that Perry moonlighted as a professional gambler, running a covert gaming operation out of the back room of the club where gangsters like Bugsy Siegel loved to play. Perry was also in cahoots with Tony Cornero, the king of the wildly popular floating casinos like the *Lux* and the *Rex*, that were anchored several miles offshore in Santa Monica Bay, floating just outside the reach of the law.

But Perry's luck ran out one night when two gamblers from the back room walked into the front room to poach an annual dinner meeting of a civic organization with wealthy members. They mingled and charmed the guests into playing a "friendly" game of craps. The swindlers then ran the tables. Unhappy guests called police, and the morning headlines on February 5, 1940 read, "Detectives Smash Door to Reach Games; Poker Chips Taken from Tables."

Perry was found guilty of running an illegal gaming operation and paid a fine but apparently didn't learn his lesson. He continued to play hide-and-seek gambling games with the cops, all the while complaining loudly and publicly that police were harassing him. "I am," he insisted, "a gracious and philanthropic host."

Once, when police tried to shut down yet another illegal gaming event and get Perry's liquor license revoked, they were outmaneuvered. The smooth operator flooded the State Board of Equalization with glowing letters of support from civic groups, rabbis, and priests who all had received reduced rental rates for charity events at the club. The notes praised Perry's kindness and the club's "atmosphere of refinement." Perry won that legal round and kept his liquor license. Chief Anderson was dismayed. "Once again the Perry affair demonstrates…how smooth-talking con men can hoodwink many reputable citizens, who then personally vouch for them as character witnesses."

Perry eventually sold the club but never got to enjoy retirement. He was found dead in a car parked near the La Brea Tar Pits a few months later, shot twice in the head. Police said it was a gangland-style slaying. The killers were never caught.

CLARK FOGG'S ANALYSIS:

Perry was consistently trying to cover his tracks, not only with the police and federal authorities, but also with organized-crime figures. Those gambling ships were probably the main reason for his downfall. A number of reliable sources stated that Perry was not only getting a share in the profits from these floating "money machines," but he was also skimming additional funds. Perry's murder, conducted in a typical mob fashion, also sent a clear message to all: do not to skim monies from the higher-ups. As for the local gaming halls—they were small stuff, used primarily to bolster his fancy lifestyle and give him an appearance of legitimacy with community leaders.

1942

Charlie Chaplin Paternity Scandal • Is He the Dad?

Charlie Chaplin was the world's biggest star of the silent movie era—the internationally loved "Little Tramp" with the too-small suit, the too-big shoes, and that twirling cane. But his reputation was tarnished by another starring role: a real-life drama that exploded into the biggest celebrity scandal of the decade involving babies, blood tests, and big problems for the Beverly Hills Police Department.

On December 23, 1942, twenty-three-year-old aspiring actress Joan Barry (*nee* Joan Berry; Chaplin Studios changed her name to Barry in 1941) arrived at fifty-four-year-old Chaplin's Summit Drive mansion with a gun. She broke into his home and cornered her former lover. He'd promised Barry a part in his new movie, called *Shadow and Substance* (it was never produced), but had been ignoring her for weeks—no more acting lessons, no more private dates. Plus, she'd heard rumors he had a new girl. Barry was furious, demanding answers, wildly waving her gun. (Chaplin, she would later claim, was turned on by the sight, telling her he liked this new "wrinkle" in their love life.)

Chaplin didn't call the police that night, but he did about a week later, on New Year's Eve, when his former protégée-turned-stalker showed up again, this time scantly clad in men's clothing, sitting in her car, refusing to leave. Officers arrived, and, at the star's request, arrested the redhead for vagrancy. Barry pled guilty, was put on probation, and taken to the train station by a Beverly Hills police officer who gave her a ticket out of town and one hundred dollars from one of Chaplin's "people."

But Barry wasn't done with Chaplin yet. In May of 1943, she walked into gossip columnist Hedda Hopper's office and confided that she was pregnant with the superstar's baby, and that he had tried to "float" her out of town with the help of the Beverly Hills police. For the next three years, Chaplin was embroiled in a riveting legal drama. Not only did Barry slap Chaplin with a paternity suit after the birth of baby Carol Ann, but Chaplin and his "people," including that officer who put Barry on the train, were also indicted for conspiring to violate her civil rights. Those federal charges were eventually dropped, but

his fan base was rapidly diminishing, especially when Chaplin romanced, then married, yet another young woman, eighteen-year-old Oona O'Neill, during the trial. (He courted O'Neill with the promise of the lead in that same movie he'd offered to Barry.)

The paternity suit ended on a dramatic note. Chaplin had voluntarily taken blood tests that his attorney said proved he wasn't the father, but the results were inadmissible in court. So in the climactic final moments, Chaplin was asked to stand next to the toddler so the

Curious spectators line the halls as an FBI agent escorts Joan Barry into court.

Joan Barry told the court she and Chaplin became intimate two weeks after she signed his acting contract.

Chaplin's fourth wife, Oona O'Neill, was the daughter of famed playwright Eugene O'Neill, who was outraged over the marriage.

[left] The alleged love child appears in court. [above] Chaplin smiles with several of his children. Does his son to his left resemble Barry's baby Carol Ann?

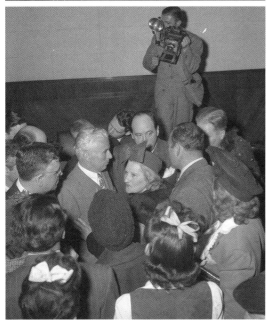

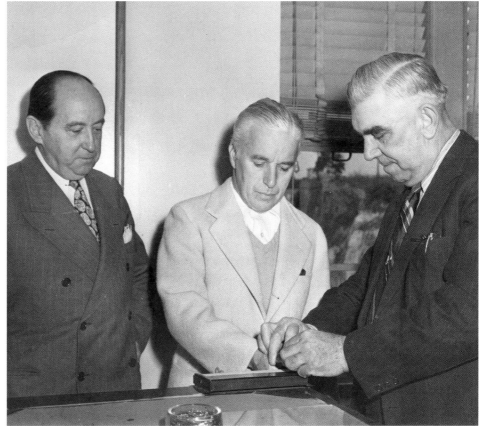

[left] Fans surround Chaplin during a break in court proceedings. [above] Chaplin submits to being fingerprinted, with attorney Jerry Geisler at his side.

jury could compare profiles. They decided he was the father, and Chaplin was ordered to pay child support. He unsuccessfully appealed the case all the way to the California Supreme Court.

More drama followed the sensational trial. In 1952, when Chaplin was in London for the premiere of his movie, *Limelight* (1952), he was denied re-entry into the United States because of alleged Communist sympathies. Chaplin and Oona moved to Switzerland in self-imposed exile, where they raised eight children, the last was born when Chaplin was seventy-three. Chaplin did make one trip back to Beverly Hills after twenty years of living overseas. He accepted a special honorary award at the 1972 Academy Awards, where he was greeted with thunderous applause and a standing ovation. The Chaplin marriage lasted thirty-five years, until Chaplin's death of natural causes at the

Chaplin seduced Barry at his Beverly Hills home, 1085 Summit Drive.

Joan Barry admitted in court that she wrote this note.

age of eighty-eight. Oona Chaplin survived her husband by fourteen years, struggling with alcoholism before dying of pancreatic cancer at the age of sixty-six.

One final scandal occurred after Chaplin died. His body was stolen by grave robbers who dug up his 325-pound oak coffin from a Swiss cemetery a few months after his burial. Two suspects were arrested. Chaplin's body was reburied, this time with six feet of concrete poured over the top of his casket.

As for Barry and her daughter Carol Ann? After a failed attempt at a singing career, Barry had a breakdown, and a legally appointed guardian raised her child. *Time* magazine reported in 1953 that Barry, then thirty-three years old, was institutionalized after she was found walking the streets barefoot, carrying a pair of baby sandals and a child's ring, murmuring, "This is magic."

CLARK FOGG'S ANALYSIS:

If today's technology had been around, there probably would never have been a Chaplin paternity trial. DNA results are so conclusive that the case would have been resolved out of court. It's also interesting to note that this kind of seduction story repeats itself throughout history. We had a similar case in 2007 (detailed in a later chapter) involving a clothing designer who also preyed on young girls. The method of seduction, or "grooming," is the same: the men use their power and promises of fame to lure their prey. The big difference these days, however, is the increase in the use of date-rape drugs, such as GHB, Rohypnol, and ketamine that are secretly put into drinks or food. In a recent case, a supplier was arrested with over 800,000 tablets destined for distribution throughout Los Angeles.

[bottom left] Velez appeared in more than forty films, including a comedy with Laurel and Hardy. [left] The Mexican-born beauty preferred death to unwed motherhood. Lupe Velez committed suicide in her bedroom [above].

1944

"MEXICAN SPITFIRE" KILLS SELF AND UNBORN CHILD • TRAGIC GOODBYE

Whenever I see a man, there is something in here which must make me wrinkle my eyes at him. I cannot help myself any more than you can help yourself from breathing. Sometimes I say I will never flirt again. I sit around. I grow sick. When I cannot flirt with some mens, I get a fever.
—Actress Lupe Velez, also known as the "Mexican Spitfire"

Lupe Velez loved and lived for high drama. She died that way, too, at her 732 North Rodeo Drive home. Just thirty-six years old, the actress was found dead on December 14, 1944, reportedly lying under a silk coverlet in her movie-star-worthy bedroom decorated with white carpets, white satin drapes, and lush velour seating. She had surrounded herself with rose petals; an empty bottle of sleeping pills and two suicide notes were nearby.

The successful actress—who'd had many love affairs with leading men like Gary Cooper and a failed marriage to *Tarzan* star and Olympian Johnny Weissmuller—was pregnant. She wanted the father, actor Harald Ramond, to marry her. He wanted to wait. The couple had a fight, and Velez shoved the younger twenty-seven-year-old lover out of her house. Then she killed herself.

Her first suicide note read: "Harald, may God forgive you and forgive me, too, but I prefer to take my life away and our baby's before I bring him shame or kill him. How could you, Harald, fake such a great love for me and our baby, when all the time you didn't want us? I see no other way out for me, so goodbye and good luck to you. Love, Lupe."

A senseless tragedy, especially because it may have been the result of

[above] "I asked her to marry me," claimed lover Harald Ramond.

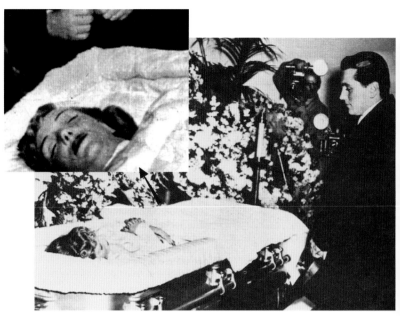

Harald Ramond gazes at Velez as her body lies in a silk-lined casket.

Lupe left a hastily penned suicide note for her lover, Harald.

Velez's two constant loves were her dogs Chips and Chops.

a language barrier. Like Velez, English was not the Austrian Ramond's first language. He said he was willing to marry Lupe, but he wanted to wait until his career was stable, telling friends he didn't want to depend on Lupe's money.

"I loved Lupe," he confided to reporters. "I told her we could announce a 'fake marriage'—but it was not wise to use that word." Velez, he said, flew at him in a wild rage, unwilling to listen to his explanation that they would have a legal ceremony at a later date.

No doubt Velez would have loved all of the attention paid to her even after her death. After viewing the actress's open casket at the funeral, gossip columnist Louella Parsons wrote in the *Los Angeles Examiner*, "Lupe was never lovelier [than] as she lay there, as if slumbering…a faint smile, like secret dreams…looking…like a good little girl."

Then, after Velez's funeral, there was a final moment of drama at an auction of her belongings. Silver trays, love seats, and her collection of expensive colognes were selling at a brisk pace when, suddenly, the bidding came to a screeching halt. Velez's seven-foot-square, silk-covered suicide mattress was on the auction block. After several minutes of awkward silence, one of the auctioneer's assistants bid seventy dollars, and the auction continued.

Velez's second suicide letter, written to her secretary, read: "To my faithful friend. Say good-bye to all my friends and the American press that were always so nice to me. Take care of Chips and Chops" [her dogs].

CLARK FOGG'S ANALYSIS:

A famous urban myth surrounds this story: that Lupe Velez died in her bathroom, head in toilet, while vomiting a combination of sleeping pills and her last, spicy Mexican dinner. We have nothing in our files that supports or disproves that theory. But there could be some truth to it. People respond differently to overdoses. Quite often, in fact, these suicide-by-pill incidents are accompanied by vomiting, diarrhea, abdominal pain, nausea, foaming of the mouth, confusion, sleepiness, even comas—all dangerous if the person breathes (aspirates) vomit into the lungs. With Lupe, I believe she didn't want to vomit in the bed, since she was all dressed for the occasion. So I wouldn't be surprised if there was vomit in the toilet, thus the rumors. We'll probably never know exactly where she was when she died. Interestingly, this is one of the only cases in our files with no scene photos showing the deceased.

1946
The Borrowed Baby Bank Robbery • Newlyweds Arrested

Clearly, the good-looking young couple robbing the bank was not experienced. Their handwritten ransom note had some grammatical errors, and they had taken the time to cross out the mistakes and correct them. But what these newlyweds and first-time criminals lacked in expertise, they made up for with ingenuity: they "borrowed" a four-year-old boy and used the little guy as a miniature hostage in a brazen mid-day robbery on November 30, 1944.

The bandit husband, Thomas Loritz, a Marine on medical discharge, held the child in his arms as he handed the bank manager the note, which read, "This child in my arms is not my own…its life depends solely on your willingness to do as told. Refrain from giving any alarm or you will be killed first, then the child. One quiver of your lips and it will be your last warning."

The manager quickly counted out the ransom demand, three thousand dollars, and gave the money to the couple. With cash in hand, the pretty redheaded bride, named June, and her handsome husband left the bank. They returned the child to his mother, checked into a swank hotel nearby and then took off for an afternoon at the racetrack.

How did they even get the child in the first place? Hard to believe, but they simply drove into a neighborhood, saw a mother playing with her pre-schooler in the front yard, walked up to the mom and told a whopper of a lie. June Loritz tearfully confided that their son had just

died of an illness, and he had looked just like this little boy, Dougie. Would the mother mind if they took him for ice cream? They promised to be back in ten minutes. "Oh you poor things," consoled the mother, allowing them to take her little boy for a treat.

At least the mother wasn't completely oblivious to the oddity of their actions; she wrote down the couple's license plate number as they drove off. She waited for Thomas and June to bring her baby back, growing more nervous with each passing minute. After an hour, just as the now-terrified mother was about to call police, the couple returned and dropped Dougie off. The relieved mother hugged her son. "Man play cowboy," Dougie told his mom as the couple drove away. She had no idea what he meant, until she read the newspaper report the next day about the "Baby Burglary." She immediately called police.

The four-year-old child gave police valuable clues, telling them he was at a place that had a swimming pool. Armed with that information and the license plate info from the mom, the cops tracked down the Bonnie and Clyde wannabes at a local hotel and arrested them. Turns out the couple had been married for just two weeks and had only met six weeks before; they'd never had a child. June was the twenty-two-year-old daughter of a wealthy plantation owner in Hawaii. Her new husband was an unemployed twenty-six-year-old Lothario who had swept her off her feet by promising her a lifetime of adventures.

Thomas Loritz and his bride June were charged with kidnapping and robbery. Mom Mildred Gray, child in hand, confronts June Loritz.

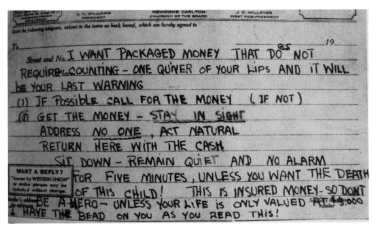

A second note threatened, "I have the bead on you as you read this!"

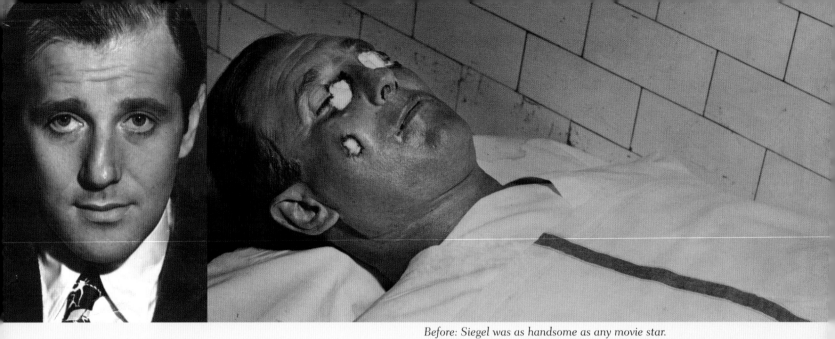

Before: Siegel was as handsome as any movie star.
After: Siegel as he appeared in the morgue.

1947

WHO KILLED MOBSTER BUGSY SIEGEL? • CASANOVA MOBSTER SLAIN

Benjamin "Bugsy" Siegel liked to think of himself as a classy guy, which is why he hated his nickname, one that stuck because it described his rage-filled outbursts—he would "go bughouse."

Siegel, a gangster from Hell's Kitchen in New York, was sent to Los Angeles by his East Coast crime bosses to tap into the West Coast's lucrative vice market. He moved to Beverly Hills with his wife and two kids and began living a double life, hobnobbing with movie stars at fancy parties one day and, allegedly killing mob man "Big Greenie" Greenberg the next. Siegel hired big-gun attorney Jerry Geisler to defend him, and the murder charge was dismissed. Only one charge (out of dozens filed against him) ever stuck: a conviction for illegal gambling at a Miami hotel. He was fined one hundred dollars.

Siegel was quite the ladies' man, despite the fact he was married. His entrée into the social world of Beverly Hills was not only his charm, but also his relationship with hot-blooded Countess Dorothy Taylor di Frasso, an heiress and world-famous socialite who was jaded by her wealth, bored with her husband, and longing for adventure. First, the countess bedded bad-boy Bugsy, then she squired him around town. She loved having a real-life mobster in her social circle. Their adventures were epic, like the time she took Bugsy to Europe

to meet her friend, Italian dictator Benito Mussolini. The countess was trying to interest Mussolini in buying Atomite, a new explosive material Dorothy had invested in, thanks to Bugsy's advice. A test of the explosive failed, producing just a puff of smoke.

Another expensive disaster was funded by the countess: a wacky treasure-hunting cruise for buried gold on Cocos Island off Costa Rica. It began with a wedding on deck. (Jean Harlow's stepdad married his new girlfriend on board; Bugsy and the countess were best man and maid of honor.) Once the motley crew reached the island, they dug for a few days, found nothing, then retreated to sit in the shade on board. They sipped exotic drinks as they watched a determined, but unsuccessful, Bugsy nearly blow up the island in search of the elusive fortune.

Siegel's next conquest was Las Vegas, where he built the city's first luxury casino, the Flamingo, with the help of mob investors. Construction costs spiraled out of control. Siegel was deep in debt, by about three million dollars. The Flamingo was a flop. His investor pals in the syndicate wanted their money back, especially once they heard the rumors that Siegel was skimming money from the building budget for personal use.

On the night he died, June 20, 1947, Siegel went out with pals

Mr. Benjamin Siegel

Bugsy's business card was found in his wallet the night of the murder, along with $408 in cash.

Whoever killed Bugsy Siegel crept up to a rose trellis by a window at this house at 810 North Linden.

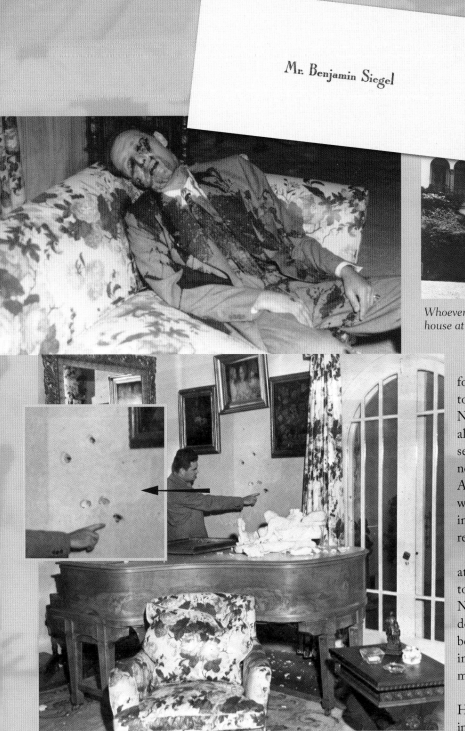

A total of nine shots were fired; some shattered a statue before puncturing the wall and a painting.

for a trout dinner, then he and his friend Al Smiley returned to the house of Siegel's current girlfriend, Virginia Hill, on North Linden Drive around 10 p.m. (She was out of town, allegedly having been alerted to leave "for her health.") Siegel settled into the pillows on the sofa and started reading the newspaper. Suddenly, shots rang out; bullets from a .30-caliber Army carbine came smashing through the living room window. Smiley ducked, unharmed. Siegel was killed almost instantly—two bullets to the head, two to his body. An eyeball reportedly flew across the room like a Superball.

It was a perfectly staged execution. Bugsy Siegel was dead at the age of forty-one. As the *Daily News* put it, "Bugsy had too much lead in his head to get up off the couch that night." No one was ever arrested for Bugsy's murder, despite about a dozen "confessions" from attention seekers that all proved to be false. A deathbed confession from Eddie Cannizzaro was intriguing—but his information on the getaway route didn't match the facts. So theories linger: who killed Bugsy and why?

Perhaps the most accurate version comes from former Beverly Hills officer Dick Clason, who was on the force when a mob insider came into the station and told an officer what may be the

[left] Girlfriend Virginia Hill, mistress to many notorious mobsters, moved to Austria and never spoke to investigators about the murder. [middle] Bugsy's wife Esther Siegel told reporters, "Bugsy was a good husband." [right] Mistress Countess Dorothy di Frasso introduced Siegel to "the swells" at a birthday party for William Randolph Hearst.

real story of how Siegel was murdered. The informant said Tony Brancato and Tony Trombino were the killers, hit men hired by Joe Adonis, a crime boss who was supposedly mediating Siegel's troubles with the East Coast mob. Reportedly, when Adonis learned Siegel was stealing money from the mob, Adonis arranged for the "Two Tonys" to kill him.

Lending credence to the "Two Tonys" theory: a few years after Bugsy was executed, the two Tonys were found in the front seat of a car on a dark street in Los Angeles, each with a single bullet in the back of his head. As for Siegel, the Casanova mobster became a legend in death, but at his funeral, only a few family members and a rabbi showed up. None of his fancy Hollywood pals, not even the countess, could make it; they sent their regrets instead.

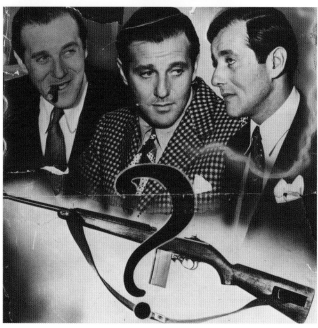

This newspaper montage about Bugsy featured a .30-caliber rifle, which had a magazine that typically holds five rounds. It's possible one shooter could have reloaded, or that two rifles were used.

CLARK FOGG'S ANALYSIS:

After looking at all the evidence, including morgue photos like the one where Bugsy's eye sockets have been filled with cotton, I believe it's quite possible there were two sharpshooters standing by the rose trellis outside the living room the night Siegel was killed. Perhaps both Tonys were "drawing a bead" (aiming) at Bugsy. It would have been nearly impossible for just one gunman to nail both eyes so precisely; the mobster's head would have turned upon impact from the first bullet. No hit man is that great. Most likely you had two guys outside; one guy said, "I'll take the left eye; you take the right."

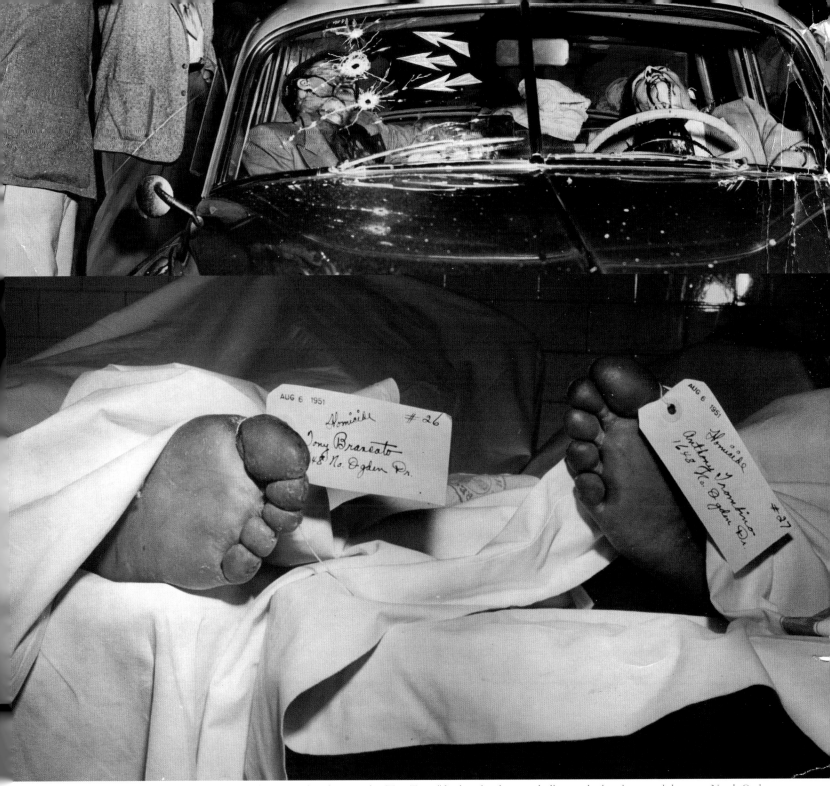

[top] The car radio was still playing when police arrived to discover the "Two Tonys" had each taken two bullets to the head, gunned down on North Ogden Street in Hollywood. [bottom] The coroner's office affixed identifying toe-tags to Tony and Tony after they were executed, gangland style.

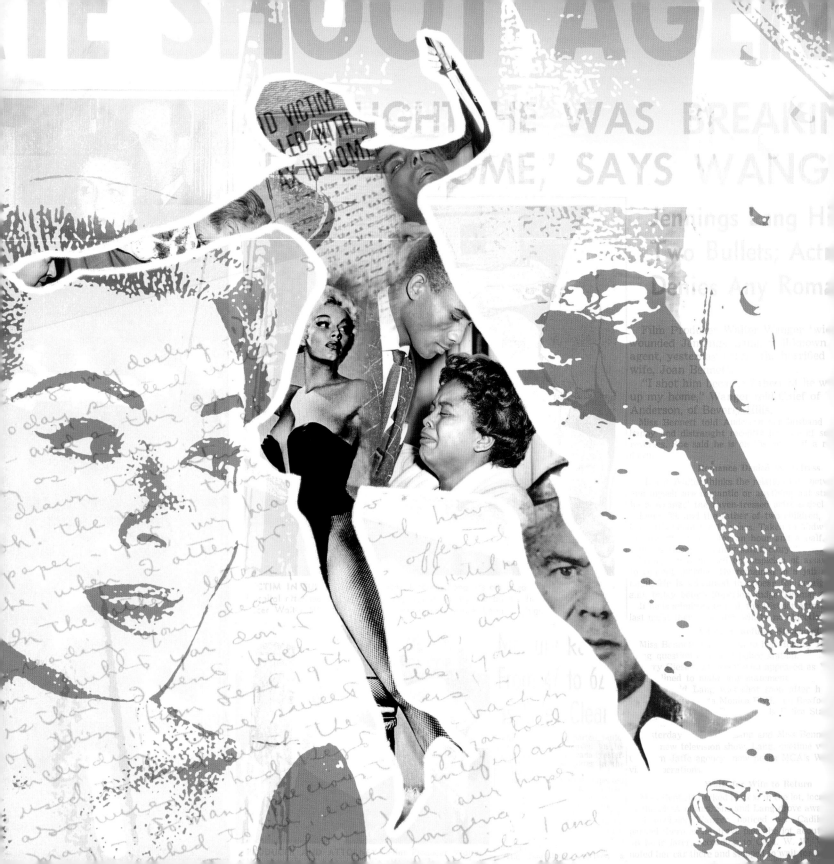

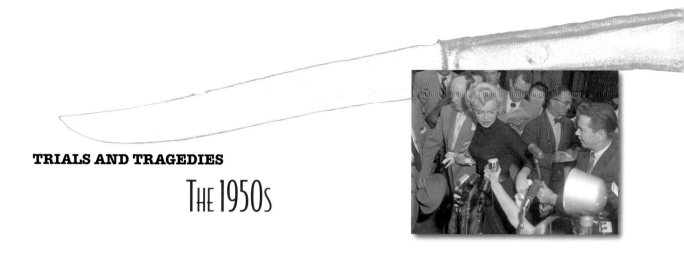

TRIALS AND TRAGEDIES

The 1950s

If you had to pick one decade of classic decadence and debauchery in Beverly Hills, the 1950s would be a good choice. Seems the whole world is watching and gossiping about the celebrity shenanigans going on in this town that all but glitters with stardust.

"She should be spanked!" screams a British tabloid headline, reporting with disdain that the beautiful eighteen-year-old "junior star" Elizabeth Taylor broke off two engagements quite suddenly before marrying twenty-three-year-old Conrad Hilton Jr., son of the famous hotel millionaire. The young couple's over-the-top wedding ceremony at the Church of the Good Shepherd causes so much fanfare that the city is shut down for a few hours. Just eight months later, the local papers unleash this juicy tidbit: "The Hero and Heroine of Hollywood's Gaudiest Wedding—Separated!"

It's not the only high-profile marriage to fizzle fast. Over on Palm Drive, police have been called out for crowd control at Marilyn Monroe's house. The press has arrived en masse, anxious to ask the blonde beauty for a comment at an impromptu press conference. Her marriage to baseball-great Joe DiMaggio has lasted less than a year. Monroe approaches the microphones, attorney by her side. The actress is losing it, barely holding on. She tries to say something but can't speak. This reaction to her shattered marriage is no act. Monroe's attorney gives a terse explanation, "The divorce is the result of a conflict of careers."

The tabloids are in their glory—actresses nearly collapsing make for great headlines. Stars getting drunk in public make for even more exciting copy. Every week it seems as if there's a new incident. The police department acquires a new weapon called the "Drunkometer," a portable device that lets officers check blood-alcohol levels on site as soon as they pull over suspected drunk drivers. One of the first actors to get nabbed is actor Cesar Romero. Romero is arrested for drinking and driving and crashing "in the wee small hours," as the newspaper reports.

But it's not just the stars behaving badly; now, it's their children too, who are all grown up. Charlie Chaplin Jr., in his early thirties, is hauled into court on a DUI charge. The press snaps a photo as he enters the police station. He's holding a cigarette, facing the cameras with an odd look on his face: should he smile or look contrite?

John Barrymore Jr., son of the famous actor John Barrymore Sr., strikes a similar pose with cigarette in hand when he's in court for a felony hit-and-run, drunk driving offense. This working actor's chiseled good looks make it seem more like a photo op than an incoming-inmate picture.

The ladies of the silver screen aren't exempt from the drunken dramas, either. Dora Dodge, a bit actress who, at twenty-eight, married fifty-one-year-old auto heir Horace Dodge Jr., is jailed on charges of intoxication and battery. Big mistake to spit on and slug the officers who are detaining you. "I spit fire," she admitted in an interview. "I always have and I always will."

"The Body," singer and actress Marie McDonald, is in trouble too. Her career isn't much to talk about, but her personal life sure is. Married seven times and a former mistress of Bugsy Siegel, she can obviously get a man, but when it comes to movie parts—not so easy. The actress tries to generate some publicity by staging her own fake kidnapping. The next time she's featured in the papers, it's for driving drunk; she smashed her car into three parked cars and rear-ended a fourth at a stop sign. When the cops arrest her, Marie bites one of the officers, then tells the press through crocodile tears that she has been the victim of police brutality. "Absolutely false—she staged a one-woman riot in our jail," clarifies the police chief, who demands, and receives, a public apology from McDonald.

Some sad and bizarre cases pop into the headlines. The sad cases include a tragic ending for aging actor Lewis Stone. He dies of a heart attack on his front lawn while chasing neighborhood kids who were throwing rocks at his garage. Among the bizarre is the wacky story of "The Ink Attack" at a Beverly Hills movie theater. A jealous thirty-eight-year-old wife, Leona Levenson, walks in and starts casing the aisles, looking for her cheating husband. She finds him sitting with his older mistress, fifty-year-old Fritzie. The wife pulls out jars of ink and hurls them at the covert couple. Not only does she douse her spouse, but she also slimes everyone sitting nearby. Leona is arrested and admits to police that she is also the person who poured molasses all over the couple at a ballgame about a month earlier. "Next time," she threatens, "I think I'll use a ball bat." The couple is soon divorced, and no more attacks are reported.

Temptation means trouble for many in Beverly Hills. Vice officers get a tip about an underground strip club operating at a private hall just around the corner from the Beverly Hills Pawn Shop on Wilshire Boulevard. More than 150 guys pile into the makeshift club anxious to see the show. But instead of exotic dancers, that night's entertainment features undercover officers who take center stage and announce, "This is a raid. Hands up—everyone." Ten people, including two strippers, are taken into custody.

Stories of broken dreams in this beautiful city continue to draw press attention, but the poster child of failure during this decade is Marshall "Mickey" Neilan, one of the most talented and witty actors-turned-directors of early motion pictures. Neilan drinks too much and squanders his fortune, estimated at over eight million dollars. He is arrested repeatedly for writing bad checks. "I was making fifteen thousand dollars a week one year—the next, I couldn't get fifteen cents."

Although he dies almost penniless in 1958, his colleagues in the industry rally for him at the end, sending him to the Motion Picture and Television Country Home and Hospital, a special facility funded by Mary Pickford and other actors to "take care of their own." It is a bittersweet ending to a fabulous life, and a sometimes fabulous decade.

[right] Thirty-eight-year-old Leona Levenson admits to police she sloshed ink at her philandering husband, Frank, [left] and his mistress.

The uniforms of the stylish meter maids, known as the "Parkettes," were designed by the famed Parisian couturier Christian Dior.

[above] Elizabeth Taylor married Conrad "Nicky" Hilton in 1950. [right top] John Barrymore Jr., poses for a mug shot. [right] Charles Chaplin Jr., posed for a mug shot, too.

BEVERLY HILLS
THE CITIZ

B H PUBLIC LIB
CITY HALL
B H 14

IN CONJUNCTION WITH THE BEVERLY HILLS BULLETIN

BEVERLY HILLS, CALIFORNIA, SUNDAY, APRIL 12, 1953 · FIVE C

Vivian Lingle, the sweet-faced scam artist, told her arresting officers, "I don't know what to say."

1950s

Charity Scammer's Tragic End · The Vivian Lingle Lies

When it came to getting money from the rich in Beverly Hills, Vivian Lingle was the best fundraiser in the city. But unbeknownst to society matrons and superstars (like singer Bing Crosby), Vivian was a world-class scam artist who launched some of the most ingenious war-themed scams police had ever seen.

Her story has an ugly ending, but it began quite innocently. Lingle worked her way up the Beverly Hills social ladder with a legitimate fundraising group called The Women's Emergency Corps. Once she saw how easy it was to get people to donate money for causes that helped war veterans, she started hatching schemes for her own benefit. The Emergency Corps disbanded right after the war, but Lingle usurped the name and used it as the perfect cover to finance the good life she craved.

When Vivian wanted a new place to live, she came up with this plan: find a luxury rental apartment and get other people to pay the bill. The scheme worked like a charm. She raised money by convincing romance-starved society wives and friends to donate money to rent and furnish an apartment that would serve as a special welcome-back spot for returning war vets reuniting with their wives. The money poured in. Vivian moved in. Then she held Champagne and caviar parties to show off the luxury digs, raising even more money to keep the scam going.

When she wanted a fancy car to drive, Vivian charmed local auto dealers into loaning her their best vehicles to "transport war heroes." When the dealers demanded their cars back, Vivian just ignored them, smiling as she drove around town, secure in the knowledge she couldn't be arrested; after all, she had permission to drive the cars.

And in yet another dodge, Lingle sold raffle tickets for a non-existent Cadillac, with all proceeds allegedly going to worthy veterans. No war hero ever saw the money, but Vivian did, investing just a few hundred dollars to print the tickets, then reaping a quick six-thousand-dollar profit.

Vivian lived a lavish lifestyle, all while constantly working her carefully honed list of rich-and-famous friends who just handed over money without asking questions. But eventually, Vivian's devious deeds caught up with her. Singer Bing Crosby's business manager, furious when he heard rumors of the scam, gave police checks she had forged on behalf of the fake Emergency Corps.

The fifty-five-year-old society maven was finally arrested for selling illegal raffle tickets. While trying to keep her chin up as she was walking out of court, she was stopped and charged with forging checks in the Bing Crosby case. She would now be moving to a new place paid for by others: the state penitentiary. But Vivian Lingle failed to show up for her final court sentencing appearance. When police searched her apartment, they found her dead—she had committed suicide.

1951

Jealous Producer Shoots Wife's Agent • Real Life Drama

Distinguished movie producer Walter Wanger had a hot wife, hit movies like Cleopatra (1963), and a near-deadly jealous streak. Add a gun to that equation, and you have the makings of a melodrama even more dramatic than his blockbuster films.

The fifty-seven-year-old Wanger (who told everyone to pronounce his name so it rhymed with "danger") was married to actress Joan Bennett. There was only one marital issue: her agent, Jennings Lang. Lang was married, with kids, but why did he pay so much attention to Mrs. Wanger?

"I'll shoot anyone who breaks up my home," Wanger said randomly and cryptically to the agent one day. To back it up, the producer bought himself a gun. He also hired a private detective, who reported seeing the forty-year-old Joan and her thirty-nine-year-old agent rendezvous often, at a parking lot located across from the police station. There was no sign of physical contact, but the information was enough to send Wanger into a rage.

On December 13, 1951, Wanger drove over to the parking lot himself and waited. It was dusk, the "golden time of day," in movie parlance. He watched in disbelief as he saw two cars pull up. The agent got out of his vehicle and sauntered over to Joan's car; she rolled down the window. He leaned over for a cozy chat.

Wanger's eyes zoomed into his beautiful wife's face for a close-up; she was smiling. He had seen enough. Wanger raced over to the oblivious couple, pulled out his gun and without a word aimed at the agent's crotch and shot him twice. Lang screamed in agony as his bloody body crumpled to the ground. Joan was stunned to see that the shooter was her husband; he looked like a madman. "Get away and leave us alone!" she cried, cradling the bleeding agent as tears streamed down her face. Wanger retreated slowly to his car in a daze.

A nearby gas station manager rushed over and whisked the agent and actress to a hospital. Police arrived almost instantly; they heard the shots from inside the station and wondered what was going on in the nearby parking lot. Wanger immediately confessed, "I shot him because I thought he was breaking up my home."

Lang survived the shooting, and eventually forgave Wanger. "Aren't you sore at him?" queried an incredulous reporter. "No," Lang replied. "Life is too short to be sore at anyone."

Wanger pled temporary insanity and spent four months in prison for his crime of passion. Upon his release, he produced an anti-capital punishment film called *I Want to Live* (1958). It was, he said, his favorite film of all. He got the girl back, too. Joan forgave him and finally convinced Wanger he was indeed the only man she loved. The couple stayed together for twenty-five years before they divorced.

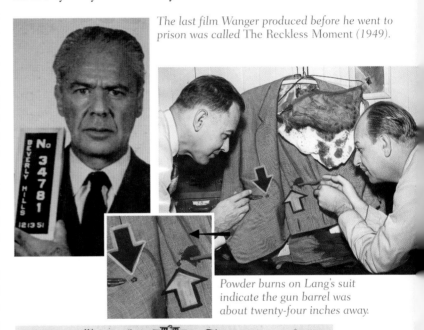

The last film Wanger produced before he went to prison was called The Reckless Moment *(1949).*

Powder burns on Lang's suit indicate the gun barrel was about twenty-four inches away.

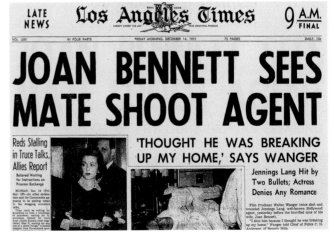

LATE NEWS — **Los Angeles Times** — 9 A.M. FINAL

JOAN BENNETT SEES MATE SHOOT AGENT

'THOUGHT HE WAS BREAKING UP MY HOME,' SAYS WANGER

Jennings Lang Hit by Two Bullets; Actress Denies Any Romance

1951

"WORLD'S MOST BEAUTIFUL STRIPPER" IN COURT • ANGRY WIVES WANT HER GONE

Stripper Lili St. Cyr was in hot water, literally. The ultra-sexy blonde, famous on the burlesque circuit, was onstage at the Sunset Strip hotspot, Ciro's. She smiled seductively at the audience. She knew exactly what those men wanted.

Slowly, she unzipped her dress and began to slide it off, revealing barely there lingerie. Nearly naked, she slipped into a giant plastic see-through tub filled with soapy bubbles. St. Cyr giggled. Her hands dipped underwater and, voila, off came her bra, next the panties, her "private bits" strategically concealed by the white frothy suds.

An assistant came onstage and held a towel to strategically cover the vamp as she bent and strode suggestively, then stepped out of the tub, dripping wet. Wait, had the audience just caught a glimpse of her totally naked? That was exactly what two undercover cops were there to find out. They'd been tipped off by some angry Beverly Hills housewives who wanted "that bubble girl" gone and out of their husbands' sights.

The officers had seen enough. Lili was charged with staging a "lewd and lascivious performance." She hired the best defense attorney in town, Jerry Geisler, who told the jury in his opening statement that St. Cyr was not a bawdy stripper. "The lovely and talented Miss St. Cyr is an artist!"

The Beverly Hills courtroom became quite the scene inside and out as bystanders and fans crowded around to get a glimpse of the exotic dancer. Geisler explained Lili's performance as nothing less than a work of art. With a dramatic flourish, he waved the white terry cloth towel she used in the act. It was clearly not see-through. He also displayed her barely-there, mesh underwear that covered her private parts.

After a six-day trial, the jury deliberated for just over an hour (including a lunch break) and declared Miss St. Cyr not guilty of giving an indecent performance.

All the publicity from the trial got the stripper noticed by Hollywood producers, but her film career, unlike her clothes, never took off. Low-budget movies like *The Naked and the Dead* (1958) and *Teaserama* (1955) didn't connect with the movie-going public.

Although St. Cyr was once the highest-paid burlesque dancer in the country, earning around seven thousand dollars a week, she ran out of money and husbands after six childless marriages. She started a mail-order lingerie business and sold her signature "Scanti-Panties," but that business didn't take off either. She lived out the rest of her life in virtual seclusion, several cats by her side, when she died alone in her Hollywood apartment at the age of eighty in 1999. In one of her last interviews, Lili raised eyebrows one more time, telling newsman Mike Wallace, "People need some loosening up. Most of the people in this country are too hypocritical. Underneath, we're all the same."

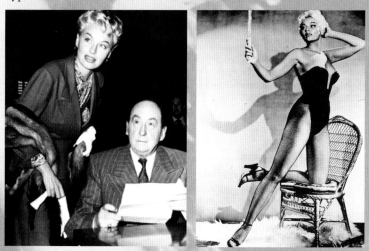

[left] Lili St.Cyr with attorney Jerry Geisler in court and [right] in character for a photo shoot.

Rich Beverly Hills Wife Slain

FIND VICTIM KILLED WITH AX IN HOME

Struck Down After Answering Doorbell In-Sister Said

BEVERLY HILLS, Feb 3 —Two suspects were taken into custody tonight in connection with the ax murder earlier today of Mrs. Katie Hayden, 71, wife of a millionaire land developer, in her $250,000 home here.

BONELLI IND IN RACKETS

Lie Test Traps Maid in
Beverly Hills Ax Murder

The murder took place at the Hayden home at 817 North Whittier Drive [top right].

1955

The Ax-Murdering Maid • Deadly Row Over Roast

As soon as Peggy King pulled the crispy browned roast from the oven, she sighed with relief. Her boss, the frail seventy-one-year-old Mrs. Katie Hayden, would most surely be impressed. King had only been on the job for three days; she'd been hired to cook and clean for the Haydens, a couple with a reputation for swiftly firing staff members who didn't perform well. In fact, one employee, Leon Bennett had just been let go two weeks before King started, because the Haydens didn't like his cooking.

Tonight's dinner had to be really good. King needed this job; the guy she had lived with for the last two years had just up and left her. She made a promise to herself to stay strong and never cry again, especially not over that creep.

The attractive twenty-four-year-old housekeeper carefully placed the hot slab of meat on a cutting board, the smell of garlic and caramelized onions mingling with the fragrant seasonings. She leaned in to take a deep whiff and allowed herself a small smile, savoring the moment. This job was a lifesaver; she was making good money working in a Beverly Hills mansion for one of the richest families around. Sam Hayden was a big-time developer; the newspapers said he'd built over three hundred million dollars worth of real estate. His wife seemed real nice, too; she was a bit sickly, but said she was feeling better these days, especially since the couple had just moved into this new house a few weeks ago.

Mrs. Hayden had told King during her interview that this was the couple's dream home, even though it was right across the street from the big mansion where Bugsy Siegel was murdered in cold blood. King glanced across the street; strange how the cops never found out who did it. She took a small, but sharp kitchen knife and gently sliced into the roast: perfection. It was tender and moist; pink and medium rare, just the way Mrs. Hayden liked it. That's right, King told herself; keep this up and soon you'll be getting that bonus pay for the big parties, like the Hayden's upcoming fiftieth wedding anniversary.

Mrs. Hayden stepped into the kitchen. King looked up with anticipation, expecting praise; but instead, she heard disappointment in her boss's voice. "Oh no, dear," said Mrs. Hayden, "that knife won't do the job. Go get something bigger to cut out the bone."

King walked to the broom closet and pulled out a small hand ax. She returned to the kitchen and gave the roast a firm whack. Hot liquid spurted out and flew across the room. "No, no," exclaimed Mrs. Hayden, wiping some greasy drops off her face and grabbing the little hatchet from King's hand. "Like this."

And with that, pretty Peggy King inexplicably snapped. She reached for that ax and began struggling with the old woman for control. A morbid dance of death had begun. "She continued arguing

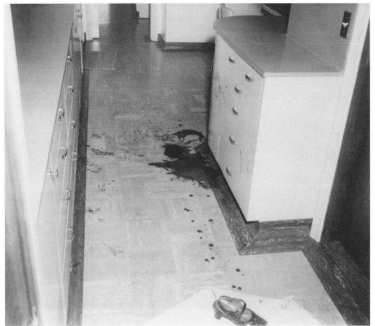

Investigators were able to lift fresh fingerprints off kitchen counters because the maid had cleaned on the morning of the murder.

with me, and then I just took the ax from her," King would later explain in courtroom testimony, "I struck her in the head. She didn't fall after I struck her once, and then I struck her again and again. I don't know how many times…"

Mrs. Katie Hayden, a multimillionaire's wife, mother of three and grandmother of two, lay dying on her new kitchen floor, brutally hacked. Bright red blood was streaming out onto the tiles King had just polished so carefully that morning; the crimson liquid now pooling up by the sink where that roast sat, cooling off, bone intact.

The coroner's report would state that Mrs. Hayden suffered at least thirty deep gashes to the head and neck area from a cleaver-like instrument, gaping wounds that looked like raw meat in the autopsy photos.

King stood and stared at the scene for a moment, then calmly wiped her bloody hands on a nearby dust rag. She took off her blood-splattered apron and along with the rag, threw them in the back of a closet. She turned, went

Peggy King tearfully embraces her brother, crying "I'm sorry, I'm sorry."

upstairs, and ransacked Mrs. Hayden's room, "I opened all the drawers in the dressers and scattered clothes to make it appear someone had broken into the house."

The maid returned to the kitchen, took a deep breath, closed her eyes, and let out a piercing scream so loud that six men installing a new sprinkler system outside came running. While waiting for police to arrive, King began dusting the house as if in a bizarre trance

At first, King thought she could get away with it. She suggested to investigators that the killer might be Leon Bennett, the cook recently fired by the Haydens. Police arrested Bennett, who vehemently denied the charge. Lie detector tests were given to all employees. Bennett passed. King failed, miserably. She buckled under pressure, finally admitting she had, indeed, killed her lady boss with an ax.

A jail psychiatrist pronounced King mentally and emotionally stable; she was ordered to stand trial. The case was heard without a jury. Her attorney suggested a plea of self-defense, and King testified she was afraid Mrs. Hayden was going to hit her with the ax. When the judge questioned how a little grandmother could have frightened her so, King was cornered. She broke her promise to herself and began crying, and then sobbing as she choked out the words, "I just can't understand what happened. She was so nice to me." King was sent to prison, her sentence: five years to life.

But that's not the end of this story. Mr. Hayden would make the headlines one more time for another incident that occurred three years later in a new home that he had built—this one for his new wife, Ann. The couple had only been living in the house for six days when two masked gunmen entered the home, walked into the couple's bedroom and ordered them to be quiet while they ransacked the house, stealing a hundred thousand dollars in jewels.

The culprits were quickly arrested; front-page photos showed the couple in their silk pajamas and slippers holding up a phone cord cut by the bandits. A reporter wrote the perfect one-liner for the family saga: "New homes appear to be a jinx for Samuel Hayden."

Samuel Hayden and his new wife Ann were victims of a burglary in their new home; perpetrators had cut the phone cord.

1955

The "Fur King" Al Teitelbaum Case • Tenor in Trouble

In an era when furs were elegant to wear, the most coveted coats were the slinky minks from the Teitelbaum Furs store at 414 North Rodeo Drive. Owner Al Teitelbaum was a genius at marketing. The press dubbed him "Furrier to the Stars," noting with glee that his store walls were lined not with wallpaper, but with mink. And that furry lingerie on display? Genuine ermine and real chinchilla.

Movie studios loved Teitelbaum too; his luxury fur-rental program was novel and budget friendly. Starlets were grateful as well. They couldn't afford to buy a signature ten-thousand-dollar "Black Mist" mink, but they could afford to rent one for a night, looking like fur-wrapped Cinderellas at their movie premieres. They all wanted to look as exquisite as Marilyn Monroe did when she covered up her famous cleavage with one of Teitelbaum's snow-white mink stoles, lined with triple-pleated ivory silk.

About the only thing Teitelbaum enjoyed more than draping an icon in one of his sixty-five-thousand-dollar black Russian sables, was socializing with the celebs. When the once-famous superstar singer Mario Lanza was down on his luck and in a career slump, he came to his friend Teitelbaum for help; would the furrier consider buying back the furs Lanza had bought for his wife? The operatic tenor was in serious financial trouble—he'd squandered his fortune and had failed miserably at an attempt to become a pop-singing movie star—and now the IRS was after him for back taxes.

Teitelbaum sensed an opportunity. Maybe he could make some money by resurrecting the singer's career; after all, Lanza had been RCA's best-selling artist at one time. A 1951 *Time* magazine cover called him "The Voice of the Century." He made the singer a deal: not only would he buy back the furs, but he would also loan Lanza some money to pay his bills. In exchange, Teitelbaum would become Lanza's personal manager and do for him what he'd done for the fur business: market him to success.

Lanza happily accepted the offer. His career was cold as ice; maybe the furrier could warm it up. Unfortunately, Lanza wasn't the cash cow Teitelbaum had hoped for. The singer was a wreck, struggling with extreme weight gains and losses, showing up drunk at the big comeback event that Teitelbaum set up in Las Vegas. There would be no prosperous payday.

The fur business wasn't what it used to be, either. Demand was down, and soon Teitelbaum found himself in need of money. While he

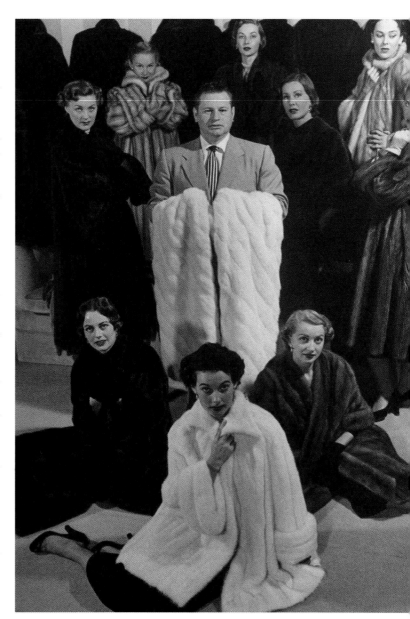

Teitelbaum claimed more than two hundred furs had been stolen from his shop. He is surrounded by models ready for a magazine photo shoot.

BEVERLY HILLS CONFIDENTIAL

68

never would have sold fake furs, it apparently did occur to him to engineer a fake robbery and collect hundreds of thousands in insurance money. Teitelbaum hired a few con men to help pull off the phony heist. They broke into the store and loosely tied up Teitelbaum but didn't even bother to take any furs; instead, they hid the coats by wedging them between others in a storage room.

Ironically, it was Lanza who inadvertently helped put Teitelbaum behind bars. The night of that alleged robbery, the singer had stopped by to see his pal. "Al, you in there?" he shouted, knocking on the front and back doors. "It's me, Mario!" At Teitelbaum's trial, Mario testified that he saw no sign of any getaway trucks or bandits who were supposedly robbing the shop of some 230 furs worth around three hundred thousand dollars.

At his trial, Teitelbaum refused to testify on grounds of self-incrimination. Nevertheless, the furrier was found guilty and sentenced to one year in jail. He told anyone who would listen that he'd been framed and was totally innocent. "The charges are bunk," he exclaimed. "Hokum!"

Teitelbaum eventually closed down his store and moved to Oregon, where, by all accounts he lived an exemplary life. But his shady past reared its ugly head again in 1999, when writer James Ellroy wrote a salacious story about a fur salesman and bogus burglaries. Teitelbaum slapped Ellroy with a twenty-million-dollar lawsuit for invasion of privacy. It was dismissed.

But Teitelbaum's darkest moment didn't come until the following year, when his son, the most successful Teitelbaum of all, passed away. Ronn Teitelbaum was the founder of the famous and very successful Johnny Rockets hamburger restaurant chain. He was sixty-one when he died of brain cancer.

Al Teitelbaum lived to the age of ninety-six; he died in May 2011. In his last brush with publicity, in 2005, he was interviewed on the radio and shared several stories about his glory days in Beverly Hills, including how tycoon Howard Hughes bought furs for each of his starlet lovers. In one year alone, Hughes purchased two dozen coats. Teitelbaum also shared his tragic connection to blonde beauty Carole Lombard, the actress who was the love of actor Clark Gable's life. She died in a plane crash at the age of thirty-three. "She was wearing my mink coat when they found her body," Teitelbaum said sadly, traveling back in time to the Golden Age of Hollywood—that time long, long ago when the name Teitelbaum meant only the best.

Teitelbaum's wife Sylvia hugs her husband after the verdict.

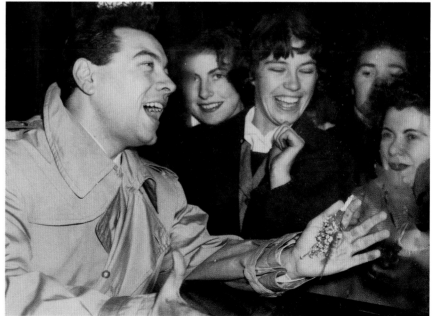

Mario Lanza, thirty-eight years old, died suddenly of a heart attack shortly after Teitelbaum's trial. Five months later, Lanza's wife passed away of a suspected drug overdose, orphaning their four children, who were raised by Lanza's parents.

1958

Actress's Lover Knifed to Death ♦ A Mother/Daughter Whodunit

The arrow indicates the location of the bedroom in the Turner home where Johnny Stompanato was found.

Movie star Lana Turner was the reigning sex goddess at M-G-M studios. Her on-screen appearances were sizzling and so was her private life—married eight times to seven men. The actress had just one child, daughter Cheryl Crane, who spent much of her time at her father's house or at boarding schools, leaving Lana with lots of time for romance. In between marriages, Lana fell hard for the handsome Johnny Stompanato, a local gigolo known not only for his prowess as a lover, but also because of his ties to the mob and gangster Mickey Cohen. The love-struck Lana didn't care about Johnny's reputation; he made her feel things she'd never felt before, and thus the two began a torrid affair.

But the relationship became volatile and abusive. Lana occasionally wore sunglasses to hide bruises on her pretty face. Hot-blooded Johnny Stompanato became even more menacing when he found out Lana wasn't taking him to the Academy Awards, Hollywood's biggest night; he was good enough to be in her bed but not on her arm? The arguing was relentless. Finally, Lana's mother called police to report that her daughter had become terrified of "this hoodlum Stompanato" and wanted to know what could be done. The police chief advised her to come in immediately with Lana and file an official complaint; they never did. Exactly one week later, the couple would have their last argument.

[above] Lana Turner and her fourteen-year-old daughter Cheryl Crane flank Stompanato at the Los Angeles Airport. [left] Mother and daughter conferred with their attorney Jerry Geisler.

On Good Friday, April 4, 1958, around midnight, police were called to Lana's home at 730 North Bedford Drive. Inside the star's nearly all-white bedroom, officers found Johnny Stompanato face up on the carpet, dead—stabbed with a knife; a major artery had been severed. Oddly, Lana's attorney, Jerry Geisler, was already at the scene.

"Cherie killed Johnny," Lana told investigators between sobs, "He threatened to kill me, and poor Cherie got frightened." The trembling teenager told investigators she ran to the kitchen after hearing the violent argument and grabbed a butcher knife—determined to protect her mother. "I didn't mean to kill him, I just meant to frighten him," Cheryl told the chief, before she was taken into custody and placed in juvenile hall.

A sensational, three-week trial followed. Lana's testimony on the stand was described by many as the best performance of her life. She broke down twice while defending her daughter and spoke in barely a whisper as she tried to explain to the judge why she stayed with a man who abused her, confessing it was something even she couldn't understand. The murder was ruled a justifiable homicide,

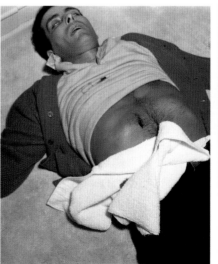

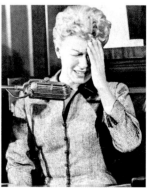

Turner testified in court that Stompanato "grabbed his stomach, walked a little, half turned and fell. He didn't talk, just kept gasping."

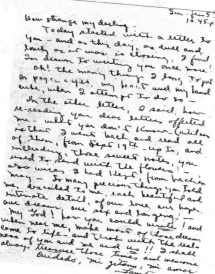

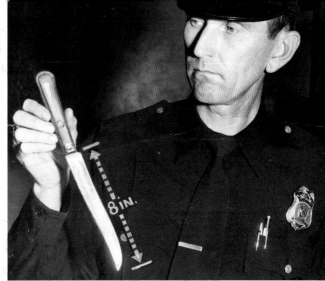

Turner, known as "The Sweater Girl," signed this love letter [above] to Johnny with his pet name for her: Lanita.

An officer displays the weapon found at the scene of the crime.

Cheryl was released and sent home.

Rumors persisted that Lana Turner herself had murdered Johnny in a fit of rage, because she found out he'd molested her daughter, and that Geisler had talked her into letting Cheryl take the rap since the teen would be less likely to be found guilty. While there's no hard evidence to support that theory, there are two facts that conspiracy theorists point to:

1. Police Chief Anderson noted in his biography that on the night of the murder, "Although [Lana's] voice shook slightly, she appeared to be a remarkably composed woman under the circumstances."

2. In unpublished FBI files, letters Cheryl Crane wrote to Johnny Stompanato reveal a young woman who has some kind of a special relationship with her mother's lover: "Love ya and miss ya loads," wrote the teenager to Johnny, "Write soon, be good."

Crane is now an author and real estate agent living in Palm Springs. She admits one of her mother's husbands abused her, but she says Johnny never did. Stompanato's death, she insists, was really just a freak accident, "Nobody wants to believe the truth. I was the only one there, and I had to do something. John was coming toward me, I stepped through the door and he ran into me, literally ran into the knife."

Cheryl Crane also says that she and her mother weren't really close until later years, and that shortly before her mother died, in 1995, at the age of seventy-four, Lana thanked her for the first time for killing Johnny. She also told Cheryl she was glad her daughter had finally found what she never could: a long and happy relationship. (Cheryl celebrated her fortieth anniversary with her partner, Josh LeRoy, a former model and girlfriend of actor Marlon Brando.)

Shortly after Stompanato died, someone turned in to the police a wooden box that had belonged to the playboy. Inside, police found photos of several women—wives of attorneys and doctors and other socially prominent men. Apparently Stompanato, a lover of ladies, was a blackmailer as well. In a never-published police report, a detective revealed the women claimed they'd been drugged and photographed in the nude. The detective noted, "The Chief and I decided after interviewing third parties that it would serve no purpose to…possibly ruin marriages." The photos were destroyed. The closing line in the report reads: "In my opinion, Cheryl did society a favor in disposing of Stompanato."

CLARK FOGG'S ANALYSIS:

A fourteen-year-old takes down a mobster with one blow? Highly suspect, and it's very unlikely that "he ran into the knife." There was not a lot of blood at the scene, most likely due to a major internal injury. The knife used had a very long blade, which means the weapon was plunged into Stompanato with force. It's very possible that Cheryl brought the knife into the room, but it was soon taken away from Cheryl by her mom, who then plunged it into Stompanato. (Possibly explaining why the blade was upside down when it was used to stab Stompanato). If Cheryl was "just holding" the knife and Stompanato ran into it, the wound would have been much lower on Stompanato's torso area. Those letters in the FBI file from Cheryl to Stompanato are quite interesting. Maybe Lana Turner was angry or suspicious that something was going on between Stompanato and her daughter? I think with today's DNA technology, if we had that knife, we'd find Lana Turner's DNA all over it.

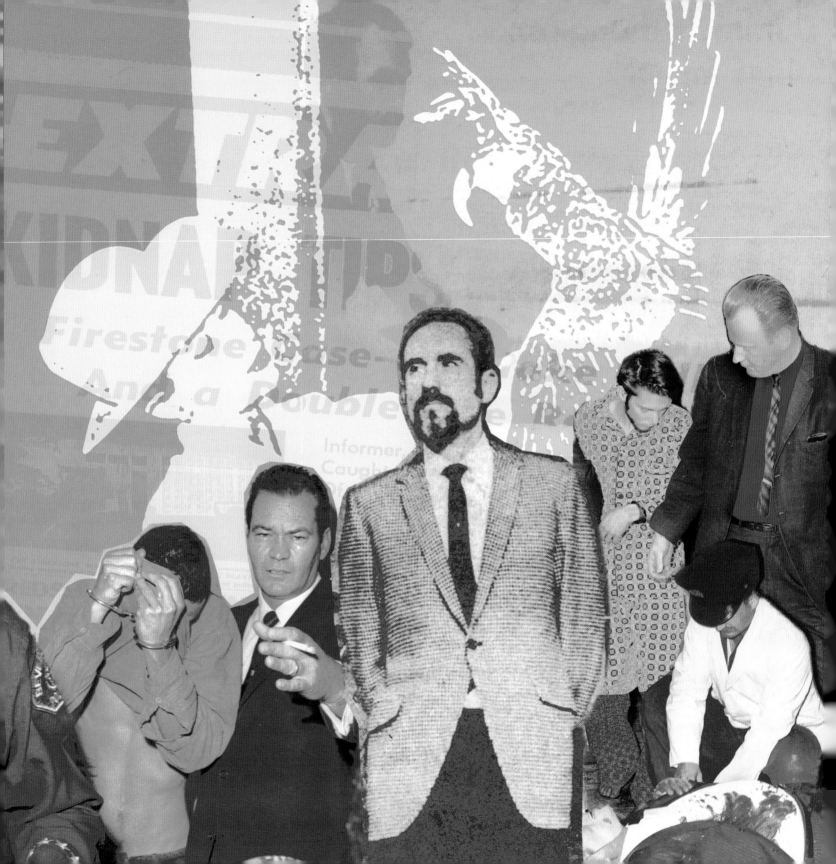

THE TIMES THEY ARE A-CHANGIN'
The 1960s and 1970s

The winds of change are blowing across Beverly Hills—the Pacific Electric Railway trolley cars are dismantled in 1965 and the city's bridle path is paved over. Several of the supersized mansions built in the 1920s and 1930s are being torn down, and properties are subdivided.

Over on Rodeo Drive, more high-end stores appear, like Gucci. Hairdressers named Vidal Sassoon and Gene Shacove (he inspired the character in the movie *Shampoo* [1975]) take the town by storm, becoming quasi-celebrities themselves. Speaking of celebs, superstar Doris Day can be seen riding around town on her bike, and the new hotspot in town is The Daisy, a private club where new and old Hollywood like to mingle.

Big changes at the police department too: crime-fighting equipment is getting more sophisticated; radar units are mounted inside patrol cars. The police chief reports that his officers are noticing a shift in illegal activity: fewer crimes of passion, more crimes of opportunity, and an increase in narcotics-related cases.

One of the most shocking (and not widely talked about incidents) involves popular athletes at Beverly Hills High School. The players have fallen prey to professional drug dealers who recruit them to sell marijuana to fellow students. The high school boys receive a most unusual reward: all the free sex they want from prostitutes who are kept in a residence across from the high school. The operation is quickly shut down after an anonymous tip to the police department.

Nearby at the Friars Club, a card-cheating scandal has been exposed. Swindlers drill peepholes into the ceiling and use signaling devices disguised as burglar alarms to let their fellow scammers know what cards to play. Several customers are fleeced out of as much as one hundred thousand dollars, including big names like Dean Martin and millionaire shoe-store mogul Harry Karl. Karl, who is married to

actress Debbie Reynolds at the time, has gambled away much of her fortune. (More bad-husband behavior for Ms. Reynolds. She already has endured a humiliating divorce from first husband, Eddie Fisher, who left her for actress Elizabeth Taylor.)

Other stars blazing through the headlines during these decades include popular singer Vic Damone, who is arrested in 1964 for "kidnapping" his own nine-year-old son. The arrest warrant is prompted by accusations from Damone's ex-wife, the beautiful, Italian-born actress Pier Angeli. The couple has been embroiled in an ugly and highly publicized custody battle that took years to settle. Then, tragically, Angeli dies in 1971, at the age of thirty-nine, of an accidental barbiturate overdose. She had just been chosen to play a part in *The Godfather* (1972).

Jan Berry, half of the surf-music sensation Jan and Dean, nearly dies in a horrible car accident two years after the duo wrote a song about a crash called "Dead Man's Curve." In 1966, Berry smashes his Corvette Sting Ray into the back of a parked truck on Whittier Drive, just north of Sunset Boulevard, a few miles away from the spot the song refers to. Berry, twenty-five years old, suffers severe brain damage and partial paralysis; his recovery is slow and painful.

Aging actress Barbara Stanwyck finds herself in a pickle with police. Stanwyck, the star of the classic film *Double Indemnity* (1944), sets her silent alarm off three times one night. The same officer responds each time, but finds nothing. As he walks out the door, the actress grabs him and both tumble onto the bed. "I got off that bed fast—I'm a married man," the shocked officer told his boss. "Then I got the hell out of there!"

In 1968, actor Nick Adams, the popular star of the TV series *The Rebel*, is found dead in his Roble Lane home in Beverly Hills. The medical examiner finds no alcohol in the actor's bloodstream, but does find sedatives and other drugs in his system. Did the thirty-six-year-

old want to die, or was it an accidental overdose? The death certificate merely states: suicide, undetermined.

Another sign that perhaps the most magical era of Beverly Hills has drawn to a close: Police Chief Anderson retires in 1969 after a forty-year career with the department. It will be a while before the city sees such dedication and longevity again. In the 1970s alone, three chiefs of police come and go, including Joseph Kimble, the first top cop hired after Anderson. Kimble is barely in office before he falls into disfavor with city leaders for making bad decisions, like the time he doesn't ask for the council's permission to participate in security operations at the New York rock festival, Woodstock.

Some of those big-name stores on Rodeo Drive are making national news. Tiffany & Co. is hit by five jewel thieves who get away with about $250,000 worth of gems. The culprits are all apprehended, but much of the loot remains unaccounted for.

Over at the swank Giorgio boutique, Louise Lasser, spacey star of the hit TV show *Mary Hartman, Mary Hartman,* is arrested on a felony narcotics charge after getting into a fight with store clerks over a purchase. Lasser, a former wife of writer/director Woody Allen, claims somebody gave her the vial of cocaine and that she has absentmindedly thrown it in her bag.

Beverly Hills is no longer a haven for just rich-and-famous Americans. Big changes are occurring half a world away that drastically shift the makeup of the population. The late 1970s mark the beginning of an influx of Iranian immigrants. The Middle-Eastern expatriates are troubled by the state of affairs in their own country where a revolution is taking place, and Shah Mohammad Reza Pahlavi is about to be overturned. When the shah's sister quietly moves into Beverly Hills and his ailing mother arrives to visit, anti-shah protestors storm the gates of her Calle Vista Drive estate. "These are criminals...living in mansions in Beverly Hills," says a spokeswoman for the crowd, mostly made up of students, "If they'd stayed in Iran, they would have faced trial." The furious mob sets several small fires around the manor and shatters windows. Police use tear gas to drive back more than five hundred protestors. The

shah's sister escapes out the back of the home carrying bags reportedly stuffed with cash.

The demographics may be changing, but one thing remains constant: this city of glitz is filled with scandalous stories that can only be found in Beverly Hills.

Debbie Reynolds poses with husband Harry Karl.

[above] Jan Berry (left) survived this car crash.

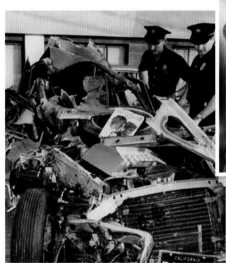

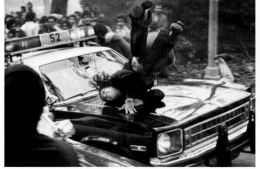

Anti-Shah demonstrators stop a sheriff's vehicle while the more peaceful carry signs reading "Shah is a Fascist Butcher."

Pier Angeli enjoying the moment with husband Vic Damone.

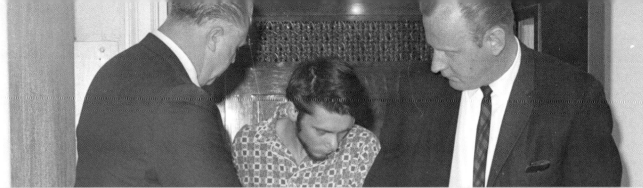

Police say Gary Livingston "went beserk" because his parents were "bugging" him.

1965

Cinderella Songwriter and Wife Shot By Son • Barricades and Bullets

Three-time Oscar-nominated composer Jerry Livingston was famous for his lighthearted, fun songs like "Bibbidi-Bobbidi-Boo" from the movie *Cinderella* (1950) and the children's classic "Mairzy Doats." One of his earliest hits was "It's the Talk of Town," and his family became exactly that when he and his wife were almost killed by their son.

Gary Livingston was still living at home at age twenty-one. He had "mental issues" according to news reports, and his temper could be triggered by the smallest slight. His mother explained to friends that her son was just trying to find his place and purpose in life; not to worry, the family could handle it. Besides, her son was seeing a doctor, and he appeared to be much better. If only a mother's love could make everything right.

On February 17, 1965, young Livingston had slept in again. It was almost noon. Exasperated, Ruth Livingston asked her husband, "Can you check on him this time?" She was tired of struggling with her son. "He still hasn't picked up his room."

"Of course," said Jerry Livingston. They'd been after their son for weeks to straighten up his mess. The elder Livingston climbed the stairs, knocked on the door, and walked in.

The young man was still in bed. He ignored his dad's order to get up and clean his room. His dad wouldn't leave him alone, kept hassling him like a broken record: Gary, do this; Gary, do that; do what we ask, Gary. Sick of his parents' constant nagging, he'd had enough. He stared at his father then wordlessly turned away. Instead of picking up the clutter, Gary Livingston picked up a pistol that he'd taken from his father's gun collection and took aim.

"Gary, no!" screamed his dad, but it was too late. He pulled the trigger; this was how he would get his father to shut up. A flash exploded. Hot pain seared through Jerry Livingston's arm, "Ruth, oh my God, Ruth, he shot me!"

His wife raced up the stairs, unaware she was now in the line of fire. Gary aimed at his mother's heart and fired. His aim was off. Shell-shocked, but alive, his parents turned and fled, racing down the stairs, away from their child, out the door. Ruth didn't make it far; weak and bleeding, she fell by a tree. Her husband ran to the neighbor's house and called police.

Within minutes, an ambulance arrived. Paramedics pulled Jerry Livingston onto a gurney. Next, they raced over to his wife. Her pure white sweater was stained with a slowly expanding bright red circle of blood. But instead of asking officers to stop her suddenly homicidal son, Ruth Livingston was begging them not to hurt him, "He didn't mean to do it," she whimpered.

"Where is he, ma'am?" asked an officer.

"Upstairs," she hesitated. "His room is upstairs. Please don't hurt him; he's not well!"

The shooter barricaded himself on the second floor. More officers arrived and surrounded the house. Two cops cautiously entered the home, calling to him, telling him to come out. Instead, he began shooting again. This time he fired four shots from behind his closed bedroom doors, two blasts from a rifle, two from a shotgun.

Police retreated; time for a new tactic to flush out the kid. They lobbed tear gas canisters through the windows, but those either malfunctioned or missed their mark; the young man stayed put. Hours later, Gary was finally talked out of the home and staggered out the front door, hands over his head. He was escorted into a squad car and taken to the prison ward of the county hospital. His parents chose not to press charges against their son.

Jerry and Ruth Livingston recovered from their wounds. Their son continued seeing doctors for his emotional problems. The family never spoke publicly about the incident again, but on a website dedicated to Jerry Livingston's music, the couple's other son posted a photo of a smiling family with a caption that says Gary passed away. The picture was taken in 1980 on the night Jerry Livingston was inducted into the Songwriters Hall of Fame.

1966

TYCOON KIDNAP PLOT BACKFIRES ◆ INFORMANT KILLED

If this story were a movie, the closing scene would be the dramatic last moments of a police informant dying in an officer's arms, and it would have played out like this:

The informant lay on the mansion's marble floor, gasping for his last few breaths. "What went wrong?" he implored, clutching the arm of the police officer kneeling next to him.

The detective put down his smoking gun then reached out to comfort the soon-to-be dead informant. "Why didn't you hit the deck?" he asked softly.

George Skalla hesitated, gathered up every last little bit of life left in him, and managed a few final words. "I…I…I froze," he sputtered. And with that, Skalla—a twenty-five-year-old, former first-string football tackle, turned small-time criminal, turned police informant—was dead. So was his partner-in-crime, forty-four-year-old ex-convict Calvin Bailey. Bailey's lifeless body was just a few feet away from Skalla's, a grotesque plastic Halloween mask still on his face, blood seeping out of bullet holes in his chest. Four police officers stood over him. Such a shame, this was not at all what they had planned. No one was supposed to get killed.

The whole saga started when Skalla recruited Bailey to help him with his latest plan to kidnap a rich guy. The two daredevils decided to kidnap multimillionaire Leonard Firestone, of the wealthy tire-manufacturing family. Bailey was in his glory planning the big payday, he kept nattering on about how the ransom demand should be two million—then four—no, he decided, maybe they should go for eight million? Skalla was scared by Bailey's intensity and began wondering if this greedy bastard might kill him once they got the payoff.

Skalla had a "Come to Jesus" moment—he told his mother he was tired of being on the wrong side of the law. He turned himself in to the police, not only telling them about the kidnapping plans, but also confessing to more than fifty unsolved robberies in Beverly Hills and Los Angeles. Detectives were elated, and they gladly recruited Skalla as an undercover operative, asking him to help snare Bailey. They carefully planned a sting operation. On the night of the kidnapping, January 13, 1966, Skalla was to bring Bailey to the mansion, and once the maid (an undercover policewoman) let them in, Skalla would hit the deck, and

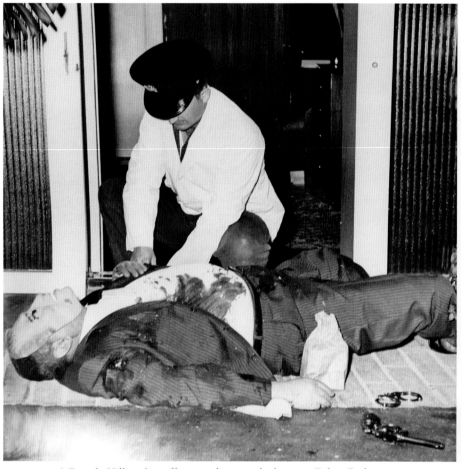

A Beverly Hills police officer tends to masked victim Calvin Bailey.

officers would step in and apprehend only Bailey.

Skalla was given a special undercover car: a 1965 black sedan equipped with a tape recorder in the trunk and a microphone hidden in the dash. He could press a tiny button and record everything his partner said during the crime.

[left] Police inadvertently shot and killed their informant, George Skalla and his partner-in-crime, Calvin Bailey [right].

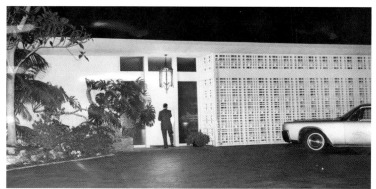

Industrialist Leonard Firestone's family left their Alpine Drive home for a week so police could remain on site.

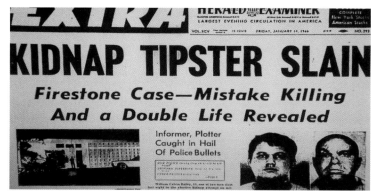

The kidnappers planned to ask for a two-million-dollar ransom.

A few days before the event, police moved the Firestone family out of their mansion on North Alpine Drive. On the day of the kidnapping, four officers moved into the house. Skalla secretly placed a call; he and Bailey were about to leave his house to go to Beverly Hills.

The sun had just set. Skalla and Bailey got into the sedan. Bailey threw a mask, gloves, rope, tape, knives, and guns in the backseat. A few miles before they reached their destination, Bailey got out of the car and entered a phone booth to call the Firestone house, just to be sure the millionaire was there. Skalla pressed the little button on the dash and whispered into the microphone, "He's making a phone call to Firestone now."

Bailey got back into the car and told Skalla, "Firestone's there. I just talked to the maid; she told me he's working on the garbage disposal. Guess he's throwing Coke bottles down there."

Bailey had misunderstood. What the maid/undercover cop actually said was, "Mr. Firestone is indisposed," not "Mr. Firestone is in the disposal."

The two criminals drove up to the mansion, stopping at the far end of the drive, lights and engine off. Bailey pulled on the full-face mask, and Skalla put on just a hat, heart pounding now. He'd be the one doing the talking. The duo grabbed their guns and stepped up to the front door, Bailey off to the side, and Skalla in front of the peephole. "Parcel Post delivery, ma'am." The door opened, and, suddenly, the carefully orchestrated plan went haywire.

"They moved in fast and saw us," maintained an officer. "Bailey raised his gun and pointed it at us. They were prepared to shoot us. We shot first."

"Skalla kept coming," said another detective, "They were bunched right together. He was going to jump aside, which he did not do. He didn't jump aside, and that was it."

Neither Bailey nor Skalla ever fired a single bullet. Caught in the cop's rapid-fire barrage, Bailey was killed instantly, taking direct hits to the chest, heart, and lungs. Skalla was hit by ricocheting bullets and lingered for several minutes until he succumbed from wounds to the neck and gut. A full investigation and hearing into the shooting was launched; the coroner's jury ruled the officer's actions as justifiable homicide.

Skalla's family was now burying their son instead of hailing him as the hero he had hoped to be. His mom wept to reporters, "George said, 'Mom, I'm officially connected with the police department now. Don't worry, I'm doing something for society—not against it.'"

CLARK FOGG'S ANALYSIS:

This was such an unfortunate incident and an example of what can happen when the best-laid plans go awry. It's always tricky when individuals are working with the police department. Detectives can only protect their informant to a certain point; when officers and other individuals are at extreme risk, police have to respond. Informants are not trained police officers. They don't have the skills and tactics to handle adverse conditions, especially those involving firearms. In this attempted kidnap, the informant froze, then followed the other suspect's lead. It's possible the detectives on site thought the informant changed his mind and aligned with the suspect.

L.A. KIDNAP

EXCLUSIVE!

FBI, Grand Jury Link Ex-IRS Man

$250,000 Ransom Paid In 1967 Case

Los Angeles County grand jury today was asked to indict a former Federal Internal Revenue agent as a suspect in the 1967 kidnapping of a Beverly Hills boy, for whom $250,000 ransom was paid.

The money—all in $100 bills—was paid by Herbert J. Young, president of Gibraltar Savings & Loan Association, for the release, unharmed, of his son, Kenneth, then 11. Authorities have never announced whether any of the money was recovered.

The Herald - Examiner learned exclusively that evidence largely compiled by the Federal Bureau of Investigation will be presented against Ronald Lee Miller, 38, on the Internal Revenue staff here until his arrest last October. He lived in Van Nuys.

Miller is held in County Jail on bookings of armed robbery and kidnapping for ransom, unable to raise $18,850 bail. He was arrested last Oct. 18 by Alhambra police on a warrant charging holdup of a supermarket. He had worked for the government since 1964.

Miller was then a Federal employe. He was discharged after his arrest.

[above] Kenneth Young points to a Los Angeles Herald-Examiner *headline.*
[right] Young's kidnapper, Ronald Miller, a former makeup artist, was a master of disguise.

OTHER HIGH-PROFILE KIDNAPPINGS

1967 ELEVEN-YEAR-OLD SON OF CEO KIDNAPPED

When eleven-year-old Kenneth Young's parents came home late from a party one night, they took a quick look into their four children's bedrooms. All was well. Imagine their horror the next morning when Kenneth didn't come down for breakfast. He had been kidnapped from his first-floor bedroom in the middle of the night, a ransom note pinned to his pillow. "Do not call the police, or your missing merchandise will be vindictively destroyed," warned the abductor. "We need $250,000."

The boy's father, Herbert Young, president of Gibraltar Savings and Loan, notified police and the FBI. Agent Paul Chamberlain successfully negotiated the recovery of the child who was found unharmed, four days later. But it took three years to track down the kidnapper, Ronald Lee Miller, a former IRS agent whom authorities said led a triple life. By day, Miller was a federal agent, working not only for the IRS, but assigned as a bodyguard to politicians, like President Nixon. By night, he was "a swinging ladies' man." But his full-time obsession was getting away with crimes: the kidnapping and several robberies.

While Miller may have been slick, he was not lucky. One of his accomplices snitched on him, and three days before a statute of limitations on the kidnapping charge ran out, FBI agents arrested Miller. His bad luck continued when he was released from prison after doing thirteen years—he was murdered while jogging around a track in Sacramento, his skull crushed and his ribs broken. His killer was never caught.

KIDNAP BOY RESCUED

[above left] Little Stanley Stalford was back in the safety of his father's arms after a wild predawn car chase. Kidnapper Robert Dacy [right] was arraigned while he was in the hospital.

1968 Four-year-old Son of Banker Kidnapped

What would you do if a kidnapper tied you up and was about to take your baby away? Little Stanley Stalford's mom deserves a mother-of-the-decade award for what she did when that happened to her. "It's a game, Honey, a burglar game," she said as the kidnapper began to stuff her mouth with a gag. "Do what they want you to do." The abductor wanted a $250,000 ransom from the boy's father, Stanley Stalford Sr., the wealthy board chairman of Fidelity Bank. The FBI helped Stalford arrange a payoff meeting; the abductor brought the sedated child with him. But at the last minute, sensing a trap, the kidnapper sped off with Stanley, unbuckled, in the front seat. Officers and agents took off in hot pursuit; the twenty-eight-block chase ended in a spectacular gunfight and car crash. The child, slightly injured, cried, "I want my Mommy!" as officers pulled him from the car. The ex-con kidnapper, Robert Dacy, suffered a broken leg and lacerations. He was taken into custody at the crash site, sent to a hospital, and then to prison where he died several years later.

1969 Nineteen-year-old Stanford Student Kidnapped

Alan Ramo, son of multimillionaire missile expert and TRW founder Dr. Simon Ramo, stepped outside of his family's Trousdale Estates mansion on a Monday morning to feed some kittens. The little tabbies would go hungry that day. Alan was kidnapped by a masked gunman, taken to a nearby canyon and handcuffed to a tree. A $250,000 ransom note was left at the house by the front door. Meanwhile, back at the tree, Alan worked his gag loose, called for help, and was rescued by a city employee working nearby. Since the kidnapper had said he would return with food later that night, police set a trap. A detective took Alan's place at the tree, and when twenty-three-year-old John Jacob Santen showed up with a peanut butter sandwich later that evening, he was promptly arrested. Santen, a merchant seaman, was sent to prison. His mother told reporters, "I cannot explain my son's activities. I was flabbergasted."

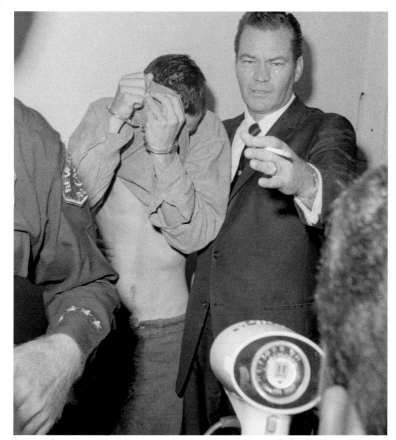

Twenty-five-year-old kidnapper John Santen was sentenced to life in prison for kidnapping Ramo.

1966

Frank Sinatra Polo Lounge Fight ◆ Millionaire In Coma

Iconic "Mr. Rat Pack" crooner Frank Sinatra was known for many things: his "cool" factor, his love life (especially the affair with the luscious actress Ava Gardner), and his rumored ties to the mob. Then there was the incident where kidnappers abducted his nineteen-year-old son, Frank Jr., from Harrah's Casino in Lake Tahoe. (Senior paid the abductors $240,000 and got his son back, unharmed. The kidnappers went to prison.)

But for all of this drama, the only time Sinatra was in legal trouble in Beverly Hills was when he stood accused of assaulting the president of Hunt Foods, Frederick R. Weisman. Sinatra claimed he never touched the man. But one fact the singer could not deny: Weisman was in a coma after undergoing cranial surgery, and his wife was receiving calls warning them not to press charges against Sinatra.

So what really happened the night of June 8, 1966? Picture a plush and darkened Polo Lounge at the Beverly Hills Hotel, a late Tuesday night about a half-hour before closing time. In one booth: Sinatra's entourage—his pal Dean Martin, a few more buddies, and some pretty girls. The drinks were still flowing; the conversation was loud and rowdy. In the next booth: Frederick Weisman was sitting with Franklin Fox. The two fathers were quietly celebrating the engagement of Weisman's son to Fox's lovely daughter, a former Miss Teenage Boston. Annoyed by the noise in the booth next to them, Weisman got up to leave.

What happened next, in a matter of just moments, was a blur: a struggle, a crash, fisticuffs. Dean Martin was overheard urging Sinatra "Let's get out of here! Let's get out of here!"

When police arrived, they found Weisman semi-conscious, flat on his back amid ashtrays, tablecloths, and broken crystal. He was taken to an emergency-care facility and released. When Weisman failed to wake up the next morning, doctors sent him straight into surgery.

Police interviewed several staff members who all gave similar accounts. They didn't see exactly what happened, but they did see a short struggle. So did Sinatra hit Weisman? Or did Weisman hit Sinatra then fall accidentally? None of the staff could say for sure, but the chief of security did confirm, "Sinatra had a mouse [bruise] under his right eye."

Given that Sinatra had a history of fist fighting, it wasn't a stretch to think he may have busted Weisman in the face. (Just the year before, Sinatra punched out a hotel owner in Pebble Beach during the Bing Crosby golf tournament after he and a friend—Dean Martin again— were told the kitchen was closed. No charges were filed in that case.)

Sinatra was photographed around the time of the Polo Lounge tussle.

But the bruised singer swore he never laid a hand on Weisman and denied rumors that he or one of his cronies beaned the millionaire with an ashtray or one of the phones that were at every table in the Polo Lounge. "He walked up to me and said 'You talk too f*#&ing loud and you have a bunch of loud-mouthed friends,'" claimed Sinatra. "I thought he was kidding, then I realized he wasn't. I told him, 'Hey Mister, you are out of line.' Then the man hit me. Another man jumped between us. I at no time saw anyone hit him, and I certainly did not."

Weisman eventually came out of his coma and recovered. He never filed charges against the singer, saying he wanted to just "forget the whole thing ever happened."

SINATRA STARS AS 'CHAIRMAN'

Sinatra Enterprises has entered into a co-production venture with Kennedy-Quine Productions on Jay Richard Kennedy screenplay, "The Chairman," to begin shooting in Washington in January.

Frank Sinatra will star. Kennedy, in addition to other associations, is a v.p. of Sinatra Enterprises and heads its story department, although he wrote "The Chairman" before he joined Sinatra.

Sinatra Case 'Closed' By District Attorney

The Frank Sinatra-Frederick R. Weisman incident has ended with district attorney's office stating, "No prosecution is indicated and the case is closed."

Deputy D.A. William L. Ritzi yesterday said there was "no evidence of a crime" in Weisman's injury at Beverly Hills Hotel's Polo Lounge June 8. Chief Deputy D.A. Harold J. Ackerman reviewed all records on case Tuesday and agreed with Ritzi's conclusion.

Ava Gardner called Frank Sinatra "the love of her life."

CLARK FOGG'S ANALYSIS:

While it's impossible to know for sure, after reading the files, I'd have to say I don't think Sinatra ever touched Weisman, but most likely Sinatra did take the first punch from Weisman. It's a known fact that Sinatra rarely went anywhere without protection. I think his mob buddies were with him that night, and they wanted to give Weisman "something to remember," a message not to mess with Frank.

Sandra West at road's end

One funeral spectator said thirty-seven-year-old Sandra West [above right] proved "You can take some of it with you."

1977
Buried in a Ferrari ◆ An Eccentric Last Wish

She never got the fame she craved in life, but in death, Sandra Ilene West made an everlasting impression. The young Beverly Hills millionaire was buried in a Ferrari, just as she had stipulated in her will, "next to my husband, in my lacy nightgown, and in my Ferrari with the seat slanted comfortably."

To discourage grave robbers, two truckloads of concrete were poured over the twenty-foot-long container cradling the high-performance vehicle with Sandra's body inside. Her husband, Ike West, was in the plot next to hers. He had been buried in the San Antonio cemetery nine years earlier. Finally, the couple was reunited. They'd both led a wild, but short, life together as man and wife in Beverly Hills.

Ike was only thirty-three when he died. His body was found in a hotel room at the Flamingo Hilton in Las Vegas. The coroner's report states he died of natural causes. Family and friends wondered if his early demise had anything to do with his health problems or history of drug use. After all, he and Sandra had been living life in the fast lane, thanks to Ike's millions. (Ike and his brother had inherited a fortune from their Texas-tycoon father, a cattle rancher and oil investor.)

Sandra was devastated when Ike died, but she carried on with style. The attractive widow, draped in furs and dripping with jewels, could often be seen cruising down Sunset Boulevard in one of her three Ferraris or a 1975 Stutz Blackhawk. Eventually Sandra retreated from the social scene and began staying home more. She had a few accidents in each one of the Ferraris, leaving them all slightly damaged. The last accident left her with serious injuries, and she began taking medication to control the pain. The night Sandra died, she told a nurse she had a stomachache and went to bed early. Sandra was found dead the next morning. The coroner's report lists the cause of death as an overdose from barbiturates and pain medication.

When executors read her will, they were shocked by her request, especially the instructions she left behind to make sure her unusual demands would be carried out. If her executor (her husband's brother) followed through with her wish to be buried in her favorite Ferrari next to her husband, then the brother would get her three-million-dollar estate. If he didn't do as she asked, he would only get ten thousand dollars. So the slightly dented baby-blue 1964 Ferrari 250 GT was shipped to Texas, where cranes and cement trucks were put into position. The staff carefully lowered the lady in the nightgown, in the car, in the super-sized coffin, into the ground.

One tiny mystery remained: was Sandra really buried in her favorite Ferrari? A woman who claims Sandra was her aunt blogged on a Ferrari fan site that Sandra was not buried in her car. The anonymous blogger posted photos of Sandra and personal information, including how everyone in the family knew Sandra's favorite Ferrari was her Daytona 365 GTS/4 Spyder, but that car was more valuable than the baby blue Ferrari. Did the executor of the estate switch Ferraris right before the burial? The blogger declined to discuss anything else about troubled family dynamics, saying only, "She led a helluva life," before signing off.

TV-news crews, reporters, and over one hundred people gathered to watch the bizarre burial, which was estimated to have cost fifteen thousand dollars. As the cement was being poured into the gravesite, a police sergeant holding back the crowd was overheard commenting, "I hope we don't have a wave of these funerals now. Next thing you know, someone will want to be buried in a 747."

The victims of the tragedy: [from left] Forty-two-year-old Joanne Cotsen, her fourteen-year-old son, Noah, and his sixteen-year-old friend, Christopher Doering. Doering's funeral [above].

1979

NEUTROGENA CEO's TRIPLE-MURDER TRAGEDY • A BITTER KILLER

Lloyd Cotsen, the president of Neutrogena Corporation, was reportedly in a taxicab in New York when he heard the news on the radio. A triple shooting had occurred in Beverly Hills in a house on the 900 block of North Bedford Drive. His wife Joanne, their fourteen-year-old son, Noah, and one of his friends, Christopher Doering, had just been found gagged, bound, and shot in the head, barely clinging to life. The killer was still on the loose.

Initially, it appeared to be a robbery gone wrong. Then came information that Joanne Cotsen had been serving on the jury for a trial involving the Iranian protestors; perhaps there was a connection. But as officers pieced together the stories of eyewitnesses — and discovered one key piece of evidence—they knew they had a different kind of maniac killer on their hands. It would take detectives six months and several overseas trips to far-flung locations like Paris and Brussels to finally crack this case.

Here's how the events unfolded according to never-before-published excerpts from police files. (One note: the Cotsens were renting out their guest house, and the young man who lived there, and his girlfriend, walked into the main house unexpectedly during the crime. Their names were not made public. In this report they are described as Victim 4 and Victim 5.)

On 5-23-79 Approximately 1245 hours, Victim 1 [Joanne Cotsen] left Beverly Hills Courthouse where she was a juror in a trial involving demonstrators arrested in connection with the Iranian student demonstration of 1-2-79.

At approximately 1415 hours, Victim 2 and 3 [Joanne's son Noah and his friend Chris] left school to go home and prepare for Hebrew school.

The suspect entered the residence probably around 1300 hrs,

confronted Victim-1, tied Victim with cord from residence. When Victim-2 and Victim-3 arrived…they were also confronted and tied. All Victim's were tied hand and foot and gagged after being placed on the living room floor.

The suspect then prepared for a long wait. (Possibly for Victim-1's husband who was due back from New York)

At approximately 1820, Victims 4 and 5 [the renter and his girlfriend] arrived and entered from a rear entry. As they entered the front…they were confronted by the suspect who was hiding in the adjacent powder room. Victim-4 and 5 were then taken to the living room and Victim-4 was tied with neckties and gagged. Suspect then walked Victim-5 toward rear bedroom. Victim-4 immediately freed his hands and feet and ran from the house for help. When the suspect heard Victim-4 slam door, he ran toward front of residence leaving Victim-5 alone. Victim-5 freed her hands and ran down a hall and through a glass door. As Victim-5 was running the suspect fired four rounds at her, all missing.

Suspect returned to living room and shot Victim-1, 2, 3 in the head. Suspect exited the residence via the front door and drove away in a vehicle belonging to the family.

Police, called to the scene by the renter, arrived around 6:30 p.m. Joanne Cotsen and the boys were taken to UCLA Medical Center, where she and Christopher Doering died the next day. Noah Cotsen died a week later. The renter and his girlfriend gave police a description of the murderer, saying he spoke with a Middle Eastern or European accent and

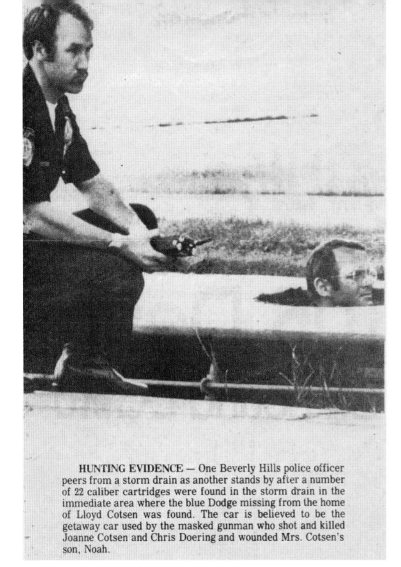

HUNTING EVIDENCE — One Beverly Hills police officer peers from a storm drain as another stands by after a number of 22 caliber cartridges were found in the storm drain in the immediate area where the blue Dodge missing from the home of Lloyd Cotsen was found. The car is believed to be the getaway car used by the masked gunman who shot and killed Joanne Cotsen and Chris Doering and wounded Mrs. Cotsen's son, Noah.

unusual scent was totally unique; there was nothing like it on the shelves in America. Cotsen came up with a marketing strategy that made the soap a huge success. The company changed its name to Neutrogena and became highly profitable.

Tali was livid. He felt his company deserved much of that money. He accused Cotsen of stealing international rights to sell the soap, but Cotsen owned the trademark and rights. Tali sued Cotsen unsuccessfully at least three times, growing angrier as years went by. A co-worker in Brussels told Beverly Hills police, "Tali contains enough hate to kill anyone associated with the American firm."

At one point, before the murders, Cotsen reportedly sent Tali a round-trip plane ticket to come to Los Angeles as a peace-making gesture. The angry businessman never used that ticket; instead he bought his own and made the surprise visit to Cotsen's house. When it became clear Cotsen wasn't home, Tali took the rest of the family hostage. Police believe he was waiting to kill Cotsen upon his return, and that when the backyard renters showed up unexpectedly, Tali's plan was foiled, so he killed the witnesses and fled.

Investigators were hot on his trail. Armed with DNA evidence from the ski mask and a sweater he left behind, plus the eyewitness testimony from the renters, detectives made a cross-continental flight and arrived to interview Tali at his home in Brussels. When they rang the bell, his wife opened the door, tearfully explaining Tali had killed himself just a few hours earlier.

In 1994, Cotsen sold Neutrogena to Johnson & Johnson. He took his millions from the sale and became a philanthropic retiree, giving away the riches that so infuriated his Belgian rival. As American inventor David Sarnoff once said, "Competition brings out the best in products and the worst in people." No truer words could describe this tragic story.

was wearing dark brown, pressed slacks and a ski mask. Officers found the stolen car just four blocks from the residence in a storm drain.

Investigators also discovered a small, brown, pharmaceutical bottle left in the powder room where the suspect had been. It contained chloroform. All the victims had been subdued with the chemical. Police had hit the evidence jackpot. The bottle was made exclusively at just one factory in Brussels, which happened to be where one of Cotsen's bitter business rivals worked, one who had just recently made a trip to Beverly Hills: Erich Arnold Tali.

Tali, forty-six, was married to a woman who had inherited a company that made a special soap called Neutrogena, a soap that Lloyd Cotsen had purchased the rights and trademark to some twenty years earlier when he was looking for ways to grow his father-in-law's beauty products company. The translucent, amber-colored soap with the

CLARK FOGG'S ANALYSIS: This is an excellent example of a crime where physical evidence left at the scene solved the case. It was a combination of trace hair fibers, fingerprints, and other physical evidence that collectively led investigators to a viable suspect. Also key: the victims were tied-up for a substantial time with no ransacking or sexual assaults taking place. This indicates there was a suspect-victim relationship of some kind. The investigation took the form of "the funnel format"—where detectives start by carefully investigating many aspects of the victims' lives, subsequently reducing the facts down to identify the suspect.

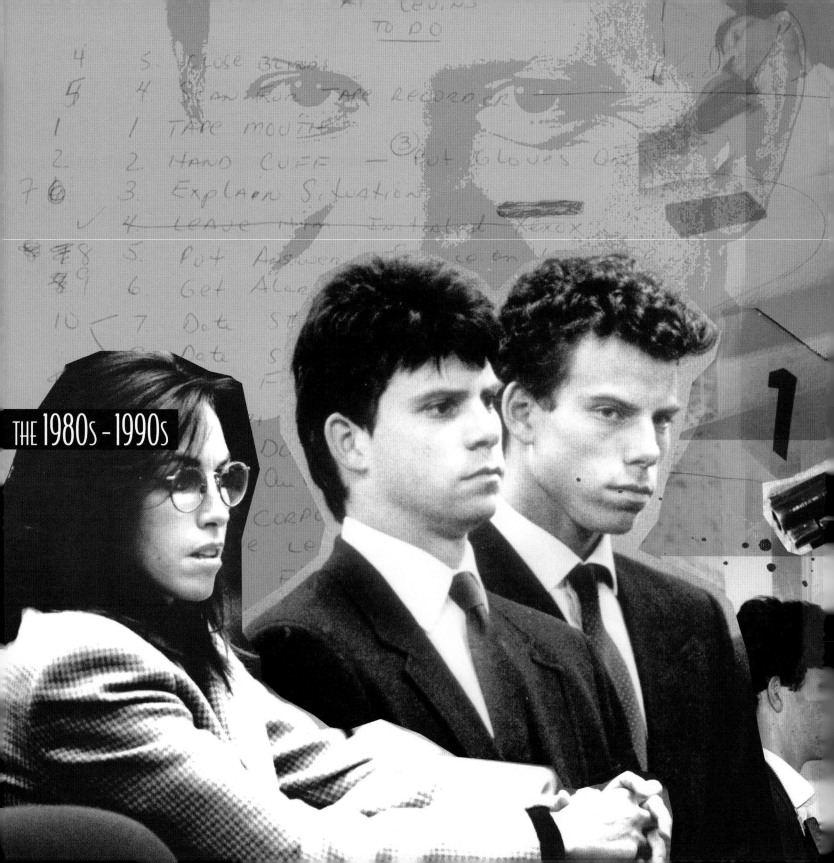

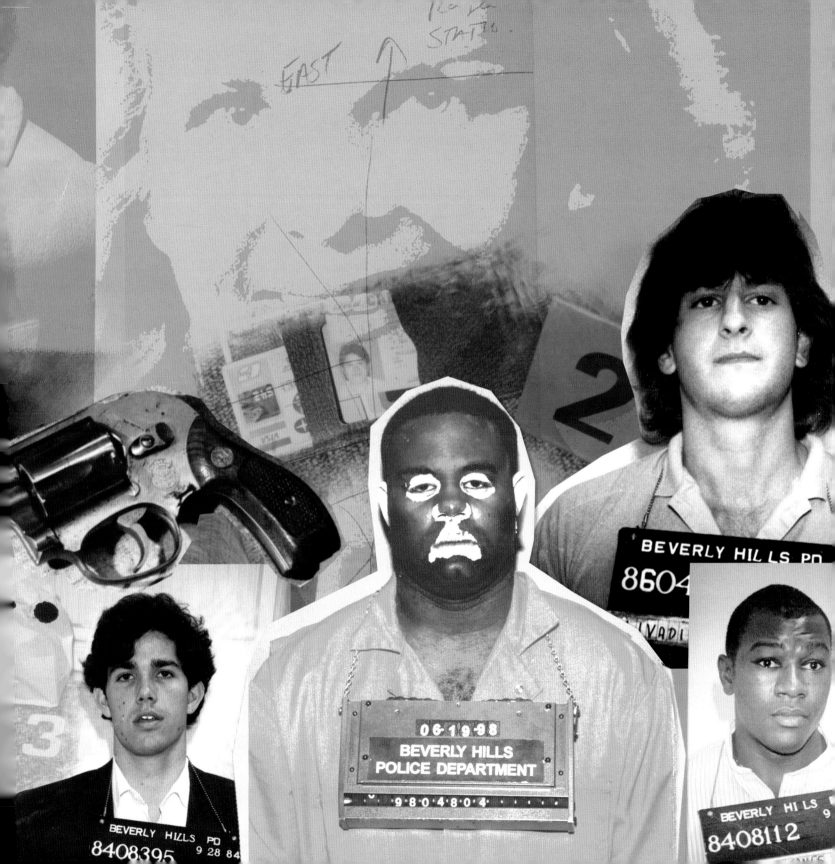

1. TAPE MOUTH
2. HAND CUFF — ③ Put Gloves On
3. Explain Situation
✓ 4. ~~LEASE Him Initiated Xerox~~
5. Put Answering Service on 668 1st Ring
6. Get Alarm Access Code and Pan Code
7. Date Stamp documents
8. Date Stamp letters
9. Make File of letters (Take Holes with You) and other Material
10. Kill DOG (EMPHASIS) ~~Hard Blow~~
11. Xerox Authorization (if Any)
12. Use Corporate Seal

SINS, SONS AND SORROW
THE 1980S AND 1990S

Salacious sex tapes, stars slapping cops, and spoiled rich kids slaughtering their parents. Welcome to the 1980s and 1990s, no doubt the wildest period in Beverly Hills history.

The juiciest of scandals starts off the Eighties: videotapes that supposedly feature department-store heir Alfred Bloomingdale frolicking with his kinky-sex mistress of twelve years, Vicki Morgan, and also allegedly feature some prominent Republican figures from President Reagan's "Kitchen Cabinet." The tapes are a pawn in an unusual palimony lawsuit filed by Morgan. (She wasn't getting any more love money from Alfred. He was on his deathbed, and his wife, socialite Betsy Bloomingdale, had cut off the mistress's weekly check.) The tapes never materialize—if they even existed at all—and a year after Alfred Bloomingdale dies, his mistress is killed in a bizarre attack by her mentally deranged roommate.

Also the talk of the town: nude statues on Sunset Boulevard. A twenty-three-year-old sheik and his nineteen-year-old wife buy and renovate a mansion, then paint the statues decorating the front fence with such lifelike details that traffic slows to a halt as people gawk and stare. One local interior designer laments, "I wouldn't object to painting the hair brown—but even the hair 'down there'?" The garish manor is destroyed by a mysterious fire in 1985. Crowds gather and chant, "Burn! Burn! Burn!" as flames light up the night sky.

The Beverly Hills Police Department is finally stable, after several chiefs have come and gone. Seasoned Los Angeles Police Department veteran Marvin Iannone is now in charge and will stay for several years. Iannone is very familiar with handling all things celebrity: he was one of the first officers at Marilyn Monroe's Brentwood home the night she died in 1962, something Iannone would never speak about publicly. His steely reserve and silence are traits very welcome in a town like Beverly Hills.

The streets of Beverly Hills become a movie star of sorts as films like *Beverly Hills Cop* (1984) and *Pretty Woman* (1990) are released, but it's what's happening with actual stars on the streets that fill the tabloids. Talk show host Johnny Carson is arrested for drunk driving. Too intoxicated even to say his ABCs, he tries unsuccessfully to resist arrest. "I'm not going to the police station," he slurs. "Not so you can have the *National Enquirer* and the press waiting for me!" The next night, Carson tells his national TV audience he regrets what he did, and he follows through on a promise that it will never happen again.

Hot-blooded Hungarian actress Zsa Zsa Gabor gets the most press she's had in a long time after she slaps a handsome police officer as he's writing her a ticket for driving her white Rolls-Royce with expired tags. She is slapped with a fine and spends three days in jail for misdemeanor battery on a police officer. Officer and actress file dueling slander suits that are later dropped; Gabor finally pays her fine and does some time. The license plates and a flask found in her car remain in the evidence section of the city's police department.

There's a new crime in town as the 1990s unfold: jewelry stores along Rodeo Drive and throughout the city are the victims of a rash of Rolex watch robberies. One such robbery turns deadly when a thief follows a man wearing a Rolex home. The thief shoots the man in front of his wife, then pulls the timepiece off the dead man's arm. The wife struggles with the gunman, to no avail. She isn't hurt; the thief is never caught. Several stores stop selling the hot timepieces after that incident. No wonder residents love this local news headline: "Man, 81, Kills Robbery Suspect." Octogenarian Thomas Korshak, a retired jewelry merchant, walks into his Beverly Hills apartment lobby with his wife when a twenty-six-year-old thief accosts them, demanding their money and jewels. The frail Korshak pulls out a gun and kills the robber on the spot.

The new Beverly Hills Civic Center opens in 1990, linking the library, and fire and police departments with the historic City Hall. This is the same year police are called out for another big crowd-control situation. It's May 16, 1990, and beloved "Rat Pack" legend Sammy Davis Jr. has died

[far left] Betsy Bloomingdale was humiliated when her husband's mistress, thirty-year-old Vicki Morgan [inset] revealed intimate details about sadomasochistic romps she had with Bloomingdale's husband, sixty-six-year-old Alfred. [left] Courtney Love (with daughter Frances and husband Kurt Cobain) is booked into Beverly Hills jail, charged with drug possession. Sammy Davis Jr., [above] photographs his wife May Britt and their newly adopted son, Jeff.

After his first DUI, talk-show host Johnny Carson never had a run-in with police again.

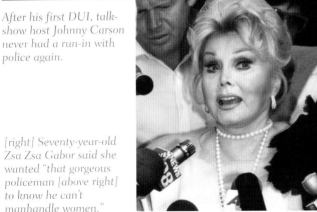

[right] Seventy-year-old Zsa Zsa Gabor said she wanted "that gorgeous policeman [above right] to know he can't manhandle women."

at the age of sixty-four from throat cancer. Hordes of reporters, satellite trucks, and a seemingly endless stream of visitors and friends make a steady pilgrimage to the singer's home at 1151 Summit Drive.

Officers are dealing with a slew of attention-grabbing celebrity cases these days, including a real-life car chase between *Rocky* star Sylvester Stallone and paparazzi photographers. Stallone and the photographers' vehicles crash into each other three times, neither side ever copping as to who really hit whom.

At the posh Peninsula hotel, singer Courtney Love is arrested after allegedly overdosing on heroine; this happens at the same time her husband, Nirvana musician Kurt Cobain, is believed to have shot and killed himself in Seattle.

And in 1998, "I Want Your Sex" singing-sensation George Michael is apparently acting out that title after he's arrested for committing a lewd act in a restroom at Will Rogers Memorial Park across from the Beverly Hills Hotel. The singer, who alleges he was entrapped by an undercover "pretty cop," tells television talk-show host Jay Leno that the officer played a game called "I show you mine, you show me yours, and I'll take you down to the police station." The officer's slander suit against Michael is dismissed. The singer is fined and put on probation.

There's no doubt police work in Beverly Hills is unique; it's a tough job protecting one of the wealthiest communities in the world. But as this century draws to a close, the department will find itself facing the most heinous and famous crimes ever to hit this one-of-a-kind town, giving new meaning to the phrase, "Only in Beverly Hills."

1984

THE BBC: BILLIONAIRE BOYS CLUB ◆ CULT-LIKE CLUB OF RICH KIDS WHO KILL

Joe Hunt wanted attention and fame in the worst way, and that's exactly how he got it. Hunt, called a psychotic genius by many who knew him, used some of his rich friends to help fund a Ponzi scheme that spiraled out of control and led to two murders, three books, and a television miniseries.

It all started during Hunt's high school years at the prestigious Harvard School for Boys (now Harvard-Westlake). Hunt was admitted on a scholarship. He was, said a teacher, "One of the brightest students I've ever seen." But while academically impressive, socially, Joe didn't quite fit in. He longed to be liked by his classmates.

Fast forward a few years. Hunt finished college, became a CPA in Chicago, made a lot of money, and returned to Los Angeles to start that Ponzi scheme, calling it "The Billionaire Boys Club." He recruited several of his former classmates who were dazzled by his money, newfound confidence, charm, and generosity. At one of his motivational company meetings, Hunt handed out ten shiny new motorcycles as a reward to his top producers. One of his old high school acquaintances, Dean Karny, was so impressed with the boss's business skills, he convinced his parents to invest $150,000 in the new company.

Hunt finally had the respect he always felt he deserved from his high school acquaintances. Had anyone bothered to check, they would have realized Joe was a fraud: his trading privileges had been revoked in Chicago due to "questionable ethics."

After blowing through over a million dollars, Hunt suddenly found himself in need of a quick cash infusion—investors were getting nervous. He turned to an acquaintance, Ron Levin, a shady character who promised the BBC boss access to a big loan. When the money never materialized, Hunt wanted revenge. He decided to pay Levin a visit. He took his new security chief, Jim Pittman (the doorman at his condominium), to Levin's home. Levin was never heard from again. As the security guard would later testify, he shot Levin in the head, then he and Hunt wrapped the body in a comforter and dumped it in a canyon.

Hunt returned to his office and told his team the BBC was in serious financial trouble, and he asked if anyone had access to some big

A prosecutor once described Joe Hunt as having a "Charles Manson-like" personality.

money—and fast. According to Hunt, group member Reza Eslaminia volunteered; he said his dad, a wealthy Iranian who lived in San Francisco, had plenty of money. Hunt decided that a select group of BBC members, including Reza, would abduct the dad and bring him to a safe house in Los Angeles where they would torture him until he transferred thirty million dollars to the group. Joe anointed himself "The Torture Master."

But the extortion plan backfired. The young men had stuffed the fifty-six-year-old Eslaminia into a steamer trunk, and while on the trip back to Los Angeles, he either suffocated or had a heart attack and died. The group rolled the elder Eslaminia's body down a hill in Soledad Canyon.

Club member Dean Karny, who was part of the kidnapping crew, decided he'd seen enough. He got nervous and went to the police. He asked for, and was granted, immunity in exchange for telling officers the almost unbelievable story behind the BBC. Murder charges were then filed against Hunt and other members of the kidnapping crew, including Ben Dosti. Reza Eslaminia and Ben Dosti were sentenced to life without parole for the murder of Reza's father. The court of appeals reduced their sentences in 1998, but after twelve years in prison, their convictions were overturned on a technicality. After a retrial, Dosti pled guilty. Both were sentenced to time served and are

THE BILLIONAIRE BOYS CLUB CASE
INFORMATION AS TO WHEREABOUTS WANTED
REWARD OFFERED

RONALD LEVIN BEVERLY HILLS

DISAPPEARANCE

Ron Levin, a Beverly Hills conman, disappeared from his home during the night of June 6 - 7, 1984. At the time of his

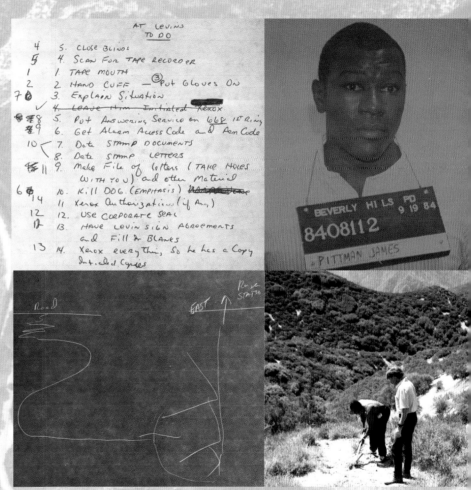

now out of prison. The charges against Eslaminia were eventually dismissed due to lack of evidence. Dosti is now a pastor in Northern California. Eslaminia says he is a legal consultant and also involved in film production and financing. Karny, who received immunity, was given a new identity and is a lawyer practicing somewhere in California.

Pittman, the former doorman, was sentenced to three years and six months in prison after pleading guilty to an accessory to murder charge. He admitted on the TV show *A Current Affair,* "Yeah, I did kill Ron Levin, but I can't be tried for it twice." Pittman died of kidney failure in 1997. Levin's body has never been found.

Hunt was tried and sentenced to life in prison. Ever the showman and slick marketer, Hunt co-authored a book with his prison cellmate. It's a fictional tale described on a website as an "epic encounter between good and evil" that takes place in a distant part of the universe. An online bio for Hunt states: "Hunt maintains his innocence. He occupies himself now with his ongoing challenge in federal court to his conviction…the stock market, handball, and Kriya Yoga."

[top left] A detailed to-do list was left behind after Hunt and bodyguard Jim Pittman visited financier Ronald Levin. [top right] James Pittman. [above left] Pittman had drawn a map for police indicating where Levin's body was buried. Pittman and Detective Les Zoeller search unsuccessfully for Ron Levin's body [above].

The police were confused about who the perpetrator was because he had forced a victim to switch pants with him.

1986
THE DEADLY VAN CLEEF AND ARPELS ROBBERY • HOSTAGES KILLED

June 23, 1986 was a lovely summer day, a Monday morning. President Ronald Reagan's wife Nancy was in town for a visit, the national news media in tow. A few streets over, on Rodeo Drive, the exclusive Van Cleef and Arpels jewelry store just opened up as usual at 10 a.m. The high-end gem shop was like a fortress: bulletproof windows, closed-circuit security cameras, an on-site security guard. No jewel thief had ever penetrated the perimeter—until that day.

A young man dressed in a dark gray suit, carrying a briefcase, walked up and rang the bell. An employee mistook him for a salesman and buzzed him in. But instead of jewelry samples, twenty-two-year-old Steven Livaditis took out a gun, a nickel-plated .357 Magnum. With a sweeping gesture he showed employees he meant a different kind of business. "Everyone on the floor," he yelled. "This is a robbery!"

Chaos ensued. Employees scattered. One hit the panic button. Upstairs, staff in the factory area looked over at monitors and saw the gunman. They activated a silent alarm and quickly slipped down the backstairs; several employees escaped. Within minutes, dozens of police

cars and officers arrived at the scene. Rodeo Drive was shut down; the First Lady's entourage diverted.

Livaditis, unaware the alarm had been tripped, grabbed jewelry and gems by the handful and was about to leave when he spotted an officer. Cornered, he hustled five employees into an interior showroom and locked everyone in: the store manager

Livaditis was arrested for reckless driving a month before the tragic heist.

Hugh Skinner, security guard William Smith, and three salespeople, including Ann Heilperin. News helicopters thundered above; reporters on the ground began what would be the first live, all-day broadcast of an unfolding news story in Beverly Hills. They could only report what they saw going on outside. Now, for the first time, details from police

Security guard William Smith was the first victim to die, stabbed with a knife.

Police found saleswoman Ann Heilperin dead, lying face down with her hands tied behind her back.

Store manager Hugh Skinner was accidentally killed by a sharpshooter.

The standoff lasted thirteen and a half hours. Livaditis phoned police requesting a meal, but he never retrieved the brown-bag lunch they delivered.

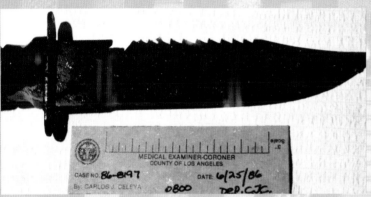

Investigators found this survival knife lodged in security guard William Smith's back.

Detectives from the Beverly Hills Police Department and the Los Angeles County Sheriff's Department enter the jewelry store after the siege.

files reveal what was going on inside.

The thief had come prepared. His hostages watched as he pulled out of his briefcase some tape, twine, ammo, a survival knife, and a switchblade. Livaditis was irritated. Smith, the guard, was talking smack to him.

"He called me some names," Livaditis would later tell a probation officer, "I had a lot of anger. I felt I had to take control of the situation." Livaditis duct-taped the guard's hands and feet, took a knife and plunged it into the fifty-three-year-old's back, leaving the blade in the body. Ann Heilperin began crying quietly.

SWAT members arrived; the building was completely surrounded now. Negotiators made phone contact with Livaditis. They asked if he'd killed anyone. At first he said yes, then he said no. Then he yelled into the phone, "You better back off!"

One of the hostages needed to use the bathroom. Livaditis made him (and eventually all the others) use the room's trashcan in front of everyone. Heilperin was trying not to cry. Livaditis was annoyed, "I couldn't take it," he explained. "I told her to be quiet; she was whimpering too much." Livaditis duct taped the forty-year-old's hands and legs, covered her mouth, then pulled up her hair and shot her in the back of the head. Now there were two dead bodies in the room.

The afternoon dragged into night. Livaditis looked over at the two bodies; rigor mortis had set in. Around 11:30 p.m., Livaditis decided to

make a run for it. He told the store manager to trade pants with him. The manager was now wearing the thief's dark suit pants.

Livaditis loosely tied the remaining hostages to himself and threw a blanket over everyone as they exited out a back door. The area was illuminated by streetlights. The sudden movement of people leaving the building took authorities by surprise; they trained their night scopes on the group of four, looking for the suspect. (They had a description from the employees who'd escaped earlier that day; the gunman, they said, was wearing dark suit pants.)

Officers lobbed a flash-bang concussion grenade to stop the escapees. The manager was separated from the others. He fell to the ground, rose up to a sitting position, and extended his arm to the others now huddled under the blanket. On top of a nearby parking garage, a deputy spotter who'd been told the suspect was wearing dark pants saw the extended arm and told the sharpshooter next to him, "He has a gun, he's going to shoot." A single, precise shot was fired. The man in the dark pants collapsed to the ground. The deputy unknowingly had just shot and killed the store manager, sixty-four-year-old Hugh Skinner.

Livaditis tried to escape; officers were on him instantly, taking him down and into custody. His briefcase contained over two million dollars worth of jewelry, watches, and loose gems.

During the trial, which took place in a heavily guarded courtroom, Livaditis explained why he pulled the heist. "I was running out of money."

The shooting death of the store manager was ruled accidental. By all accounts, the deputy who fired that lethal bullet acted according to protocol, but he was so upset by what he had inadvertently done, that he quit and left a career he loved.

Livaditis sits on Death Row at San Quentin. He recorded an audio interview for a group called "Greeks for Christ," in which he spoke about a newfound connection with the Lord. The once cold-blooded killer says he's hoping to get his sentence commuted. "Ever since I accepted Jesus, I have a clear conscience," he notes.

Livaditis, who had robbed jewelry stores before, stuffed jewelry worth over two million dollars into a briefcase.

Authorities conducted hostage negotiations with Livaditis via telephone throughout the day.

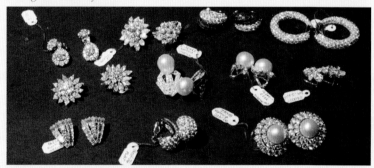

Police retrieved custom-made jewelry that Livaditis had stashed into his pockets.

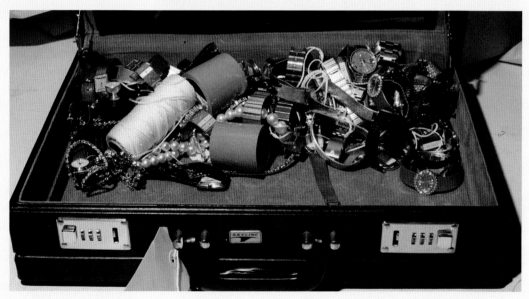

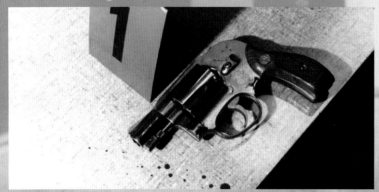

The murder weapon Espina left behind was registered in her name.

Espina's license describes a five-foot two-inch, 135-pound female with black hair and brown eyes.

1988

Pawn Shop Double Murder ◆ Female Killer on the Run for Decades

"The Rolls-Royce of Pawn Shops"—that's what customers called the Beverly Loan Company, a high-end pawn shop owned for almost five decades by seventy-nine-year-old Julius Zimmelman and his brother, Louis, eighty-one. No guitars or records were pawned here, just pricey and valuable items, like the diamonds a Saudi Arabian princess brought in for a loan while waiting for the monthly check from her oil-rich father.

For forty-seven years, the Zimmelman brothers had carefully built a solid reputation. The loan company was tucked away in an office on the third floor of the Wells Fargo Building at 9350 Wilshire. Julius's son, Harry, thirty-eight, had been working with his father and uncle for years, and would be taking over the business soon. At least that was the plan, until the day a short and stout Filipino woman walked into their shop.

Around 4:30 p.m. on April 6, 1988, Asunción Espina had a discussion with Julius. Perhaps it was a dispute over a loan, maybe an argument about a pawned item; whatever it was, it triggered a profound rage-filled reaction. Espina pulled a gun from her purse and began firing at Julius. His son heard the shots and ran over. She began shooting at him. Once the bullets ran out, she dropped the gun and raced out of the store. In her haste, she left behind her purse, which held her driver's license and other identification. Both father and son were able to tell police who shot them before they passed out. Julius died on the operating table. His son Harry was put on life support, never regaining consciousness. He died almost three months later.

The Beverly Hills Police Department took more than twenty years to apprehend Espina. Immediately after the shooting, she fled to the Philippines where she was protected by many high-level government friends. (Her father reportedly had been a general in the Marcos regime). Stymied by a lack of help from Philippine authorities, the case was cold until the two countries signed an extradition treaty in 1996. Espina continued to fight extradition until 2009 when Beverly Hills police officers, working through State Department channels, were finally able to bring her back to the scene of her crime, some twenty years later. Asunción Espina is spending the rest of her life in prison at the Central California Women's Facility.

The Beverly Loan Company lost two good men that fateful day. No doubt they would have been thrilled to know their family business has not only survived, but is thriving at a new location, with a new owner: a Zimmelman grandson.

1989
THE MENENDEZ MURDERS • SCHEMING SONS EXECUTE PARENTS

It is the most gruesome crime in the history of Beverly Hills. Two privileged rich kids, eighteen-year-old Erik and twenty-one-year-old Lyle Menendez, slaughtered their parents in the living room of the family home at 722 North Elm Drive on August 20, 1989. The coroner's report describes "gaping lacerations" five inches wide in Jose Menendez's skull. He was shot six times, his slumped-over body still in a macabre seated position on the couch in the family living room. His wife Kitty had fallen between the couch and the coffee table; she'd been shot ten times, half her face torn off by the bullets.

But perhaps nothing drives home the gruesome nature of the attack more than this fact that never made news: as a group of investigators prepared to bag up Mr. Menendez's bullet-riddled body, his brain detached from his skull and slid across the marble floor. Even the most hardened professionals had to leave the room.

While the public wouldn't know who killed the video executive and his wife for many months, police had their suspicions immediately. Clark Fogg was called to the family home. He was one of the first on the scene, videotaping and collecting key evidence.

An odd question was one of the first clues that the sons may have been involved. While Fogg was escorting Lyle Menendez to his father's office to get elimination fingerprints (taken to rule out potential suspects), the oldest son nodded his head in the direction of the den, where his parents' dead bodies lay. "Is that the room it happened in?" he asked. As Fogg points out, Lyle knew the answer to that question; he and his brother had already "discovered" the bodies and called police. "It's a red flag when someone asks a question they already know the answer to."

Beverly Hills detective Les Zoeller began watching the boys' every move. Despite putting on a good show (when Lyle called 911, he blubbered convincingly into the phone, "They shot and killed my parents!"), the brothers were not very slick at covering up their crime. Barely a week after the murders, the sons went on a wild spending spree: new clothes, Rolex watches, new cars. Lyle got himself a Porsche 911 and Erik bought a Jeep Wrangler. They rented ocean-view apartments, one for each of them. Within a few months, they'd burned through almost a million dollars of their inheritance. But police needed

Kitty and Jose Menendez met in a debate class in college. He was nineteen when he asked her to marry him.

some evidence they'd committed the crime.

About two months after the murders, Zoeller interviewed Erik at the mansion, making the boy so uneasy that Erik panicked and called his therapist, Jerome Ozeil. During his next therapy session, the young man fell apart and made the shocking confession, "We did it; we killed our parents."

Ozeil was stunned, and he taped the following sessions where not only Erik, but also Lyle talked about how much they had hated their Dad. The sons had worried their dad was going to disinherit them because they weren't as smart and successful as he wanted them to be. They also spoke of having seen the Billionaire Boys Club television movie, and how it had inspired them when one of the boys was willing to kill his dad for money.

Lyle bragged on the tapes that he and Erik had "shown great courage by killing their mother." Lyle also said he "missed having these people around. I miss not having my dog around." But neither brother ever expressed real remorse. The tapes became key evidence in court. (Doctor/patient confidentially guidelines are negated if threats are made—the brothers had told Ozeil they'd harm him if he told anyone about the confessions.)

Lyle (left) and Eric (right) spent three years in jail waiting for their trial to begin. Lyle lost most of his hair when he was in his teens and wore a hairpiece in court.

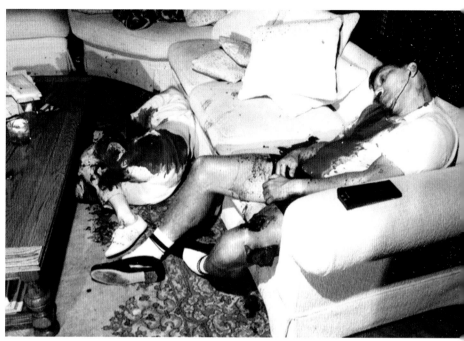

Body parts and blood were found splattered throughout the room, including on the ceiling. A bowl of berries and cream was still on the table in front of forty-seven-year old Kitty and forty-five-year old Jose Menendez.

In all of their therapy sessions, the young men never mentioned any abuse, physical or sexual, by their parents, but that's the excuse defense attorneys would use in court. The boys cried crocodile tears as they testified. Lyle said his mother Kitty sexually abused him when he was eleven. Lyle also said he himself molested Erik when Erik was five. Erik claimed his dad had forced him to perform sex acts on him, and that as a child he would put cinnamon in his father's coffee and tea because he heard it made semen taste better. The prosecution elicited testimony that the boys were blatant liars and sociopaths driven by hate and greed, spoiled brats who couldn't wait for Daddy's money.

The brothers' first trial ended in a hung jury. Both were found guilty in the second trial. During the sentencing phase, the jury spared them the death penalty. Erik and Lyle are in separate prisons for the rest of their lives. According to an aunt, "In prison, they're perceived as a couple of rich guys and people hate them."

CLARK FOGG'S ANALYSIS:

We actually had our suspicions that Erik and Lyle were involved shortly after we arrived at the scene. Here's why: the boys came in and told us they thought the mob was behind the murders. That seemed odd to us because so many shots had been fired; a hit doesn't require that many shotgun blasts. The two also made several trips in and out of the house that night to gather personal items. Usually grieving family members don't want to go into the scene of the crime right away. They seemed very cold and calculating.

[left] At age twenty-five, Heidi Fleiss was making millions a year with more than one hundred call girls, many "stolen" from her former mentor-turned-rival Madam Alex, aka Elizabeth Adams [above].

1993

HEIDI FLEISS' HOOKER RING BUSTED • MADAM WITH MORALS?

When Heidi Fleiss was just twelve years old, she was already showing signs of being quite the entrepreneur—she started a mini babysitting empire and recruited her girlfriends as employees. As an adult, she recruited girls again; only this time, as high-end hookers who serviced the rich and powerful.

Heidi had learned all about the call girl business from the best: Elizabeth Adams, better known as "Madam Alex." Madam was looking for someone to take over her enterprise. After Fleiss turned a few tricks herself (Adams said Fleiss rated only about a 4 on a scale of 1 to 10), Heidi became the madam's assistant, increasing profits by bringing prettier and younger girls into the stable.

Eventually Fleiss wanted a bigger share of the profits, and the twenty-five-year-old struck out on her own. She became a rival in what Adam's called "The Whore Wars." The elder madam would bristle at the mere mention of Fleiss's name, complaining, "She stole my business, my books, my girls, my guys."

But Fleiss prevailed. Her stable had better-looking, younger women who were in demand, and she paid them more money: a sixty/forty split. (The typical rate was fifteen hundred dollars a night, sometimes ten thousand dollars for special girls, weekends, and overseas travel.) Heidi

made millions, telling an interviewer once, "On my best day, I think it was ninety-four thousand dollars in cash. And that's [for] me, just forty percent."

There was one important trick Heidi failed to learn from her mentor: how to play nice with law enforcement. Madam Alex was an informant, passing along key client pillow talk to authorities. She lasted twenty-five years in the vice business before getting a slight slap on the wrist: probation. Fleiss only lasted a few years. She was cocky, telling an undercover police officer once, "In the history of this business, in one year, no one has ever been able to do what I do." Fleiss boasted that her call girl ring catered to the top one percent of men in the entertainment, corporate, and political worlds.

Police couldn't ignore her booming business any longer, and they set up a sting. Beverly Hills police detective Sammy Lee posed as a wealthy Japanese textile businessman who wanted to book some girls. He called Fleiss, who asked him what he wanted. "Basically nothing bizarre," he said. "I don't want to see a llama coming through the house." They agreed on six thousand dollars, and Heidi sent over four hookers and some cocaine. The ladies arrived at Lee's Beverly Hilton hotel room and got some surprise welcome gifts: bracelets—as in handcuffs. Fleiss

was arrested the next day at her hillside home.

When detectives found her little black book (actually several red Gucci day planners) even they were amazed at the size of her enterprise and the number and caliber of clients. She really did service the cream of the crop of tycoons, movie studio executives, and heads of state.

Fleiss's arrest and trials were a media sensation—much of Hollywood was trembling: would she tell tales of debauchery and kinky sex, maybe reveal her clients? Say what you will about the madam, but she stayed loyal, never giving up her clients. "She probably could have traded off that," said her attorney Anthony Brooklier, "but she never did." He says Fleiss told him she didn't ever want to have some sixth grader go to school after seeing his dad's name in the paper.

Fleiss pled not guilty to pandering and narcotics possession charges, but the jury found her guilty on the pandering charge; she was sentenced to three years in prison. The verdict was overturned on appeal, Heidi then pled guilty to one pandering charge in exchange for an eighteen-month sentence. The federal government stepped in as well, charging Fleiss with tax evasion and money laundering. She was convicted in 1995, sentenced to thirty-seven months and served both the state and federal sentences concurrently.

Fleiss wasn't happy with the outcome of the trial. "I am going to prison, and for what?" she asked. "Sex. That's it. I would never hurt another human being. I'm a vegetarian because I can't even think of hurting animals. The police, the FBI—nobody cares about the men! They're not even being investigated."

After her release from prison, Fleiss struggled to find her place in the world. She wrote a biography called *Pandering*; made sex-tip videos with her friend Victoria Sellers (actor Peter Sellers' daughter); got into an abusive relationship with actor Tom Sizemore; and decided to open a brothel in Nevada, but with a twist—it would be a stud farm for women. The locals didn't let that happen, so instead, Fleiss opened a Laundromat called Dirty Laundry. In recent years, she's made appearances on reality shows like *Celebrity Rehab*.

The high life and good times are now just part of the Hollywood Madam's past. Heidi summed up what happened best in a 2003 interview. "I think that I came about it in a unique time period. And that time period is over. I mean, now it's modems, not madams."

Fleiss did not name names in her book, but actor Charlie Sheen admitted he paid Fleiss more than fifty thousand dollars for "her girls."

Children of divorce never have it easy, but for nineteen-year-old Michelle Sison, divorce created a special kind of hell. Michelle's mom and dad, Annie and Errol Sison, had been separated for about a month; it wasn't an amicable split. Her mother had moved out and was now living at her business in Sun Valley. Michelle was living with her dad in the family condo at 424 North Palm Drive.

On Friday night, January 3, 1993, Michelle was on her way out to go visit friends when she noticed her mom in the kitchen with her dad. The pair was planning on having a "discussion." Michelle said goodbye to her parents, hoping they'd at least be cordial with one another; the two had been arguing lately about alimony and child support.

Errol Sison is on the run, accused of murdering his wife.

Michelle came back home around 8 p.m., but her parents weren't there. She called out their names: no answer. She dialed her mom's work number, no answer. Then she phoned the Beverly Wilshire hotel where her father worked as the executive chef. The staff told her he wasn't working. In fact, he had called in to request four unscheduled vacation days. Michelle was perplexed. Her dad hadn't mentioned he was going out of town, but her parents weren't acting predictably of late. She decided to spend the night at a friend's house.

For the next two days, Michelle repeatedly tried calling her parents, but they never answered their phones. On Sunday morning, Michelle tried calling her parents again. This time when there was no answer, the very worried daughter called police and filed two missing persons reports. She called and asked her uncle to come over and meet her at the condo.

Michelle walked into her parent's bedroom and sat down on the bed. She leaned over to turn on the answering machine to listen for possible clues. After a few minutes, she felt a wet spot along the side of her thigh. She reached down and looked at her hand. Blood. It was seeping through the comforter. She looked at the carpet, saw more red and screamed for her uncle. He raced into the bedroom; Michelle was staring at the crimson patch on the comforter. Her uncle pulled back the sheets. She helped him move the pillows, and that's when she saw her mother again, wedged between the headboard and the mattress. Annie Sison had been bludgeoned to death.

When police arrived to gather evidence, they were able to determine the killer must have used some kind of blunt object to kill Annie, perhaps a meat cleaver, a tenderizer, or a hammer. The weapon never was found. (But whatever instrument was used to kill Annie Sison, the force from the blows was so tremendous, that her injuries looked like knife wounds.) The coroner estimated the mother had been struck at least twenty times to the head, arms, and rest of her body.

Police immediately issued an arrest warrant for Errol F. Sison. Family members reported seeing the victim's husband for a moment at Sison's funeral, watching from afar before he drove off. He fled the country soon after and has played a cat-and-mouse game with Beverly Hills detectives ever since. Investigators found his car in Mexico shortly after the murder—he'd sold it to a new owner for two hundred dollars. Several tips have come into the department, and there have been several sightings of Sison working at various luxury resorts outside the U.S., but every time detectives get close, he suddenly leaves his job and disappears.

Michelle, who is now in her late thirties, told officials she's had no contact with her father. To this day, the executive chef is on the Beverly Hills Police Department's "Most Wanted" list, most likely cooking up gourmet meals somewhere in Mexico or Central America at a lovely vacation resort along the beach.

CLARK FOGG'S ANALYSIS:

This case is currently open. Detectives are seeking the suspect with the help of Mexican authorities. Unfortunately, with all the unrest in Mexico and the drug cartels war currently in full swing, it means this case is not a high priority and progress is extremely slow. However, the murder scene has been memorialized with extensive documentation and photography. The department is confident that the suspect will be arrested and brought to justice for Michelle Sison's murder.

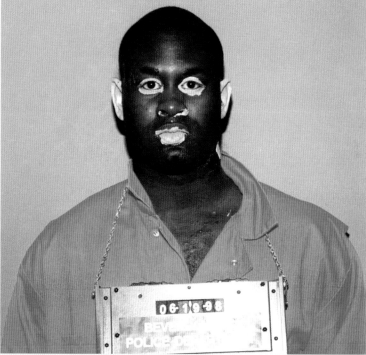

[left] Derrick Miles and Anthony Crute [above] had gotten away with robbing several banks before getting caught in Beverly Hills.

1998

THE BLACK-AND-WHITE ROBBERS • MAKEUP TO BREAKUP

When ex-cons Anthony Crite and Derrick Miles, both twenty-four-year-old African American men, decided to rob yet another bank, they wanted a really good disguise. So they hired a Hollywood special effects makeup artist to "turn them into white guys." They told the artist they were working on a class project about racism, and they nonchalantly handed over the fee upfront in cash: two thousand dollars each. They wanted the best mask money could buy.

It took several hours to apply the latex. The artist carefully painted and glued the skin-like, light tan latex around the eyes, nose, mouth, ears and hands, all the way up to the forearms. With their makeup complete and wearing heavy jackets, the now Caucasian-looking duo began their real project: robbing a Beverly Hills bank on Wilshire Boulevard. They walked up to the entrance ever so casually, rang a bell, and were buzzed in to a glass-enclosed area known as "the mantrap." The two waited for the next buzzer to get inside the bank, but a savvy teller hesitated—something didn't look quite right. She

motioned to co-workers; what was that stuff on those men's faces?

Crite and Miles knew instantly something was wrong. They pulled out their guns and threatened to start firing unless the doors were opened. The staff refused and the firing began. Several bullets pierced the glass and tore through a wall between the bank and a restaurant next door. In an only-in-Hollywood moment, one of the bullets zipped past the head of a customer, actor Don Adams, who starred in the television show *Get Smart* (a satire of intelligence agencies). "It missed me by that much!" he told reporters, using a line from his show.

The two gunmen blasted their way out of the bank and as they were running away, started tearing off their masks. Sirens were getting closer. They pulled harder at the latex, but all they could rip off were bits and pieces; the makeup artist had done her job too well. Police closed in on the robbers who gave up and surrendered. Lesson learned: really good makeup lasts a long time—in this case, all the way to jail.

THE 2000s

PAPARAZZI PARADISE
THE 2000s

Just like a lot of its residents, Beverly Hills is getting a little face-lift. Sidewalks are widened, and new landscaping is put in; Canon, Beverly and Rodeo Drives never looked so good.

But one big change that most people around the world haven't really noticed: Beverly Hills, a former movie star Mecca, is no longer the address of choice for the really big celebs. They've moved to places like Malibu and Brentwood to get off the tour-bus track. Also missing from that tourist route: the home of Guess founder Georges Marciano. Sightseers used to stop by to gawk at the sculptures and multiple red Ferraris that were in the blue-jeans mogul's driveway. The cars and the designer are gone, the result of a blistering financial scandal.

Sixty-two-year-old Marciano, a rags-to-riches success story, had sold his shares of Guess in 1993, investing successfully in real estate and art. After a bitter divorce, employees say he began taking larges doses of painkillers and became erratic. He accuses his staff in 2006 of embezzling his fortune. Marciano spends over twelve million dollars in legal costs with seventeen different law firms trying to prove his case. He loses; the staff wins, successfully countersuing for some $460 million in damages. Marciano sells many of his assets and moves to an undisclosed location, reportedly far away from Beverly Hills.

Funnyman David Spade decides to leave his Beverly Hills home as well, after his former personal assistant, David Malloy, inexplicably attacks the actor while he is sleeping. The three-hundred-pound, six-foot-two-inch assistant woke up the five-foot-seven-inch Spade at 5 a.m. "He beat me, stun-gunned me, then beat me again," explains the actor, who escaped by running out of the house. "I thought I was gonna die."

Malloy, high on drugs, is arrested; he tries to commit suicide that same day. He is later sentenced to probation and community service. "He's a good friend who just snapped," says Spade.

And while some stars may not be living within city limits anymore, they're still getting in trouble here. In 2005, Oscar-winning director Oliver Stone gets arrested on suspicion of drunk driving and drug possession. He pleads guilty and is sent to rehab. A few years later, the young actress Lindsay Lohan begins her star turn as a trouble magnet. She crashes her car on Sunset Boulevard, is arrested for drunk driving, and promptly checks in for one of many rehab stints.

But the most tragic case of a falling star involves Lane Garrison, a costar of the television show *Prison Break*. The twenty-seven-year-old actor meets some teenagers at a supermarket on the night of December 2, 2006, and not only buys them liquor, but he also parties with them. While driving them to get more alcohol, the actor, drunk and high, crashes his Land Rover into a tree on Beverly Drive near Olympic, killing a seventeen-year-old boy and injuring two fifteen-year-old girls. Garrison is charged with homicide and spends forty months behind real-life bars. As one of the teens at the trial puts it, "He should have been the adult."

Beverly Hills gets a new police chief in 2004, David Snowden. He presides over a department that has not only impressive response times of about two minutes, but also has one of the nation's top CSI labs.

A big case in 2005 that isn't widely reported involves a shocking random slaying. It happens at the Wells Fargo Building (the same building where, in the Eighties, the Zimmelman pawnshop owners were killed). Two commercial painters, Jurgen Hapke and Helmut Mende, are painting outside around 7 a.m. on December 15, when a stranger in a sedan suddenly pulls up next to them, gets out, and begins stabbing both of the elderly men with a kitchen knife. Hapke, sixty-five, is slashed to death. Mende, seventy-one, is seriously injured, but survives. Officers arrest fifty-year-old Nathan Hall for the crime. Hall,

The stabbings occurred in the parking lot area of the Wells Fargo Building; the newspaper was used to obscure the knife as Hall attacked the painters.

The chef's knife used to stab both of the painters was purchased at a ninety-nine-cent store.

an African American parolee, tells police he attacked the painters because he "wanted to kill a white person" in order to avenge the December 13, 2005 execution of former Crips gang founder "Tookie" Williams. Hall is spending the rest of his life in Soledad prison.

Another case a few years later doesn't make the news either, but it would make a great episode for an "Unluckiest Criminals" special. A hotel cat burglar has just cleaned out several rooms at the Beverly Hills Peninsula hotel. Fearing he is about to be discovered, the thief jumps from a second-story balcony only to land on a contingent of Israeli Defense Forces special forces who are guarding a VIP guest.

As the first century of crimes and scandals in Beverly Hills comes to a close, one thing is certain, headlines featuring stories about the troubles of the rich and famous have the same mesmerizing effect on the public now as they did back when the city was young. When it comes to crimes and headlines, there's just no place like Beverly Hills, where stars and drama are as constant as the sunshine.

Lindsay Lohan fled the accident scene; officers tracked her down at a hospital.

Lane Garrison's blood alcohol level was twice the legal limit and traces of cocaine were found in his system.

Oliver Stone, director of Platoon (1986), was stopped at a checkpoint for drunk drivers.

David Spade's attacker was nicknamed "Skippy."

Actress Winona Ryder Caught Shoplifting ◆
"Scissorhands" Star Seeks Five-Finger Discount

Louvered doors in the Saks dressing rooms helped store security personnel observe Ryder using scissors to remove the anti-theft tags.

A Saks Fifth Avenue security guard leaned in to the surveillance monitor—sure enough, there she was, the world-famous actress, Winona Ryder. He couldn't believe what he was seeing: the thirty-one-year-old movie star was stuffing merchandise into bags. Among the items: lots of socks (including purple Calvin Klein knee-highs), a $750 white YSL blouse (size thirty-eight), a five-hundred-dollar Natori purse, and a simple-yet-sexy, $1,500 white Gucci dress.

The Academy Award-nominated actress went from floor to floor—there she was in the accessories department taking hundred-dollar hair bows off the display—then she passed through the hat section, cramming one Eric Javits black Fedora into a bag, plopping another one, called the "Lucky," on her head. The guard alerted the store's loss-prevention officer, Colleen Rainey, who followed the actress as she walked into a fitting room with all the loot. Rainey described what happened next in this excerpted police report:

> On Dec. 12, 2001, at 1619 hours I observed Ms. Ryder cut the sensor tags off of two handbags...as well as several other pieces of merchandise...Ms. Ryder then exited the fitting room with her shopping bags full of concealed Saks merchandise...after exiting, Ms. Ryder purchased 3 pieces she had selected but made no attempt to purchase the prior merchandise she had concealed. At approximately 1733 hrs I apprehended Ms. Ryder.

Ryder was taken into the security office, where she said, "I'm sorry, didn't my assistant pay for it?" Then she explained she was shoplifting because her director told her to do it for an upcoming role in a movie called *Shopgirl*. Next, the nervous Ryder offered to pay for everything, saying she "understood the economy was in bad shape."

When Beverly Hills police arrived to take Ryder into custody, she continued to make excuses, this time claiming she was doing research for an upcoming movie called *White Jazz* based on a James Ellroy book. Ryder also declared she'd never shoplifted before. But according to a 1997 *Buzz* magazine interview, the movie star admitted she'd been caught shoplifting comic books as a kid, "The police brought me home, and my parents tried to beat them up."

Instead of accepting a plea bargain, Ryder decided to take her chances in court. Reporters from around the world came to cover the trial, where Ryder pled not guilty. The prosecution tried to introduce

evidence that the actress had a history of shoplifting, including documented incidents at Barneys New York and at the Neiman Marcus store in Beverly Hills, but the motion was denied. Deputy District Attorney Ann Rundle instead relied on the evidence and this explanation, "It must have occurred to some of you, why would Winona Ryder steal? Nowhere does it say people steal because they have to. People steal out of greed, envy, spite, because it's there, or for the thrill."

Ryder's attorney, Mark Geragos, argued his client was the victim of overzealous security guards who planted evidence. But the jury (which included Hollywood producer Peter Guber) didn't buy any of the excuses. After about five hours of deliberation, they came back with a guilty verdict.

Ryder, who has a star on the Hollywood Walk of Fame, was convicted of shoplifting $4,760 of designer merchandise. She faced a prison term of three years, but instead was sentenced to three years probation, community service, and counseling. In her first and only interview on the subject, years later in *Vogue* magazine, Ryder said she didn't have a sense of guilt about the shoplifting. "Because I hadn't hurt anyone." When asked why she stole the items, she blamed her behavior on painkillers given to her by what she called "a quack doctor." Ryder's career never did regain the heat it once had, but she's been working steadily in supporting roles, including one filmed shortly after her conviction. She played a psychologist in a movie called, *The Heart is Deceitful Above All Things* (2004)

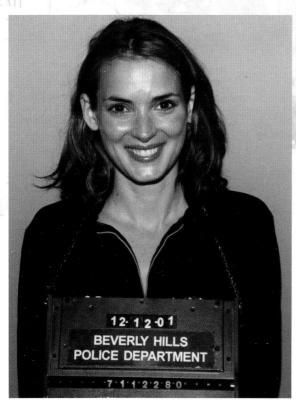

Getting booked for grand theft totalling $4,760 worth of merchandise earned Ryder this memorable mug shot splashed across tabloids.

Ryder "shopped" for merchandise in the Donna Karan section of Saks Fifth Avenue.

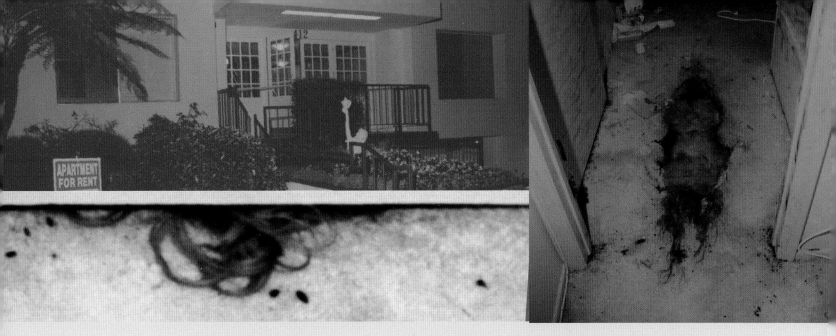

Hair and insects were seen near a closed and blocked bathroom door, so CSI had to enter the crime scene from a bathroom window. Remnants of the victim remained embedded in the carpet after it was removed.

2002
Dr. Laura's Mom Found Dead • Body Mummified

It was a white macaw named Sweetie Pie that finally alerted neighbors to the tragedy, not because it was squawking, but rather because it had gone silent. Yolanda Schlessinger (mother of talk-show host Dr. Laura Schlessinger) and the bird were found dead inside her condo in a complex on the 400 block of North Palm Drive. The coroner estimated the seventy-seven-year-old Schlessinger's body had been laying there for about three months. The coroner's report reads the victim was found with: "Dried out skin blistering and slippage, skin leathering, mummification of distal extremities. Prominent maggot activity of different stages."

Here, for the first time, are details of the mysterious death, and what really happened the day Dr. Laura's mom died. Clark Fogg was called to the scene around 4 p.m., December 21, 2002.

We went to the door, noticed a particular odor, and once we got inside, we were overpowered by the smell. It was an odd sight: furniture was turned over in the kitchen and living room, and a bench and chair in the bedroom had been piled up close to the bed. We went to where the odor was strongest, by the bathroom. The door was locked. When we looked down, we saw strands of hair peeking out from under the door; bugs were crawling in and out of the curls.

The body was blocking the door of the bathroom so we had to utilize a ladder and go around the condo complex to her bathroom window. We removed the screen from the window and made entry into the bathroom. It was quite a sight. Things were piled up in there, too: towels, rugs, a stool. The mirror above the sink was shattered. She was lying on her back. She was nude and her body was in a decomposed state. Bugs were everywhere; it was clear she'd been there for quite a while. In addition to the victim, we also found a large exotic bird dead within a very large birdcage in the kitchen.

Initially, we thought Dr. Laura's mother's death may have been a sexual assault or robbery; there was quite a bit of blood around the apartment. We found lots of latent fingerprint compressions in normal positions, but we also found many prints a few inches above the ground on the walls, doors and frames. It was obvious she'd been crawling around the floor.

At first, the coroner deemed it a murder investigation, but they called a few days later to say that wasn't the case. The coroner's office found a ninety percent

[left, top] Police found the dead woman's pet macaw at the bottom of its cage and her clock radio on the floor. [above] Dr. Laura Schlessinger said the estrangement from her mother dated back to 1986.

the wall, but they didn't want to get involved. She'd thrown something at the bathroom mirror to get attention.

Detectives called Dr. Laura Schlessinger to let her know what happened; she just said, "What do you want me to do?"

A cold response, begging the question: What on earth happened between this mother and her famous daughter, especially one known for her opinions on family values? Dr. Laura, (not a trained psychologist, her title comes from a PhD in physiology) told listeners right after her mom's death, "I'm horrified by the tragic circumstances…and so sad to learn that she died as she chose to live—alone and isolated. My mother shut all of her family out of her life over the years, though we made several futile attempts to stay connected. May God rest her soul."

The talk-show host placed all the blame for the estrangement squarely on her mother, who once worked as a receptionist in Dr. Laura's counseling practice. In an article several years after her mother's death, Dr. Laura told reporter Chris Ayres of the *Times of London*, "When it was clear that my career was taking off, I needed her to learn typing. She said, 'If I'm going to take any class, it'll be ceramics.' I said, 'Well, you can take that, too, but I really need you to take a typing class,' and she packed her bags and refused to talk to me ever again, no matter what contact we tried to make."

Schlessinger added that her family's issues began long before the estrangement. "My family was not in any way loving: the tension, the anger, the hostility, the dissension, the lack of love and affection, all had its impact."

In a *People* magazine article, Shelley Herman, a television writer who used to work with Dr. Laura, said she remembered Yolanda Schlessinger as a cheerful assistant who was inexplicably cut off by her daughter. "It's interesting that Laura is always bad-mouthing her mother," said Herman, "but [Yolanda] never said a word about her to the press."

Burial arrangements were handled by Dr. Laura's younger sister, Cyndi, who also wasn't close to their mother. (Their mother's body was in the morgue for ten days before it was claimed.) Yolanda Schlessinger's marker is engraved with her name, estimated date of death, and one line: "With Heartfelt Regret."

During the investigation at the condo, investigators picked up a small radio that had fallen to the ground in the kitchen. "When we plugged it in," recalls Fogg, "the *Dr. Laura* show came on."

blockage in her heart: she'd died of a heart attack.

Our department brought in FBI profilers used to dealing with aging victims. They determined the scene was typical of an elderly person developing a blockage and collapsing. They explained that the victim usually suffers many small strokes, not realizing what is happening to them. Hence, the blood in the kitchen, where she fell and had tried to wipe up the blood with newspaper. As for the furniture being piled up, that's apparently typical as well; they're trying to protect themselves.

Neighbors said they heard things pounding against

The videotape from security cameras at the elegant Peninsula hotel, taken on the night of March 14, 2008, shows a beautiful thirty-year-old Bulgarian model, Nora Igova, having dinner with her fifty-one-year-old husband. It would be Jacob "J.P." Lipson's last meal.

A few hours later, police arrived at Igova's condo on Durant Drive (the couple lived separately). Officers were responding to a 911 call from her neighbors, a sixteen-year-old Beverly Hills High School student and her father. Both had heard noises coming from the model's apartment shortly after they got home around midnight. The teenager told detectives she heard someone calling out "No, Nora, no!" followed by gunshots, a thump, then more gunshots.

J.P. was shot seven times, twice in the top of the head. Forensics tests using Luminol (a chemical that detects trace amounts of blood) revealed the shooting began in the bedroom then continued as Jacob crawled towards the front door. He was found shot in the head, lying face down in a pool of blood with his pants and shorts down to his knees, his bare bottom

Those who knew him described J.P. Lipson as "smart, aggressive, and greedy."

exposed.

Officers cornered Igova as she was leaving the apartment from a back entrance, headed for the garage where her Lincoln Continental and Cadillac Escalade were parked. Her husband's Bentley was parked nearby. The wide-eyed, but dry-eyed, Igova told officers emphatically that she did not kill her husband. She claimed she was in her bedroom watching a movie, while he was in the living room with a Russian prostitute who took Igova's gun from the bedroom, shot J.P., then ran out of the building. Igova had no explanation for why she hadn't called 911.

Details of the couple's private life were revealed in court. A successful model in Bulgaria, Nora Igova came to the United States in 1997 and began taking classes at the University of Colorado in Boulder, where she met J.P., a former hog farmer turned restaurant owner, who had children from a previous relationship.

Their story was not one of wedded bliss. In fact, the two had been living apart for quite a while, but Jacob still supported Igova and paid for her apartment in Beverly Hills. The couple had a history of violence, including another episode involving guns. Igova reportedly showed up

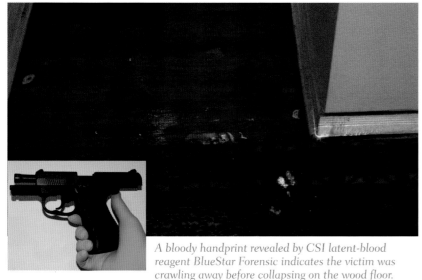

A bloody handprint revealed by CSI latent-blood reagent BlueStar Forensic indicates the victim was crawling away before collapsing on the wood floor.

Igova pounded on the neighbors' doors for help. Too terrified to open the door for her after hearing gunshots, the neighbors called the police instead.

at her estranged husband's new home in La Jolla, a resort town near San Diego. An argument broke out, and she allegedly shot up his home, shattering TVs and mirrors.

A website called Free Igova states that Igova moved to Beverly Hills to start a new life, and that her husband had attacked her numerous times. A description of her husband says he invested in an adult cable channel and several other businesses, including commodities trading, that produced "multimillion-dollar profits and provided a lavish lifestyle which led to his uncontrollable megalomania, greed, lawsuits, and violent disposition."

Igova did not testify at either of her two trials. The first ended with a hung jury; the second ended with a conviction. During the penalty phase of the trial, SWAT officers were brought into the courtroom because of rumors that Igova had ties to the Bulgarian Mafia. She was sentenced (without incident) to forty years to life in prison. Eleanora Iordanova Igova, who never took her husband's name, maintains her innocence.

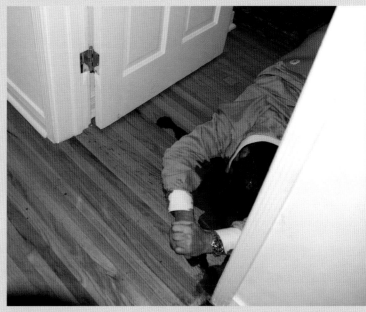

As they entered the crime scene, investigators found Lipson's body by the guest room next to Igova's bedroom.

After her arrest, Igova was taken to the police crime lab for examination of blood-spatter evidence and for photo documentation of her clothing.

[above] The murder weapon, a 9mm semi-automatic pistol was found in Igova's lingerie drawer.

CLARK FOGG'S ANALYSIS:

While our forensics tests showed no gunshot residue was found on the suspect's hands, we believe she washed the residue off in the master bathroom; a wet towel was documented on the bathroom floor. Also, DNA evidence taken from the weapon matched the suspect's profile conclusively. In addition, several live ammo cartridges matching the ammo used to kill the victim were found on top of the sheets in the master bedroom where Igova slept—more evidence that convicted the suspect.

[left] Anand Jon mingles with client Paris Hilton and Donald Trump. [top] A forensic detection method called "RUVIS" (reflected ultraviolet imaging system) revealed various bodily fluids that were documented and presented as evidence in court.

2007

Fashion Designer Anand Jon Sex Scandal • Career in Tatters

"A pedophile, masquerading as a fashion designer" is how prosecutors described Anand Jon, a thirty-seven-year-old former fashion wunderkind whose spectacular rise to fame in the industry was matched by an equally spectacular fall from grace.

The hotshot "It boy" dressed celebrities such as Paris Hilton and Paula Abdul. He was featured on television shows, including *Oprah*, and in 2007, *Newsweek* magazine placed the Indian-born designer on its exclusive "Who's Next" list of people to watch. The world was expecting to see great things from Anand Jon. But instead of runways, Jon is now walking down hallways to his prison cell, where he's spending fifty-nine years to life after several aspiring models came forward to tell lurid tales of rape, sodomy, and innocence lost.

Jon's sordid life was exposed shortly before his runway show at L.A.'s Fashion Week in March 2007. Police received a call from a nineteen-year-old woman who said Jon had sexually assaulted her. Officers arrived at the designer's messy Beverly Hills apartment. Jon showed up a short while later with a sixteen-year-old aspiring model on his arm. He had just taken her out to dinner after flying the teenager in from Connecticut.

A search of his apartment turned up about a dozen videos that Jon had made of himself having sex with several different girls. Officers also found computer files and lists that revealed Jon often prowled the Internet for victims. He kept detailed accounts of how "easy" the girls were to seduce and how involved their parents were in their daughter's lives.

After the news of Anand's arrest hit the headlines, more accusers emerged, some as young as fourteen. The district attorney's office filed an amended complaint, adding four more victims and new charges of forcible rape, sexual penetration by a foreign object, sexual exploitation of a child, sexual battery, and forced oral copulation.

In a *Dallas Observer* newspaper article, reporter Glenna Whitley detailed one of Jon's encounters in an exclusive interview with one of his accusers. "Emily," seventeen, wanted to be a model and posted her information and photos to a website called Models.com. She was thrilled when Jon called, telling her, "I launched Paris Hilton's career. You could be the next 'It Girl.'"

Jon invited Emily to meet him when he flew into her hometown of Dallas for a casting call that turned into a casting couch session. The *Observer* article details what the young girl experienced.

"I flew all the way down here to see you and you treat me like this?" the designer said. To be successful in the fashion business, he insisted, she needed to be more experimental

and passionate, like his good friend Paris Hilton. The designer poured the teenager a glass of wine. Then he was talking about sex, how it was sacred, once included in religious ceremonies. Before each show, to feel more spiritual, Anand said, he would get a blowjob. Then (as she would later tell the Beverly Hills police), he pulled her onto the bed, kissing her and pawing under her clothes while he unzipped his pants. She tried to push him away but didn't have the strength. She repeated, "I'm not having sex with you," over and over. "But it feels so good," he kept saying. She felt unable to fight him off.

In court, Jon's defense was that the sex was consensual, and that the girls all told him they were at least eighteen. He claimed his accusers were bitter and vindictive because he didn't hire them. Prosecutors described Jon as a serial rapist and played one of his homemade videotapes in court. It shows him asking a seventeen-year-old to strip before sexually abusing her. The girl says on the tape that she's eighteen, but in court, she testified that Jon told her to lie about her age.

After a two-month trial, Jon was convicted of sixteen counts of sexual abuse and possession of child pornography, and faced additional charges in New York and Texas. After his first year in prison, Jon wrote a letter to journalist Sharon Waxman of the website The Wrap, proclaiming he was "100% innocent."

"I have not seen the sky in months…I'm surrounded in filth…my pencil (I only get two per week) is running out of lead, so I also learn patience. Maybe that's what it's all about—taming the ego and revealing love.
Love and Light,
Anand Jon

Anand Jon's apartment served as headquarters, storage and living areas. The night he was arrested, a teenager had just arrived, her luggage still packed.

CLARK FOGG'S ANALYSIS:

When our department executed a search warrant on Anand Jon's apartment (situated approximately three blocks from the Beverly Hills court building), I observed a large suitcase just inside the front door. The luggage tag had the name and out-of-state address of a female written on it in a young girl's curlicue handwriting. Jon's apartment had the appearance of a halfway house. His bedroom had no bed, just a deflated air mattress on the floor with a cotton comforter on top. Next to this "flop bed" he had an HD video camera kit—the tape inside had images of prior victims and his sexual assaults. Those tapes were used as evidence during his multi-count rape trial.

HD video equipment was found next to Jon's deflated air mattress. Several tapes were broken and forensically repaired.

2008

Actor Mark Ruffalo's Brother Shot • Russian Roulette or Homicide?

Actor Mark Ruffalo and his kid brother, Scott, grew up in a big, happy Italian family. Their mother, a hairdresser, was no doubt delighted that Scott had followed in her career footsteps; he was a well-known stylist who worked in high-end salons such as Giuseppe Franco in Beverly Hills.

On December 1, 2008, police were called to Scott Ruffalo's home on North Palm Drive. A friend had found him on a couch of his condo coughing, gurgling, gasping for air. She immediately called 911. When paramedics arrived, the friend mentioned that Ruffalo had a history of seizures; perhaps that's what was happening at the moment. But medics quickly realized they were dealing with something far more sinister: a bullet wound to the head. He would not survive the injury. One week later, Scott Ruffalo was taken off life support by his family.

Police had a mystery on their hands. The acquaintance who found the victim was not there when the shooting occurred, but other people were, including Shaha Mishaal Adham and a male friend.

Mishaal's attorney, Ronald Richards, said that the two had gone to Ruffalo's condo to get the keys to her Range Rover. They claimed Ruffalo was high on cocaine and that he said something about Russian roulette before picking up a gun and shooting himself. The police report reveals the terrified couple ran out of the condo, leaving the bleeding thirty-nine-year-old behind. They did not call 911 immediately.

Beverly Hills investigators were suspicious of the suicide theory. The coroner's office ruled the shooting was a homicide; evidence showed the bullet that killed Ruffalo was delivered at a forty-five-degree angle from above and in front of his head. The autopsy report also notes there was no gunpowder residue or "stippling" of the flesh around the wound, both signs that usually accompany a suicide shot.

Police issued arrest warrants for Adham and her friend; they turned themselves in shortly after, but were released due to lack of evidence.

Compounding the tragedy, Shaha Mishaal Adham died on January 6, 2012, reportedly of a drug overdose. As of this writing, no charges have been filed and the case remains open.

Ruffalo's stepfather, Jerry Hull, was quoted in local papers saying he was hopeful this mystery would be solved one day. "I just want to see someone brought to justice."

Scott Ruffalo, shown here with his brother Mark (left), had recently separated from his wife and was living alone in the condo where he was shot.

The water was cold, but Alexandra Coggins and her boyfriend Scott Barker walked into the Pacific Ocean anyway, shivering. The couple was all alone on an isolated stretch of Malibu Beach. Dawn was breaking on Tuesday morning, July 20, 2010.

Had anyone been watching, they might have thought two crazy lovers were sharing a romantic escapade. In reality, the pair was washing blood off their hands; the blood of twenty-one-year-old college student Katsutoshi "Tony" Takazato, Coggins' ex-boyfriend. The two ran back to the sand, dripping wet and got back into their car. They had one more stop to make. Once they were deep into the canyons, they pulled over and walked down a hill to bury bloody clothes and a knife.

Police called the murder of Tony Takazato, "Horrific... there was blood evidence from the driveway all the way up to the carport."

Meanwhile, neighbors in the exclusive Trousdale Estates area were awakened by sirens and helicopters. Beverly Hills police had responded to a frantic 911 call from a Japanese woman who spoke little English. Officers quickly found a translator. The woman said she was a housekeeper who used to be twenty-one-year-old Tony Takazato's nanny after his mother died of cancer. The housekeeper said she'd seen two people—a boy and the girl Tony used to date—in the front yard; it must have been around 3 a.m. There was some kind of a fight, and the young man pulled out a knife and started stabbing Tony repeatedly. "So bloody," she said in a mixture of Japanese and English. "So bloody."

The housekeeper explained she and Takazato lived alone in the elegant, gated home on Carla Ridge Drive. Tony's father, Fuminori Hayashida, rarely stayed at the house. In fact, the film executive was living in Japan at the moment (he had produced a few Hollywood films in the Nineties, including *Lured Innocence* (2000) which starred Dennis Hopper). Father and son weren't particularly close; the boy had taken his mother's last name after she died.

The housekeeper said she had no idea why someone would want to kill Takazato, but she did tell investigators he had just broken up with the twenty-one-year-old Coggins. Police had their first clue. Two days later, they arrested Coggins and her new boyfriend, twenty-three-year-old Scott Barker, on charges of premeditated murder. The motive for the killing? Rage and jealousy, lies and misunderstandings.

According to police files and court records, Coggins had just started

dating Barker, but may still have been seeing Tony secretly. The night of the murder, she told Barker that Takazato had been physically abusive to her while they dated. Barker was furious; he grabbed Coggins and stormed over to the Trousdale house. When Takazato came outside, Barker viciously attacked him. Footprints in the blood show Barker walked away, then backtracked to the body, perhaps checking to see if Takazato was dead.

Neither of the accused killers had been in serious trouble with the law before this incident. In fact, Coggins, whose full name is Chie Alexandra Coggins Johnson, was a former rhythmic gymnast who won a silver medal at the 2004 Junior Olympics. She graduated from New Roads High School in Santa Monica in 2008.

On social networking sites, people who knew all three young adults took part in several heated exchanges. Here are a few of their comments that offer insight into this tragic killing:

July 23, 2010 at 9:47 p.m.
Tony Takazato was a good guy…He had a hard life and his father was not always there for him… His mother died when he was very young…When [Alexandra's] new psychotic boyfriend/fiancé found out [that Tony and she were still having sexual relations]…he brutally murdered Tony like a savage heartless disgraceful animal.

August 1, 2010 at 5:16 p.m.
Let me admit that Chie and Tony's relationship was dysfunctional, but know this: Tony never abused Chie, and if he did even put his hand on her it was to protect himself. Chie was a wild girl. I'm pretty sure everyone knows that.

August 1, 2010 at 7:19 p.m.
None of you knew Tony and Chie's relationship behind closed doors. Everyone here is an outsider, and shouldn't even be talking.

Both Barker and Coggins pled not guilty to the charges. After a year in jail, she was released and agreed to turn state's witness and testify against her boyfriend. She then pled no contest to charges of assault with a deadly weapon and was sentenced to time served and five years probation. At this writing, Scott Barker is awaiting trial for the murder of Tony Takazato.

It was a violent and stunning murder: Ronni Chasen, top Hollywood publicist, gunned down on November 16, 2010, on Sunset Boulevard in the heart of Beverly Hills. When the news broke, it rattled the neighborhood and movie community like an aftershock from an earthquake. A bona-fide, murder mystery—could this have been a hit? Who would want the classy blonde dead? Neighbors and colleagues were terrified; blogs were buzzing; everyone was desperate for answers. Such evil doesn't often visit the entertainment industry, especially not in Beverly Hills.

Chasen was a respected, workaholic publicist who championed composers like Hans Zimmer and successfully created Oscar buzz for movies like *Driving Miss Daisy* (1989) and *The Hurt Locker* (2008). On the last night of her life, she was attending the glitzy Hollywood premiere and after-party for the movie *Burlesque* (2010). Around midnight, Chasen left the party and drove west along Sunset Boulevard, bound for her condo on Wilshire Boulevard in Westwood. She stopped at a notoriously long red light at the Whittier Drive intersection, her sleek black Mercedes idling in the left-turn lane.

Exactly what happened during the last ugly minutes of Ronni Chasen's fabulous life will never be known. Police say it most likely was a botched robbery attempt that led to the shooting. Chasen took several bullets to the chest area but managed to step on the gas and drive off, making the left turn, but moments later crashing into a pole.

The killer, according to police, was Harold Martin Smith, forty-three, an ex-con drug and alcohol abuser, who not only had been arrested in Beverly Hills before, but had also been seen in the area recently riding his bike. Smith, it appears, was a blabbermouth who couldn't resist bragging to acquaintances that he was the guy who killed "that blonde lady" in all those news reports. When the TV show *America's Most Wanted* aired a segment on the killing shortly after the murder, one of Smith's acquaintances called the show's hotline with news of Smith's confession, and the show's producers notified Beverly Hills police.

Investigators wanted to ask Smith lots of questions, but they never got the chance. On December 1, about two weeks after the murder, officers approached their suspect in the lobby of the Harvey Apartment complex in Hollywood. Smith pulled out a revolver and without a single word, shot himself in the head. The bullets in his gun matched those found in Ronni Chasen.

Police officially closed the case, but questions and conspiracy theories remained. We, the authors—investigative reporter and lead CSI forensics specialist for the Beverly Hills Police Department—debate the details of the crime:

Barbara Schroeder: Clark, you know there are a lot of people, me included, who felt there was more to the Ronni Chasen story than just that she was in the wrong place at the wrong time. Are you one hundred percent convinced that this guy, Harold Smith, killed her? Are you one hundred percent sure it was random, that it wasn't a hit?

Clark Fogg (with zero hesitation): 110 percent. There's just too much evidence that points to Harold Smith, and

Ronni Chasen attended a movie premiere party at the W Hotel in Hollywood just hours before her attack and murder.

Chasen crashed her Mercedes Benz E-350 into a light pole at 12:30 a.m. Several homeowners came to her aid. When paramedics arrived, they determined she had been shot.

The .38-caliber Hydra-Shok bullet that penetrated Chasen's blue jacket was recovered from under the driver's seat. There were remnants of fabric in the center of the bullet.

no evidence that points to a hit.

Schroeder: What's your best evidence?

Fogg: There isn't just one piece of evidence; it's taking all the evidence together. This is a case where she was coming home late at night from a premiere, she was making a number of phone calls from the time she left the hotel to the time she was shot. If she was being chased or followed, she wouldn't have used the phone, or she would have called police to say she was in trouble. Everything she did looked like normal activity up until the confrontation with the suspect.

Schroeder: Convince me that this was not a hit.

Fogg: For one thing, the bullet wounds were not in a tight pattern as was erroneously reported. Her wounds were all across her chest and in her shoulders. A hit man would have chosen a more appropriate location to perform a hit—a boulevard left-turn lane seems unlikely. Professionals wait until they're in a more controlled environment. I'm not saying hits are never done in the street, but that wouldn't have happened in a case like this involving a high-profile person in such a public area. Another thing, Chasen was shot with a revolver, a six-shooter, that is awkward to use, and loud. Professionals are more likely to use semi-automatic weapons. Also, usually with a hit there is some telltale sign: the way the person lived, lawsuits, threats. There was nothing like that in her past, nothing on her computer or in correspondence. She had made plans to go on vacation at a chateau in France. There was no sign she felt she was in danger. And finally, we didn't find any money on or around Smith. His neighbors said he was begging for money, so there was no sign of a payoff.

Schroeder: Do you think Chasen saw the gunman, or could she have been checking messages at that long light, and he just walked up and totally surprised her?

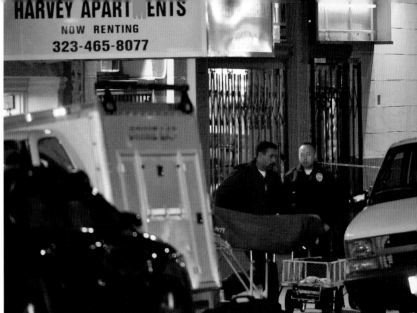

Harold Smith's body was removed by the Los Angeles County Coroner.

[above] Recently evicted, but still hanging around this Hollywood apartment complex, Harold Martin Smith boasted to neighbors that he was not going back to jail.

Fogg: That's one possibility. I think he wanted to do a street robbery and was waiting for a victim. Chasen was that victim, waiting for the left-turn signal on Sunset and Whittier. Smith possibly walked up to her vehicle and stood in front of it to prevent her from taking off. Chasen may have rolled down her window two to four inches then, and an exchange of words may have taken place. Chasen may have accelerated momentarily to scare Smith so he would move. Angry, Smith may have moved toward the passenger side and fired his weapon through the closed window as she sped away. Window glass was observed throughout the intersection.

Schroeder: So you found nothing that led you to believe there was anyone who wanted her dead?

Fogg: No, nothing. There were some individuals who didn't like her. She had a temper, but we didn't find anyone who wished her harm. We did a very thorough investigation. There was nothing in her background that indicated

someone was after her. She was very respected in her field.

Schroeder: What do you mean she had a temper?

Fogg: There was a report that about a month before the incident Ms. Chasen was driving on Sunset, not in Beverly Hills, more like Hollywood, and she was cut off by two young girls in a car. Chasen got out of her car and walked up to the girls and gave them a piece of her mind.

Schroeder: Could that have happened here? Maybe they got into a confrontation about money or him moving out of the way—you have to wonder why she just didn't drive off the minute she saw some strange man walk towards her car.

Fogg: She did drive away after the gunshots and before he had the chance to take anything from her or the car. Her purse, phone, everything was still in the vehicle. As for what happened at the vehicle during those last few minutes, we'll just never know.

Schroeder: A lot of doubters say it's ridiculous to think someone on a bike could have done this—could kill someone in a car.

Fogg: Those people have the wrong impression. He was not on a bike; he was on foot. He'd driven to the area on a bike and had stashed it in some bushes. Some people thought he was riding alongside of her, but no, that wasn't the case. We think he was looking to rob someone that night. We had reports from a number of people who saw a man on a bike in that area earlier.

Schroeder: Did you ever get surveillance video from homes or street cameras?

Fogg: No, the camera at the intersection had been removed months before. But we did get reports from various sources that indicated an individual matching the suspect's description was on a bike, riding around the neighborhood prior to the incident with Chasen.

Schroeder: He had a history of crime in Beverly Hills?

Fogg: Right, he had a history of trying to rob people in Beverly Hills. In 1998, he was sent to jail for assaulting a mother and daughter who were out walking their dog. He put a knife to the mother's throat; that's what landed him in jail the last time for ten years.

Schroeder: But what if he was just a nutcase who didn't have anything to do with the murder? Is that possible?

Fogg: No, he told people, several witnesses, "Hey, you know all that stuff going on the news, I did that." Plus his weapon was an exact ballistics match with the murder weapon. The ammunition was a unique Hydra-Shok type bullet used both in the murder and his suicide.

Schroeder: There was a local news interview with a retired law enforcement expert, not someone from your department, who claimed the ballistics tests showed the bullets didn't match the murder weapon.

Fogg: You know, the ballistics report was not completed when that comment was made. It was a negligent remark by an individual who was not connected with the official case. The Los Angeles County Sheriff's Department findings came out later and showed a hundred percent match between bullets and weapon. Those are the facts.

Schroeder: So, to the people who will never believe your version of what happened, what do you say to them?

Fogg: To those conspiracy theorists I say this: accept all the evidence. That's it. But there is something to be learned from this: Be aware of your surroundings; don't be distracted. Perhaps she had the interior light on in the car; maybe she was dialing and distracted; we'll never know. So be alert. But more than anything, if you're in a situation where you're not comfortable, don't take anyone on; don't talk; just drive off. This is a case that is so difficult to make sense of, it was such a senseless killing.

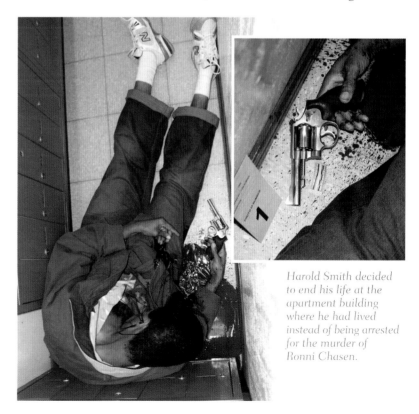

Harold Smith decided to end his life at the apartment building where he had lived instead of being arrested for the murder of Ronni Chasen.

EPILOGUE

With that, our chronicle of the first century of crimes, scandals, and stars behaving badly in Beverly Hills comes to an end. What is there to learn from the sweep of an era? Perhaps just this: human nature doesn't change all that much. There will always be people who crave fame and will do anything to achieve it. There will always be those whose passions and temptations lead them down a path of destruction—or evil. And where there's big money, big drama is sure to follow. Lives are squandered; fortunes lost; love is skewered.

There are those who find only trouble in this paradise, victims of crimes both heinous and tragic. As the second century begins for Beverly Hills, the drama behind the glitzy exterior continues: a fifty-eight-year-old woman was knifed to death on October 26, 2011. She left mysterious clues behind to help investigators identify their main suspect: a lover she'd met online.

Less than six months later, at the Beverly Hilton hotel, came the tragic demise of revered songbird Whitney Houston, discovered dead in her bathtub on the eve of the Grammy Awards, February 11, 2012—her skin blistered in spots from scalding-hot water. The singer's death was a supreme tragedy, officially listed as an accident. The cause: drowning, complicated by heart disease and cocaine use.

It is quite the cast, the pioneers of Beverly Hills and subsequent generations. Not even Hollywood could produce its equal. Oscar? Emmy? Golden Globe? One of each please, for this city that has been a playground and home to some of the richest, most eccentric, most famous, most tragic, and most beautiful people the world has ever known. Drama, illusion, human frailty; the players change, but the theme is constant. The audience, always mesmerized.

Frankly, it's a story told throughout the ages in places all over the world, but it plays much more dramatically in Beverly Hills, a town that's renowned for its glamour, all shiny and irresistible. Beverly Hills has earned its rightful place in the pantheon of famed cities. "If there were a Camelot on earth," a city councilman once said, "it would be Beverly Hills." A Camelot, may we submit, filled with secrets as dark as the sunshine is bright.

Acknowledgments

First, we'd especially like to thank Beverly Hills Chief of Police Dave Snowden for his love of history and for introducing us. His simple "You two should meet" started it all. Retired Officer Richard L. Clason and his careful documentation proved invaluable to this project, as did the late Chief Clinton Anderson's book, *Beverly Hills is My Beat*, and officers' scrapbooks found in the Beverly Hills Police Department archives, particularly the one from the late Captain Ray Borders. Many thanks to Beverly Hills Reserve Officer Michael Schwab for opening doors to get this project up and running.

We'd also like to thank the caretakers of history who helped on this adventure, especially the archivists and librarians whose professionalism was exemplary: Gail Stein, City of Beverly Hills historian and archivist; and Christina Rice, acting senior librarian and manager of the photography collection at the Los Angeles Public Library, as well as her team of Terri Garst, Fernando Sauceda, and Katarina Mekel. Special thanks to the UCLA Special Collections Library, where Angela Riggio, Carol Nishijima, Ann Watanabe-Rocco, and Brandon Bardon provided much invaluable help. Our gratitude to Erica Varela and the team at the *Los Angeles Times*. Dace Taube, head of the Special Collections at USC Doheny Memorial Library, lived up to her stellar reputation in every way, and we are grateful for her assistance. We thank, too, Katherine Timme for her expertise on the history of Greystone Mansion, and Delmar Watson Photography Curator Antoinette Watson, Daniel Watson, and his father Garry, who endeared us with stories from news-photography days in the 1950s. It was a pleasure to work with Marc Wanamaker, the founder of Bison Archives. We are so glad we met Gregory Paul Williams, author of *The Story of Hollywood*, and had access to his incredible Cliff Wesselmann collection.

Several books by journalists long gone proved to be a treasure trove of background information, none more so than *Newspaper Woman* by *Los Angeles Evening Herald & Express* City Editor Agnes Underwood, and *My Hollywood Story* by Adela Rogers St. Johns.

Many thanks for the conversations and information provided by the following: investigative journalist Pat Lalama, former *L.A. Times* reporter Cecilia Rasmussen; Tim Bird from the antique car dealership, The Chequered Flag; Darrell Rooney, co-author of *Harlow in Hollywood*; and Bob Board, Marion Davies's number-one fan. Thanks to Ernest Marquez, author of *Noir Afloat*, for his input, and to Paul Chamberlain, a former FBI agent with intel he still won't share, a class act all the way.

To graphic designer Hilary Lentini and her team, Alan Altur, Allie Williams, and Leanna Hanson: we can't thank you enough for bringing this book to visual life. And finally to the Angel City Press team, Jim Schneeweis, Lynn Relfe, intern Niree Perian, the ever-vigilant Scott McAuley and, most of all, Paddy Calistro McAuley; your vision and skill made this book everything we hoped it could be.

—Barbara Schroeder and Clark Fogg

INDEX

INDEX

INDEX

Index

Photo Credits

The authors and publisher wish to thank all the sources that have provided images for *Beverly Hills Confidential*. Except as noted below, all photographs are from the files of the Beverly Hills Police Department and are provided under the Freedom of Information Act. A good faith effort has been made to ascertain the proper source of all photographs. Any errors or oversights are unintentional; please contact the publisher.

Courtesy Gordon Basichis, from his book *Beautiful Bad Girl: The Vicki Morgan Story*, Santa Barbara Press, 1985: 87 (inset, top).

Beverly Hills Library Historical Collection: 15 (upper), 19 (top left and right), 28 (top right), 30 (right), 31 (left), 34 (bottom), 35, 40 (upper, lower), 43 (top).

Courtesy Bob Board, The Marion Davies Collection: 34 (middle).

Courtesy Glenn Boozan Photography: 13 (background).

Corbis Images (copyright © Bettmann/CORBIS, except as noted): 20 (middle, bottom left), 25 (right), 38 (right), 62 (bottom left), 68 copyright © Ed Clark.

Amy Graves Photography (copyright © Amy Graves): 112.

Jan and Dean archives (www.jananddean.com): 74 (middle).

Daniel Kincaid photography (www.danielkincaid.com): 102, 118.

Courtesy David Levinthal (copyright © David Levinthal Photography): 43 (bottom).

Los Angeles Public Library/Herald Examiner Collection: opposite page 1, 13 (center), 19 (middle, bottom), 23, 28 (top left), 42 (middle, right), 50 (middle, bottom), 51 (top left, bottom right), 52 (left), 55 (middle), 56 (top), 57 (bottom), 58 (top left, top middle, bottom), 59 (top, bottom), 64 (top right), 66 (top right), 67 (bottom left), 70 (top, middle, bottom right), 71 (top left, top right), 73 (top right), 76 (bottom), 77 (left), 82 (top), opposite page 128.

Los Angeles Times Reprints (copyright © *Los Angeles Times*, reprinted with permission): 24 (bottom right copyright © 1925), 64 (bottom copyright © 1951).

Courtesy The Lower Merion Historical Society: 42 (top left).

Courtesy The Darrell Rooney Archive: 36 (left, middle), 38 (left).

Courtesy Suzanne Skaff, Juel Park Lingerie, Inc.: 34 (bottom right).

UCLA Charles E. Young Research Department of Special Collections
Los Angeles Times Photographic Archives (copyright © Regents of the University of California UCLA Library): 22 (bottom), 25 (top left), 42 (second from left), 47 (bottom right), 54 (bottom), 61, 62 (top left, top right), 75, 79 (left, right), 87 (top right).

University of Southern California, USC Special Collections: 62 (right, middle, and bottom right), 67 (bottom right), 126.

Courtesy Michelle Vogel, from her book *Lupe Velez: The Life and Career of Hollywood's Mexican Spitfire*, McFarland, 2012: 54 (top right).

Marc Wanamaker/Bison Archives: 17 (center), 15 (postcard), 36 (right), 37 (top), 52 (top right), 53 (top right), 80 (top).

Watson Family Photographic Archive: 14 (center), 16 (bottom left, right), 20 (right), 21 (right), 22 (top), 24 (top left, center left, middle), 49 (top left, bottom), 76 (top).

Courtesy Gregory Paul Williams, The Cliff Wesselmann Collection: 30 (top left, bottom left), 37 (middle, bottom), 39, 51 (bottom left).

Zuma Press (zumapress.com): 34 (top left), (middle left; copyright © Globe Photos), 46 (top left copyright © RKO Pictures, 47 (bottom left copyright © Wolfgang Kumm), 50 (background copyright © Globe Photos), 51 (top right copyright © Keystone Pictures USA), 53 (top left copyright © El Universal), 65 (background copyright © *The Toronto Star*), 69 (bottom right copyright © Keystone Pictures USA), 74 (top, middle right, bottom right copyright © Globe Photos; middle copyright © Keystone Pictures USA), 80 (right copyright © Globe Photos), 81 (top right copyright © Lisa Krantz/*San Antonio Express-News*), 87 (top left, middle left copyright © Globe Photos; top middle copyright © Nate Cutler), 95 (left copyright © *Los Angeles Daily News*), 96 (left copyright © Lisa Rose), 97 copyright © Mylan Ryba, 103 (bottom left copyright © Bob Noble; bottom middle copyright © D. Long; bottom right copyright © Jonathan Alcorn), 107 (middle right copyright © Globe Photos), 110 (top left copyright © Rose Hartman), 116 (top right copyright © Gene Blevins).

This Marine made sure he looked presentable for his mug shot after he and his girlfriend got into an accident; she was charged with drunk driving.

ANGEL CITY PRESS

Published by
Angel City Press
2118 Wilshire Blvd. #880
Santa Monica, California 90403
+1.310.395.9982
www.angelcitypress.com

Beverly Hills Confidential
A Century of Stars, Scandals and Murders

Copyright © 2012 by Barbara Schroeder and Clark Fogg

10 9 8 7 6 5 4 3 2 1

ISBN-13 978-1-883318-70-3

All rights reserved. No part of this book may be reproduced
or transmitted in any form or by any means, electronic or
mechanical, including photocopying, recording, or by an
information storage and retrieval system, without express
written permission from the publisher.

Names and trademarks of products are the property of their
registered owners.

Design by Lentini Design

Library of Congress Cataloging-in-Publication Data is available
for LCCN 2012018186

Printed in China